SUPERVISION

Orbis Editions
Cambridge, Massachusetts

The MIT Press
Cambridge, Massachusetts
London, England

SUPERVISION

on motherhood and surveillance

edited by
Sophie Hamacher
with Jessica Hankey

Melina Abdullah
Jeny Amaya
Gemma Anderson
Nurcan Atalan-Helicke
Sarah Blackwood
Lisa Cartwright
Cary Beth Cryor
Moyra Davey
Duae Collective
Sabba Elahi
Laura Fong Prosper
Regina José Galindo
Michele Goodwin
Alexis Pauline Gumbs
Lily Gurton-Wachter
Keeonna Harris
Laëtitia Badaut Haussmann
Jennifer Hayashida
Kenyatta A.C. Hinkle
Lisbeth Kaiser
Magdalena Kallenberger
Caitlin Keliiaa
Anjuli Fatima Raza Kolb
Stephanie Lumsden
Irene Lusztig
Tala Madani
Jade Phoenix Martinez
Mónica Mayer
Iman Mersal
Jennifer C. Nash
Hương Ngô
Erika Niwa
Priscilla Ocen
Litia Perta
Claudia Rankine
Viva Ruiz
Ming Smith
Sable Elyse Smith
Sheida Soleimani
Stephanie Syjuco
Hồng-Ân Trương
Carrie Mae Weems
Lauren Whaley
Kandis Williams
Mai'a Williams
Carmen Winant
Kate Wolf
Hannah Zeavin

Contents

All interviews conducted by
Sophie Hamacher

Works by the following artists are presented throughout the book:
**Gemma Anderson
Cary Beth Cryor
Sabba Elahi
Laura Fong Prosper
Regina José Galindo
Kenyatta A.C. Hinkle
Tala Madani
Mónica Mayer
Hương Ngô
Viva Ruiz
Ming Smith
Sable Elyse Smith
Sheida Soleimani
Stephanie Syjuco
Hồng-Ân Trương
Carrie Mae Weems
Kandis Williams
Carmen Winant**

Preface

SOPHIE HAMACHER

My vision changed after becoming a mother. Unfolding over time, this change impacted all facets of my life. Whereas before motherhood I was learning to see, as a mother, I was learning to watch.

I have often thought back on the dazed first few months of my daughter's life when I would sit by her crib in our apartment in New York City gazing at her, attuned to each wiggle of her minuscule toes, each minor exhalation of breath. I stared at her incessantly, wanting to understand where this mysterious being came from, while trying to learn how to take care of her by studying her movements and tracking her carefully. Once her eyes adjusted, I remember her staring back at me, though I was much less aware of her vision and her eyes looking up at me than my own looking down at her. The condition of watching and being watched was central to our relationship of new mother and developing child.[1]

Giving birth also marked an unmistakable shift in my artistic production. Taking pictures or filming a scene had always involved a very specific kind of focus: the firm grip of the camera in my hand and the feel of it against my cheek as I peered through the lens and concentrated on composition, movement, and time. Suddenly, filming and looking through a lens or viewfinder wasn't possible as it was before because I had to watch my child. Now it was only when my daughter was strapped into her stroller, her movements confined and her safety assured, that I could look and then see through a camera.

As I became absorbed with tracking and monitoring my child, I was increasingly aware that I was a subject of tracking and monitoring by others: advertisers, medical professionals, government entities, people on the street. I began to wonder about the relationship between the way I watched her and the ways we were being watched. How were our daily activities intertwined with broader questions about care and control? This is where my research began.

I brought these concerns and questions to Jessica Hankey, who encouraged me to conceive of the project as a conversation reaching beyond the contours of my own experience. We have worked collaboratively as visual artists interested in the possibilities of the book form.

Care and Control

Surveillance is an ambivalent term, encompassing activities like policing and caretaking that seem to belong to two distinct and polarized categories. Yet in practice, these qualities of surveillance—both beneficial and harmful, intimate and distanced—intertwine and overlap. In French, the verb surveiller can have

[1] "The child gains her first sense of her own existence from the mother's responsive gestures and expressions. It's as if, in the mother's eyes, her smile, her stroking touch, the child first reads the message: *You are there!* And the mother, too, is discovering her own existence newly." Adrienne Rich, *Of Woman Born: Motherhood as Experience and Institution* (New York: W. W. Norton & Company, 1986), 36.

benevolent connotations: surveiller un enfant (to watch over a child) or surveiller un malade (to care for a patient). Both uses imply guarding, supervising, watching, and caring for, as in the close observation necessary to care for our children. In English, on the other hand, when we think of surveillance we tend to think of systems of control and power linked to government, state, institutional, and corporate hierarchies. I wondered whether the English-language associations with surveillance have contributed to the lack of inquiry into its role within families.

The connection between care and control seems most evident in the monitoring that occurs inside the family. However, the shape of the family—often defined as a private sanctuary, a refuge separate from the external world—is also regulated and determined by the outside.[2] In a letter to photographer Susan Meiselas, Eduardo Cadava writes that our perception is always mediated by our history, that our eyes can only see through the relations that have shaped our understanding.[3] For me, Cadava's observation points to the ways in which motherhood is always being shaped by familial, economic, and legal frameworks, so that there is not one essential experience. I struggled to see myself within my expanding family through the relations that shaped my life up to that point. Sometimes I felt like I had reached a point of self-knowledge only to suddenly land in a place and an identity I knew absolutely nothing about. Perception is always full of memories even if those memories are of being a daughter instead of a mother, of being cared for instead of providing care.

Monitoring—and Marketing—the Maternal

As an artist and filmmaker, my work has centered on theoretical and visual explorations of seeing in terms of framing, screening, and looking. My documentary practice is marked by a kind of surveillant gaze that was increasingly replaced by the watchful supervision of my child. After her birth, I turned to cameras, buying several baby monitors for the purpose of visual experimentation. These monitors were a touchstone as my life was further transformed by motherhood, my time consumed by my daughter instead of my film practice. I wanted to test observation with these devices and find out if it was possible to use them in alternative ways. For me, the monitors were a route through the parental gaze back to thinking about modes of watching. My interest was sparked by the images they produced which always linked them to other histories—to the history of photography and modern warfare.

The first marketed baby monitor, the "Radio Nurse," was developed in 1937 and designed by sculptor Isamu Noguchi. This monitor is said to have been developed in response to the kidnapping and death of the Lindbergh baby.[4] Capitalizing on the fear and enormous interest stirred by the kidnapping, advertisers strategically created doubts in mothers about their ability to care for their infants while making dubious promises to scare them into buying their products.[5] Modern advertising's strategy of marketing anxieties to consumers that are alleviated by their products dovetails with the state's history of sowing fears about public safety as it pushes for greater surveillance powers. As parents, it can sometimes be impossible to distinguish legitimate fears from manufactured ones; this has never seemed more true than today.

The succession of technologies used in different models of baby monitors have their origins in military research. Closed circuit television (CCTV) footage, the technology behind most contemporary baby monitors, is often captured for instantaneous playback or it's recorded and obtained for later use, a kind of automatic archive that can only be viewed by people within the circuit.

[2] As we know, governments and other external structures police, control, and manage who can marry whom, who can adopt whom, whether a person is allowed to abort a fetus, or even how a family is defined. Inside and outside can be a false binary since surveillance inside the home can be linked to consequences that are as negative as those outside the home; the home is a site of oppression for many. In the family, surveillance, control, and dominance are interlinked.

[3] Eduardo Cadava, "Learning to See," in *Susan Meiselas: Mediations* (Bologna: Damiani, 2018), 46.

[4] Rebecca Onion, "The World's First Baby Monitor: Zenith's 1937 'Radio Nurse,'" The Vault, *Slate*, February 7, 2013, https://slate.com/human-interest/2013/02/zeniths-radio-nurse-designed-by-isamu-noguchi-was-the-worlds-first-baby-monitor.html.

[5] As Susan Douglas and Meredith Michaels observe, "various companies have discovered, not surprisingly, that there are profits in such fears. And mothers, as a market, are being increasingly segmented into more specialized target markets, and thus can be serially bombarded with admonitions about the amounts and kinds of surveillance they are now meant to provide." See *The Mommy Myth: The Idealization of Motherhood and How It Has Undermined All Women* (New York: Free Press, 2004), 302.

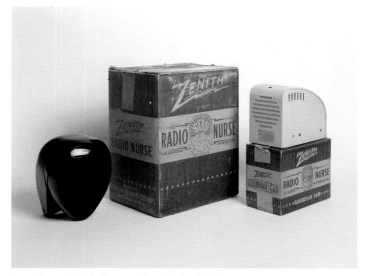

Isamu Noguchi, *Radio Nurse and Guardian Ear*, 1937

The Siemens corporation installed the first CCTV system in 1942 in Peenemünde—Nazi Germany—for observing the launch of the first ballistic missiles.[6] Electrical engineer Walter Bruch designed the closed circuit so the launch could be observed from a safe distance. Used in baby monitors, the images transmitted are not intended for viewing in a far-off future; they are meant for immediate consumption, like a type of live-stream video. They are not assigned aesthetic value per se, because they are not meant for contemplation and are not produced for lasting impression.[7] Instead, they have a real-time aesthetic of continuity and simultaneity.

Night-vision devices came into wide use during the Vietnam War but did not enter the baby monitor market until the 1990s.[8] The distortion in contemporary baby monitor images originates from the gray scale of night vision and bad resolution, making them noticeably unnatural and eerie. The images have a specific CCTV look: monochromatic cool blue or black and white, heavily pixelated, with a great deal of visual noise obscuring the image and making it stylized and blurred. Babies are depicted tinted with the subtly nefarious undertones of wartime and lurking violence. These images have a dual valence as banal artifacts that carry the threat of danger (which the monitor protects against) and the domestic intimacy of family life.

Running counter to the baby monitor's logic of immediate consumption within the closed circuit of the home, newer models now have the options of rewinding and recording, actions that suggest rewatching, contemplation, and archiving. For me, these added functions suggest the presence of other bodies: an expansion of the closed circuit—perhaps anticipating the application of the device as a "nanny cam," or for imagined future use in a lawsuit or criminal proceedings. By extension, the technology is bound to a specter of violence. After all, in a repetition of the pattern set by the first baby monitor, it was a spate of sensationalist TV news stories about caregiver abuse of children in the '90s that transformed the baby monitor industry, fueling historic growth through the introduction of the nanny cam. In addition to exploiting fears about safety, the baby monitor industry is also tapping into the historical tendency to associate cameras with reality. That association causes video and photography alike to be accepted as accurate representations of present and past, despite the indisputably subjective nature of framing.

6 Lawrence Cappello, *None of Your Damn Business: Privacy in the United States from the Gilded Age to the Digital Age* (Chicago: University of Chicago Press, 2019), 171.

7 As Hito Steyerl writes in the seminal text "In Defense of the Poor Image," the poor image "transforms quality into accessibility, exhibition value into cult value, films into clips, contemplation into distraction. . . . Poor images are poor because they are not assigned any value within the class society of images." By citing Steyerl's essay here, I'm not attempting to defend the surveillant image but to point to its imperfect quality and question if it might be considered a different kind of "poor image." *eflux Journal*, no. 10 (November 2009), https://www.e-flux.com/journal/10/61362/in-defense-of-the-poor-image/.

8 Elizabeth S. Redden and Linda R. Elliott, "Night Vision Goggle Design: Overcoming the Obstacle of Darkness on the Ground" in *Designing Soldier Systems: Current Issues in Human Factors*, edited by John Lockett, John Martin, Laurel Allender, Pamela Savage-Knepshield, (London: Taylor & Francis, 2017), 3.

9 David Lyon, *Surveillance Society: Monitoring Everyday Life* (Buckingham: Open University Press, 2001), 3.

10 I'm drawing here on Simone Browne's writing about security theater, particularly chapter four, "'What Did TSA Find in Solange's Fro'?: Security Theater at the Airport" in *Dark Matters: On the Surveillance of Blackness* (Durham, NC: Duke University Press, 2015), 145.

11 "This lack of self-consciousness suggests that parents believe they have both a 'right' and a moral obligation to know what is going on with their own child." William G. Staples, *Everyday Surveillance: Vigilance and Visibility in Postmodern Life* (Lanham, MD: Rowman & Littlefield, 2000), quoted in Margaret K. Nelson, "Watching Children: Describing the Use of Baby Monitors on Epinions.com" in *Who's Watching?: Daily Practices of Surveillance Among Contemporary Families* (Nashville: Vanderbilt University Press, 2009), 233.

12 As Eric Howeler writes, "The scopic has become a commodity and a theme—surveillance a source of mild titillation, curiosity, a social activity and cultural pastime." Eric Howeler, "Anxious Architectures: The Aesthetics of Surveillance," *Archis, no 3* (March 2002), http://volumeproject.org/anxious-architectures-the-aesthetics-of-surveillance/.

13 "For better or worse, this desire to be watched, read, or heard is a fundamental element in the evolution of the surveillance society." John Gilliom and Torin Monahan, *SuperVision: An Introduction to the Surveillance Society* (Chicago: University of Chicago Press, 2012), 143.

14 The experience of pregnancy and the myriad ways I had been tracked and monitored while my baby was still in utero prompted an interest in the surveillance of the body. As political and governmental interests seek rights to the fetus that supersede those of the mother, this scrutiny that I readily submitted myself to is implicated in broader struggles over privacy and the autonomy of women's bodies. This monitoring has continued through regular visits to the pediatrician to track my children's physical development against standard milestones, and beyond.

15 Jeremy Bentham's panopticon, a prison with a radial design, was designed to reinforce disciplinary punishment through surveillance. In Foucault's extended metaphor of the panopticon prison as a model of

Baby Watchers

Although these monitoring technologies can be used for the sake of power, they are first and most often used for the sake of care. People often participate in surveillance of those about whom they care in order to reduce the risks to which they are exposed. So "the same process, surveillance—watching over—both enables and constrains, involves care and control."[9] This can be observed in the expansion of camera surveillance into childcare facilities. When my daughter turned just a year old, I had to sign a video surveillance policy agreement in order to send her to a daycare center. The center notified me that the children, along with staff and parents, had to be kept under video surveillance to ensure their safety. In the name of care, participation in childcare centers also entails surveilling notoriously underpaid workers. It is a kind of security theater, where the staging of the surveillance through these cameras has become a compulsory assurance of safety and oversight, even though the camera's seeing is never total.[10]

I talked to a few mothers with children at my daughter's daycare who were clearly aware of their own voyeurism and who spoke of obsessing over observation, of actually enjoying being able to stealthily observe their sleeping infants on screen from a distance. It didn't seem as though parents worried about invading their children's privacy or that of the school workers.[11] On the contrary, being a better mother seemed to involve the upending of vision from the human eye, a shift that encompassed looking, watching, and being able to surveil one's child differently than in the past. Technological surveillance had become mandatory.

These forms of surveillance are presented as a way of holding the family together and facilitating safety through "watching." This dynamic is manifold, as busy parents scroll through their phones, swap between the baby monitor feed that provides biometric information and video of their child, and post images and status updates about themselves, all on one device. Families have been performing their unity and rectitude for cameras almost since the inception of the medium and today these images and videos are disseminated across social media platforms for audiences large and small. As watching others becomes an all-consuming enterprise, being watched is a diversion and a leisure activity.[12] We are brought ever closer to Michel Foucault's state of "permanent visibility," with "inmates" who want to be monitored.[13]

Controlled Images and Mother Watchers

Cameras have become so ubiquitous that much of the time we hardly notice their persistent intrusion. The mechanisms of the surveillance state can be alarmingly apparent at border controls, through passport monitoring, and interactions with the criminal justice system. Less visible is the monitoring that takes place in stores, on the street, simply by moving through cities, for the entirety of our lives. My children's generation will probably experience all this tenfold. They are surveilled while still in their mother's bodies and from the moment they arrive on earth while sleeping, eating, and breathing.[14]

With all this watching, it is no wonder that Foucault's extended metaphor of the panopticon continues to be the dominant model for understanding surveillance in our time.[15] In the panopticon prison, inmates monitor themselves because they believe they are under constant observation. As a metaphor, this is still a useful way of thinking about how social control operates and how disciplinary power comes to be internalized; how all these cameras contribute to "a state of conscious and permanent visibility that assures the automatic functioning of

power."[16] Within motherhood, the threat of being watched is diffuse and exerts power in ways that are explicitly coercive but also voluntary and apparently benevolent.

I found myself thinking about one of the world's first films, less than a minute in length, which shows Auguste Lumière and his wife Marguerite having lunch with their baby daughter Andrée in 1895.[17] Two years later, Andrée's cousin was filmed taking her first steps. In spite of the gulf of over a century separating these flickering images from today, these are scenes that I know: babies eating, drinking, crawling, learning to walk, smiling, and crying on screen. Watching these films (degraded and uploaded on YouTube), I was startled by how much they resemble contemporary home videos of the family, using the camera as a technology of family intimacy and respectability. The Victorian bourgeois values enshrined in the film are apparent through the centrality of the child,

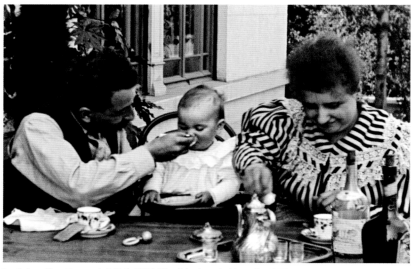

Louis Lumière, *Repas de bébé*, 1895. Film (black and white, silent), 58 seconds

the seemingly peripheral mother, the mother's dress, the silver teapot, the porcelain teacups, the pristine white frock of the baby. Considered alongside the family videos of children that are today shared online, I wondered about the exclusions and repressions at work (as they are in contemporary home movies) to create these images of charmed homelife.[18] The scene became an opportunity to consider the relations between what I could see and what I could not, presence and absence, life and death—another invitation to think about what it meant to see and to closely observe.

The interplay between the seen and unseen has reverberated throughout enactments of surveillance, particularly with the emergence of photography. In "The Body and the Archive," the artist and writer Allan Sekula suggests that in the operation of disciplinary power "every proper portrait has its lurking, objectifying inverse in the files of the police."[19] Sekula signals an interdependence between the surveillance and representation of sanctioned families and those framed as deviant or criminal.[20] Going further, he argues that photography "served to introduce the panopticon principle into daily life."[21] Race, class, gender, sexuality, and other markers of identity can operate in an interlocking way that is repressed and scrutinized, pushing families out of the frame or into "police files." Photography's role in defining and regulating zones of respectability and social

our modern condition, prisoners monitor themselves because they believe they are being watched, thereby disciplining themselves. The "panoptic principle" serves as the foundation for a system of belief that encompasses total and permanent visibility. See Michel Foucault, *Discipline and Punish: The Birth of the Prison* (New York: Pantheon, 1977), 205. Critics have rightfully pointed out that the panoptic model does not adequately describe the many ways that surveillance operates outside of the visual field, e.g. through data collection. See Shoshana Zuboff, *The Age of Surveillance Capitalism: The Fight for a Human Future at the New Frontier of Power* (New York: Public Affairs, 2019).

[16] Foucault, *Discipline and Punish*, 201.

[17] *Repas de bébé* was shown in the Lumières' first public screening in Paris on December 28, 1895. The Museum of Modern Art, *MoMA Highlights*, (New York: The Museum of Modern Art, 2004), 40.

[18] For a discussion of race, representation, and photography's role in reproducing these exclusions and repressions, see Kimberly Lamm, "Portraits of the Past, Imagined Now: Reading the Work of Carrie Mae Weems and Lorna Simpson," in *Unmaking Race, Remaking Soul: Transformative Aesthetics and the Practice of Freedom*, edited by Christa Davis Acampora and Angela L. Cotten (Albany: State University of New York Press, 2007), 116-18.

[19] Allan Sekula, "The Body and the Archive," *October* 39 (Winter 1986): 7.

[20] Sekula shows how photography and the nascent fields of criminality and psychiatry emerged around the same time and their development is intertwined. Photography's role in defining the criminal is relevant today as the idea of criminality—the fear of crime wielded through images of menace and threat—continues to be used to gain public support for policies that enlarge the state's surveillance apparatus, denying basic rights and perpetuating mass incarceration.

[21] Sekula, "The Body and the Archive," 10.

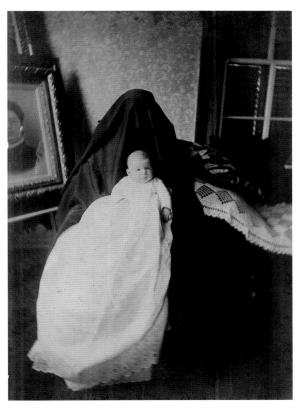

Linda Fregni Nagler, from *The Hidden Mother*, 2006–13. 997 original tintypes and albumen prints

deviance, of honor and repression, is so pervasive that it's hard to see it at times. Many mothers find that they can be subjects of a "proper portrait" while also having their very own lurking "inverse" in the files of institutions.

This project seeks to bring together accounts of the surveillance of families from across the spectrum of the sanctioned and the criminalized. As the scope of the publication progressively widened beyond my own experience to include interviews with caregivers who were affected by or who had confronted surveillance, I spoke with mothers who experienced a different frequency, intensity, and focus of the surveillant gaze. Contributors spoke about the power of surveillance to increase the life chances of some and choke off those of others—as a tool that has the binary potency of being "socially ameliorative as well as . . . socially repressive."[22] Surveillance in motherhood has the capacity to reinforce divisions, to categorize and classify, to direct desires and transmit judgment as well as to coerce and control.

Simone Browne uses the term "racializing surveillance" to point to "those moments when enactments of surveillance reify boundaries . . . along racial lines, and where the outcome is often discriminatory treatment of those who are negatively racialized by such surveillance."[23] Drawing on the work of John Fiske, Browne argues that racializing surveillance "exercises a 'power to define what is in or out of place.'" Being deemed "out of place" can simultaneously render a subject hypervisible and invisible. In a conversation included in this volume, lawyer and legal scholar Priscilla Ocen speaks about the links between motherhood,

[22] Sekula, "The Body and the Archive," 8.

[23] Simone Browne, *Dark Matters: On the Surveillance of Blackness* (Durham, NC: Duke UP, 2015), 16. See also John Fiske, "Surveilling the City: Whiteness, the Black Man and Democratic Totalitarianism," *Theory, Culture and Society* 15, no 2 (1998): 81.

criminalization, and incarceration. Ocen discusses the hypervisibility of
Black women in the U.S. in particular, who are subject to constant surveillance
by institutions within law enforcement, social services, and education.
Underscoring the difference between being seen and being watched, scrutinized
but not recognized, Ocen gives a firsthand account of the role visibility plays
in perpetuating inequality within the U.S. criminal justice system. In essays
that discuss family detention along the U.S.–Mexico border and medical racism,
contributors Lisa Cartwright and Kenyatta A.C. Hinkle further draw out the
implications of visibility and systematic unseeing in discriminatory and abusive
practices—denying rights and care for undocumented children separated from
their caregivers in detention (Cartwright) and inappropriately and insufficiently
monitoring the health of mothers of color, who die at significantly higher rates
than their white counterparts in the U.S. (Hinkle).

These dynamics around visibility within the operations of surveillance have only
been heightened during the global COVID-19 pandemic. The collapsing distinction
between private and public life and the deepening of economic inequality have
rapidly accelerated. The corporatization of public education through Zoom/Google
video classrooms, the extension of surveillance to the home by way of school are
intensifying at an alarming pace. Meanwhile, Google Classroom was repeatedly
caught and fined for datamining children pre-pandemic. As their user base has
skyrocketed to over one hundred million, their current practices and reach remain
unknown.[24] At the time I'm writing this, schools across the U.S. are going fully
remote again, forcing children to learn from home and the impossible pressures on
families, and mothers in particular, to manage parenting and work during a massive
economic downturn are unsustainable. In spite of our splintered attention spans, the
study of surveillance in our daily lives has never been more urgent.

[24] For a discussion of the rise
of surveillance during this
time of overlapping crises,
see Simone Browne, Naomi
Klein, and Shoshana Zuboff,
"Surveillance in an Era of
Pandemic and Protest," a live
virtual event, the *Intercept*,
September 21, 2020, https://
theintercept.com/2020/09/11/
coronavirus-black-lives-matter-
surveillance/. In this panel
conversation, Browne discusses
Ka'Mauri Harrison, whose case
is a stunning example of how
schools have already become an
extension of the carceral state
with overly punitive discipline
policies that overwhelmingly
target Black and brown children.
See also Tim Elfrink, "A teacher
saw a BB gun in a 9-year-old's
room during online class. He
faced expulsion," *Washington
Post*, September 25, 2020.

Opposite:
Carmen Winant, *White Women Look Away*, 2019.
Found images and crayon on paper, 38" × 33"

Following pages:
Carmen Winant, *My Birth*, 2018. Found images,
tape. Installation view of *Being: New Photography
2018* at the Museum of Modern Art, New York

12

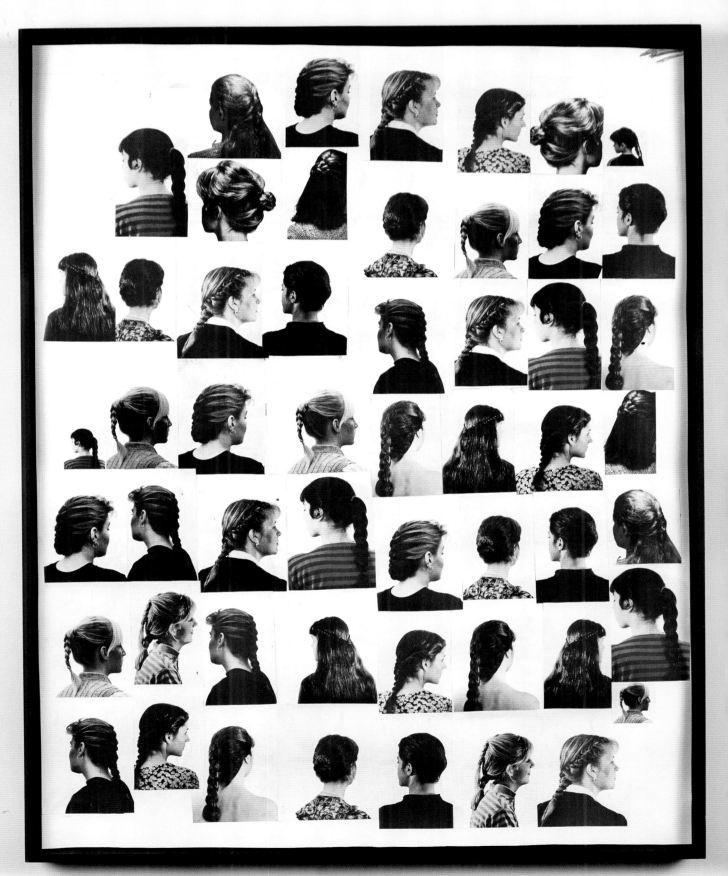

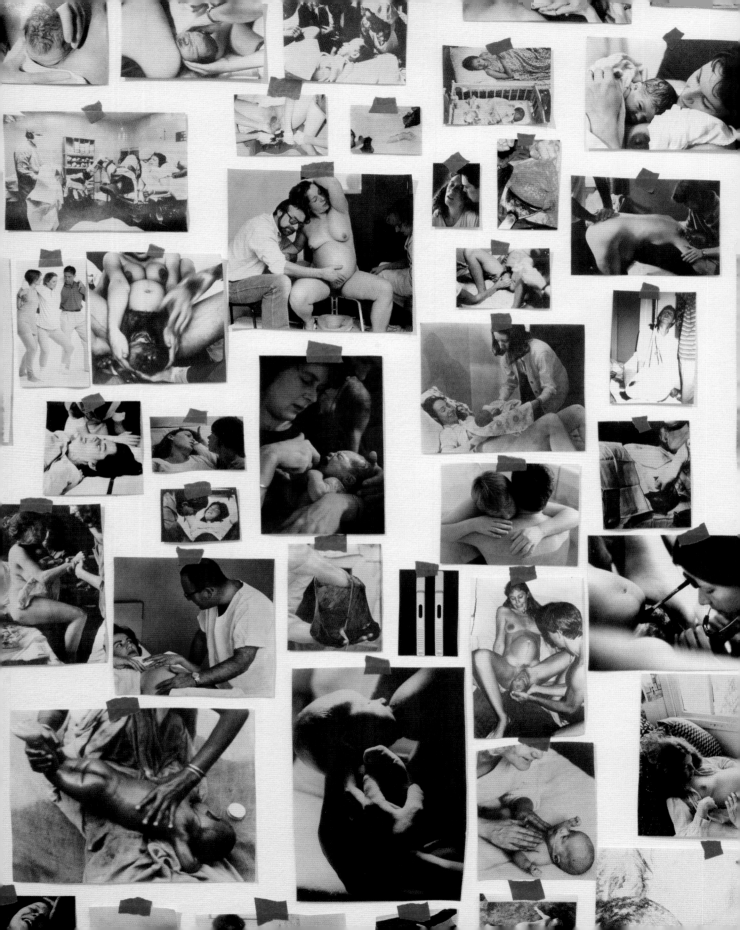

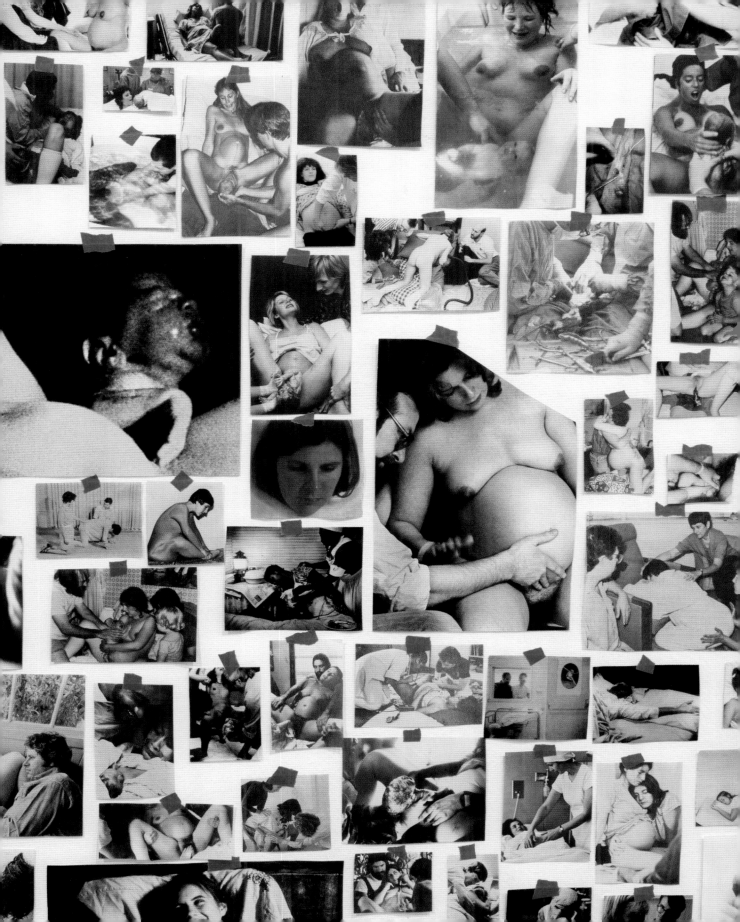

Introduction

A conversation with Lisa Cartwright, Alexis Pauline Gumbs, Sophie Hamacher, Jessica Hankey, Iman Mersal, and Jennifer C. Nash

SOPHIE HAMACHER Each of you have contributed to this project in different ways, through interviews, essays, and poetry. You have made the book what it is: a collection and a collaboration. I thank you for that and for taking the time again to be part of this conversation.

We are "talking" via email, so I hope the reader will forgive any conversational choppiness that may follow! Certainly, it is good to be and think with all of you in any form—and the digital nature of this conversation actually mirrors the process of making this book, which has been an earnest and largely virtual collaboration. Maybe one goal of this introduction can be to share about, or even somehow share in, this process with the reader.

Iman, I'd like to start by asking about your interest in "hidden mother" photographs and the way you use them to reflect on aspects of motherhood that are unseen, invisible. These Victorian-era portraits, in which mothers hide behind drapes and furniture while helping their children hold still for the longer exposure times of early cameras, are a poignant metaphor. In *How to Mend: Motherhood and Its Ghosts*, you write about the visibility of mothers to their children, using this photographic tradition to explore the gap between the seen and the experienced.

IMAN MERSAL The project came out of my research on Linda Fregni Nagler's collection of hidden mother photos. In these images, we encounter mothers who are like ghosts—blanketed silhouettes that face the camera but are invisible. Even when a mother is standing next to her child in front of the camera, as my own mother does in the only photo of us together, she is hidden. If I am unable to see my mother in this portrait, or any of the other

mothers who are present yet absent in these images, what is it that I do see when I look at this archive?

An idealized image of the mother predominates in the cultural narrative, one whose presence is direct and explicit—typically, she is deliberately posed and positioned, casting her maternal gaze toward the lens, in clear relationship with the other individuals in the frame. Yet while *motherhood* in the dominant narrative is overt, *a mother* in any photo is always, in a sense, invisible. I'm interested in this figure of the "invisible mother." The invisible mother is defined by her status as a stereotypical mother, any mother, another person's mother. Hers is a motherhood whose connections and references are banal, a reaffirmation of what we already know about mothers: their biological bond, unconditional love, care, sacrifice, and so on.

At the very least, the invisible mother is understood. If anything obstructs, opposes, or augments this general understanding, then we are dealing with a second image of motherhood: the "instrumental mother."

HAMACHER Can you talk more about the "instrumental mother"?

MERSAL In images of the instrumental mother, you are presented with a conventional image of motherhood whose meaning is then transformed by some supplementary narrative. You see, say, an image of a mother and child, and you then learn, or are "informed," that this child grew up to be John Lennon. Or you see a photograph of a mother and child in the newspaper or on social media, and then read that this innocent baby has just drowned at sea, or that it grew up to murder its mother. The image of the instrumental mother offers a pretext for taking another look, for imagining a motherhood whose features differ to a greater or lesser extent from the image of the mother we find in the dominant narrative: a motherhood

distinctive, or strange, or contradictory, or dramatic; or, simply, one with a story. And this mother, freighted with a narrative which is greater than her, may come to stand for an entire moment in history, for social strife, for disasters, for nationhood. Examples of the instrumental mother are everywhere. We recognize her when we look at Dorothea Lange's iconic photograph of a migrant mother with her two undernourished children, taken in 1936 during the Great Depression, or when we encounter a contemporary image of the Mothers of the Plaza de Mayo.

HAMACHER Jen, for me Iman's description of "invisible" and "instrumental" mothers resonates with your recent book, which shares some of the same concerns about the visibility and over-determination of mothering. In *Birthing Black Mothers*, you examine how Black motherhood has been instrumentalized in political spheres, writing "The U.S. Left has . . . tethered Black mothers to a new set of 'controlling images' that center trauma and injury, bringing Black mothers into view only through their capacity to stand for brokenness."[1] I wonder if you could talk about two works of art included here—self-portraits by Ming Smith (1986) and Cary Beth Cryor (1978)—in relationship to the controlling images you describe. In these works, I see the artists making their mothering visible and opening themselves up to scrutiny. How do you see them?

JENNIFER C. NASH I think self-representation—especially by Black women—is often an act of rejecting controlling images and insisting on the complexity of the self (and its relationship to others). And I think it's also a practice that's filled with risks and costs, that takes tremendous courage and bravery, and that puts one's body on the line. While I don't think freedom can be achieved in the visual field alone (or that Black feminists should assume that the visual field is where we should expend the totality of our political efforts), I find myself quite moved by these artworks, at least in part because they are efforts to represent vulnerability—and vulnerability is something that has so long been denied to Black women, especially as we are represented in media.

HAMACHER In your book's conclusion, you call on Black feminists to "freedom-dream." In the context of surveillance, what does this mean to you, and what do your own freedom dreams look like?

NASH I am very invested in what it means for Black mothers to have space(s) to articulate their own needs, desires, and wishes outside the framework of crisis which so often—seemingly benignly—tethers us to disorder and pathology. We have never had the space to imagine Black motherhood as, in Adrienne Rich's term, "experience," because it has been so overdetermined with meaning, even if that meaning is now about medical racism, obstetric violence, and medical apartheid. I realize this answer is somewhat vague, because my own sense of a Black feminist project is its commitment to the possible, to surprise, to uncertainty, rather than to prescription and fixity.

HAMACHER I really admire this commitment to the possible. Some of the work that you and Alexis have undertaken is to create platforms that bring to light the creative work and scholarship of mothers of color, who explore maternal world-making and possibility from significantly varied perspectives. Following your lead, *mothering* is distinguished from *motherhood* in this book, and emerges as a somewhat fluid concept. Melina Abdullah and Keeonna Harris discuss othermothering as a form of care that is widespread, and Jade Phoenix Martinez shows that there can be fluidity in biological mothering, as there is in gender.

Alexis, the book you coedited, *Revolutionary Mothering: Love on the Front Lines*, is similarly committed to opening up the concept of motherhood, including work on community mothering and parenting beyond the limits of biology. What can we learn from these practices around community motherhood? Through your work on that anthology, your engagement with all of these issues has been substantial.

ALEXIS PAULINE GUMBS The distinction between mother*hood* and mother*ing* is very important in general, but especially for this work around surveillance. As Hortense Spillers has taught us, the small letters after *mother* can change everything. The history of slavery in the United States and the violence against racialized immigrants in this current moment make very clear that mother*hood* is a status, a privilege granted not by the action of an individual but by the state—and which can also be taken away by the state. The laws denying enslaved people protective rights to testify on behalf of the people they mothered, the current denial of immigrants' custodial rights

[1] Jennifer C. Nash, *Birthing Black Mothers* (Durham and London: Duke University Press, 2021), 5.

to their children, and even losses of child custody by white women who came out as lesbians in decades past are all examples of how the status of motherhood is not inherent, but rather conditional. It exists at the discretion of the state. It is a form of status, even when it is an exploited status. It is a mechanism for achieving social stasis through a form of individual status that is necessary (in the status quo) in order to interface with capitalist structures of care.

Mother*ing*, on the other hand, is what we do. The problem is that privileges granted by the state can be taken away based on what we do or do not do when we are surveilled. The possibility, as I see it, is in the fact that the state can only process us as individuals. Therefore, there is no "community motherhood," only community mothering which does not confer status. Mothering actions outside motherhood status can also be blocked by status requirements. But community practices of mothering can also exceed the terms of the state. In fact, refusing to conflate mothering with state definitions of care can itself be an act of mothering.

As Jennifer and others have observed, Black feminists have built mothering practices on the fact that Black women have been consistently excluded by the state from the status of motherhood. Those practices—which are the central inspiration for *Revolutionary Mothering*, and really for all my work—create and move us toward another state of being, beyond individual status.

HAMACHER The line you're tracing between the legacies of slavery and current practices to withhold the status of motherhood from mothers and caregivers is evident in multiple texts in this book, including the interview with Priscilla Ocen and texts by Kenyatta A.C. Hinkle and Lisa Cartwright. Visibility and invisibility recur as dynamics through which care and rights are systematically denied.

Jessica, as my coeditor and collaborator you have worked mostly behind the scenes on this book. What do you want to ask, now that we're all in conversation?

JESSICA HANKEY Well, I'll start with a question for Lisa: your contribution to this volume is concerned with the fate of migrant children held in detention, whose caregivers are denied the rights of motherhood by the U.S. government. Twenty-five years ago in your book *Screening the Body*, you wrote about the technical and scientific developments in medical imaging that were making the body visible in new ways. Since then, the development of digital technologies such as smartphones, drones, and facial recognition software has transformed the visibility of bodies yet again. How do these new forms of data collection in daily life inform the treatment of children separated along the border?

LISA CARTWRIGHT Tagging and tracking have become ubiquitous, whether we're talking about camera surveillance (neighborhood, nanny, dash, or body cams) or identification systems reliant on biometrical, visual, satellite, or radio frequency signals. Tracking informs our workplaces and homes, our institutions of worship, culture, and cure, rendering them all as collectable and commodifiable data. The "quantified self" phenomenon is tracking turned back on itself and rendered deceptively as neutral habitus. Like paint by numbers, we pay for the privilege of having our experience rendered into conventional forms of data that we can appreciate, use for self-improvement, and display as signs of intelligent enculturation into data society. The concept of "autonomous" surveillance and tracking is deceptive, in that technologies and algorithms are always designed according to selected aims. COVID-19 tracking vividly puts on display the role of shaming in locational surveillance. The interests motivating those aims are not simply black-boxed, hidden away by the branding of the system. Rather, they are carefully unmarked, their fingerprint (intention, politics) rendered characterless and routine. There is no reason to close the curtain when the data voyeur has no face.

These dynamics of power in specific tracking systems and system applications, and the uses and abuses of tracking, all concern me deeply. They undoubtedly require specific analyses at scale. But what concerns me most at this moment and in the context of this volume about motherhood is the selective *elimination* of tracking in the care of institutionalized migrant children. That (some) caregivers and (some) children are strategically *not* tracked, that their daily habits are designed to evade the record created by tracking, is, I believe, a more complicated and more grave matter within the context of the phenomenon of otherwise vastly ubiquitous tracking. When children cross the border, they are showered inordinately with one privilege: the democratic right to personal privacy with respect to optical

and audio surveillance inside the institutional walls of the so-called shelter.

HANKEY The custodial cameras of state detention centers are hardly adequate substitutes for the supervision of a caregiver, yet, as you observe, migrant children are denied even this minimal layer of oversight.

HAMACHER The targeting of mothers and children in these policies reminds me of Malkia A. Cyril's observation in her essay "Motherhood, Media, and Building a 21st-Century Movement": "empire is sustained, and mothers become one of the tools of its continuous resurrection. But just as mothers can become the ideological vehicles for hierarchy and dominance, they are uniquely positioned to lead both visionary and opposition strategies to it."[2]

Turning back to you, Alexis, the mothers you bring together in your anthology are identified with marginalized communities that are frequently surveilled with greater intensity, including mothers who are disabled, single, queer, teenagers, and low-income. In your research and activism, have you identified ways that these mothers can resist and create opposition strategies to state surveillance?

GUMBS Yes. As usual, Malkia is so on point. Surveillance is one of the ways that marginalized mothers are policed and targeted and forced to participate in the state as it exists. I think the most inspiring ways that marginalized mothers have resisted this is by refusing to be individuals. Though the state is certainly an apparatus for surveilling and infiltrating organizations, it still requires the unit of the individual in order to recreate itself and to fully operationalize its violence.

For this reason, very simple forms of collaboration on care are subversive. Malkia knows this well. Her mother was a key figure in the Black Panther Party in New York City. And this is why the Black Panther Party's work to feed children was so threatening to J. Edgar Hoover. It was a blatant act of collective revolutionary mothering, effective because the community already understood that feeding the children was not an individual but a collective responsibility. The state can't have that, so of course the state eventually co-opted the free breakfast program and turned it into a mechanism to force caregivers to volunteer information about themselves and participate in the system

through individual registration (proving that their income is less than 130 percent of the established national poverty average, specifically) and opening themselves to further surveillance.

One of my favorite examples of resisting state surveillance is the Sisterhood of Black Single Mothers in Brooklyn in the 1980s. Their revolutionary act was to transform the "Black single mother" from a problematic individual in the eyes of both the state and the social community (as Keeonna Harris mentions here) into a collective of experts collaborating on care. The person who best knows how to support a new Black single mother, they insisted, is not the social worker, or the political author of social policy, but simply another Black single mother who has been a Black single mother longer. In their sisterhood (I might say, their *sistering*), they redefined themselves as "motherful," an abundant community of mothers, moving beyond the isolation of stigmatized individuality. By providing care and support for each other, they limited the role of the state and systems of reporting in their families and pushed against the social policing of "single mother" as a despised identity. Instead, it became a socially useful and transferable form of expertise.

HAMACHER What you are describing is very moving. There is so much to learn from these histories and practices.

GUMBS Sophie, I'm curious what connections you've felt between the care work of mothering and your creative labor on this book?

HAMACHER This project has unfolded over five years. Amid the process of editing, writing, and organizing the book, I weaned one child only to give birth to another. I began my research while living in a big city and later moved to a country road in a rural area, where most of my mothering has taken place in relative isolation, especially since the pandemic began in early 2020. A lot of the work that went into creating this collection felt like an escape from the tedious and often monotonous labor it takes to raise young children. So my first feeling is that the project has actually been a departure from the care work of mothering.

On the other hand, the more I think about it, I see connections. For me, working on this book was a way out of the isolation, a means to find others who thought about maternal agency from a range

[2] Alexis Pauline Gumbs, China Martin, and Mai'a Williams, eds., *Revolutionary Mothering: Love on the Front Lines* (Oakland, CA: PM Press, 2016), 33.

of perspectives. I think together we have begun a journey to describe, visualize, and understand what it means to live with surveillance as mothers. The labor of creating this collection has become a way for me to understand mothering as a political experience. It has given me the opportunity to learn and collaborate with others in ways that I hope to share with my children: the capacity to imagine new worlds of being together and caring for each other and the world around us.

Jessica, what about you? You've nurtured a collaborative culture around the making of the book, allowing it to come together through collective effort. Do you see a relationship between the process of making the book and its contents?

HANKEY I do. Our approach to assembling this book made it possible for you to work on it "around the edges" of days dominated by teaching and infant care, as Ursula Le Guin once described doing creative work while caring for her kids.[3] And like yourself, many of the contributors are working mothers who squeezed their work for this volume into the margins of very tight schedules. One notable example is Melina Abdullah, who took time while grocery shopping to talk with you about womanist mothering, the power of Black collective mothering. There's a particular approach to time that informs much of the work in this volume; the book unfolded within the gaps between other daily responsibilities, rather than being the outcome of open-ended contemplation.[4] In addition to what we might call its interstitial approach to work, the project takes an iterative approach to the material: beginning in 2018, the contents of the book were added over multiple years within the constraints of our schedules, and this allowed for the scope and concept of *Supervision* to evolve in response to conversations with contributors. You could say that there's a dialogue unfolding between texts and images, which readers activate. For example, in my reading, Jennifer Hayashida's poem "We Stand in the Gray Spring Light," Magdalena Kallenberger's text "The Terrible Two," and Stephanie Syjuco's photograph *Total Transparency* are in a conversation that encompasses ideas about visibility, care,

belonging, technology, and citizenship. The book's consideration of care, of attention, of visibility shifts across its contents.

HAMACHER I agree. My understanding of these frameworks shifted considerably as the book progressed. *Care* is explored here as an ambivalent term which encompasses practices of mothering and mutual support as well as policies by the state to provide resources and services. Being watched and being cared for emerge as intimately related dynamics within domestic and institutional spheres, with profound implications for freedom, rights, and quality of life.

CARTWRIGHT Sophie, on Jessica's note about the dialogue that unfolds between the texts and images gathered here, I wonder if you can talk a bit about the role of art in the book.

HAMACHER I hope the artworks that are interspersed throughout the book create pauses and redirections that can expand and problematize the ideas discussed in the texts, or explore different territory entirely. These works consider associations between making, reading, and being represented through images within the context of motherhood, the family, and civil rights. For example, the overarching theme of care's ambivalence is touched on by multiple texts and artworks in interconnected ways. Tala Madani's *Shit Moms* paintings evoke the pressures and expectations put on mothers with irreverent humor, obscenity, and sometimes tenderness. In *Ghost Sitter #1*, the phantasmagoric babysitter who is paradoxically both present and absent reminds me of the larger problem of equitable childcare access in the U.S. For mothers who are disproportionately surveilled, state mechanisms that evaluate parenting and systematically leave parents underresourced can lead to job loss or jail time. *Coloring Book 8* and *Coloring Book 41*, works by Sable Elyse Smith, evoke the facade of benevolence within the carceral state by fusing multicolored marks with blown-up pages of a found coloring book designed to teach children about the functioning of the penal

[3] Terry Gross, "Sci-Fi Titan Le Guin Wanted To 'Stand Up and Be Counted' as a Writer with Kids," *Fresh Air*, NPR, Philadelphia, WHYY-FM 1989. https://www.npr.org/2018/01/24/580222946/sci-fi-titan-le-guin-wanted-to-stand-up-and-be-counted-as-a-writer-with-kids.

[4] "I work the way a cow grazes"—so Kathe Kollwitz assessed her work life without the distractions of mothering. Ursula K. Le Guin draws from Kollwitz's observations about creative work as a mother in her essay "The Hand That Rocks the Cradles Writes the Book," in the *New York Times*, June 22, 1989. Le Guin quotes Kollwitz: "Perhaps in reality I accomplish a little more. . . . The hands work and work, and the head imagines it's producing God knows what, and yet, formerly, when my working time was so wretchedly limited, I was more productive, because I was more sensual. . . . Potency, potency is diminishing."

system. Encountering images like these without explanatory text hopefully gives readers space for their own associations and interpretations, which they can bring to bear on their reading of the texts.

Jessica, do you have anything to add?

HANKEY There is so much to discuss! But, to your point, I think we can let readers make their own connections from here.

HAMACHER Yes. I want to note that we are having this conversation in May 2022. As the landscape of surveillance and rights continually shifts, we find ourselves at a crossroads where the legal right to an abortion in the U.S. is once again in jeopardy. The choice to be pregnant and the restrictions and monitoring of that choice are critical battlegrounds to determine the rights of everyone who can become pregnant, families, and communities. LGBTQ+ people, including transgender men, intersex people, and non-binary people, are a part of this conversation and are also targets of policies and laws which seek to curtail the right to control one's reproductive future. It is imperative to defend not only the legal right to abortion but also access to resources, reproductive healthcare, and safe and sustainable communities as we are continuously pulled further into monitored, digitized lives.

More broadly, the questions and ideas that each of you have raised here—in this conversation and in your larger contributions to this book—call for further consideration. To name only some, these include the challenge to actually see mothers, the overdetermination of Black motherhood with symbolic meaning and controlling images, the differentiation of mothering from the state-conferred status of motherhood, the right to be seen as well as unseen, and the power of collectivity.

This book addresses the importance of the conditions that inform and ground our caretaking practices, as what can be seen and how we see are being transformed in ways that have profound implications for taking care of others and ourselves. It is my hope that our work here helps illuminate underexamined experiences of motherhood, both within the intimate spaces of the family and within the operations of the state.

I am honored to have had the opportunity to be in community with all of you, and with all of our book's other contributors, on this urgent project. I want to thank you for being so generous with your time and for sharing your ideas, visions, hopes, and fears with so much patience and insight.

Following pages:
Viva Ruiz, *Thank God for Abortion*, 2019

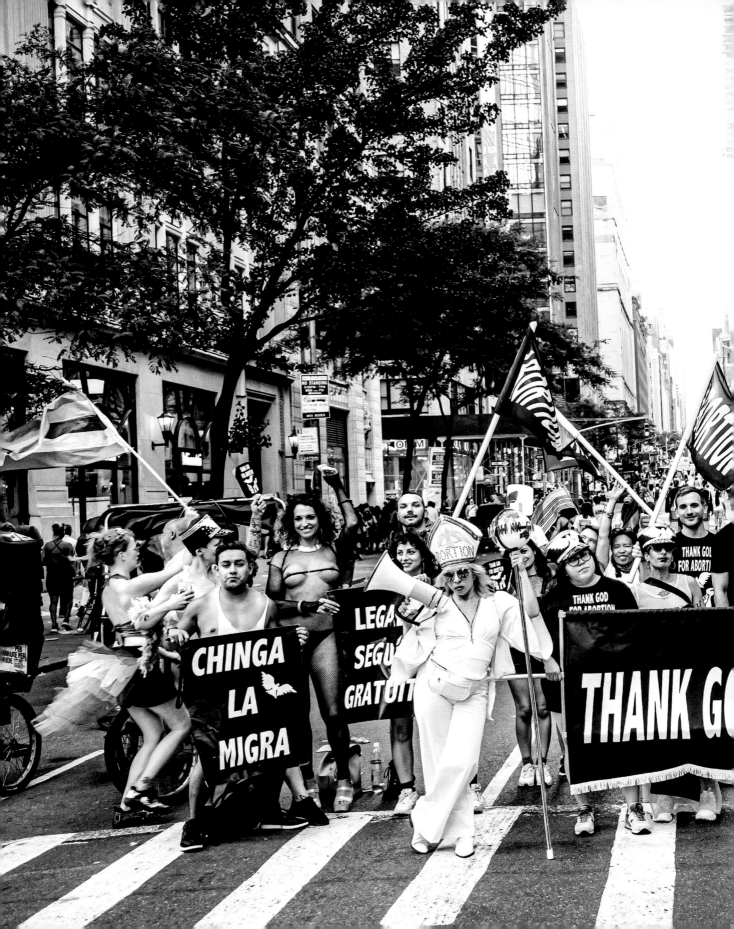

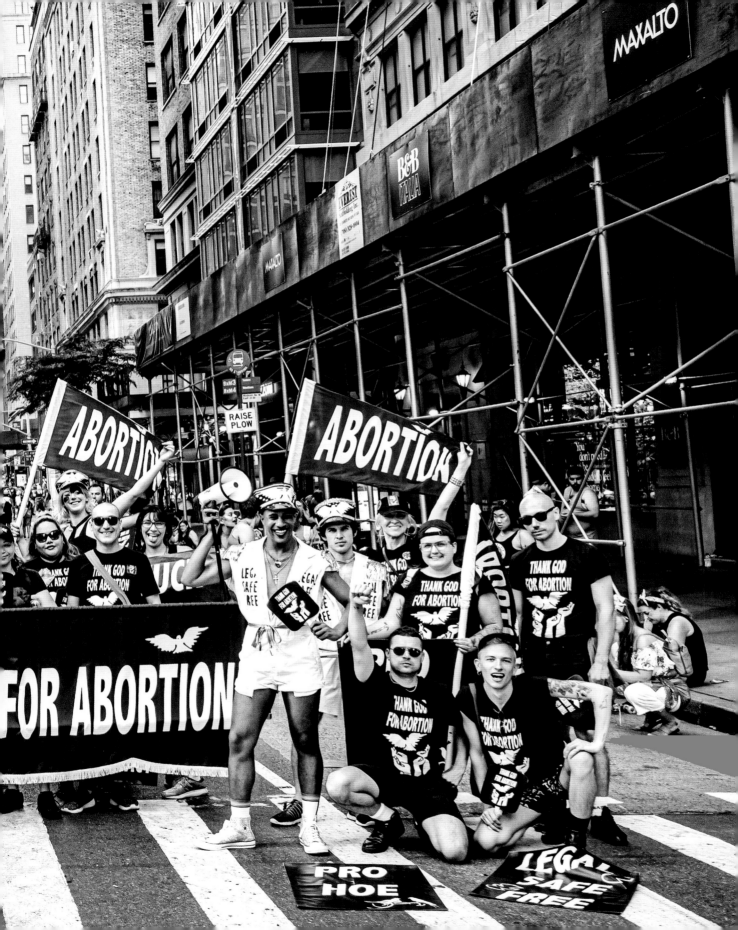

A Conversation with Lisbeth Kaiser and Erika Niwa

SOPHIE HAMACHER
The premise of this project is to understand surveillance in reference to motherhood.

ERIKA NIWA
Is it about being watched as parents or about how we watch our children?

SH I'm thinking about how mothers watch, but in a sense children also surveil their caregivers. That's how they learn. The definition of surveillance is a close watch kept over someone or something, or simply "close observation."

EN Right.

SH We closely observe our children all the time and that's how we learn to take care of them. I'm also exploring a technological history of the baby monitor, though I'm really most interested in thinking about close observation.

LISBETH KAISER
Of mothers?

SH Of mothers and of children.

EN I would say that it's different, depending on the age of your child, the ways in which you watch your children. I want to make sure I understand your question right. The second thing is—there are two changes happening over time—one is the change of the child themselves, the developmental change. So a six-month-old and a twelve-month-old, and a three-year-old and a five-year-old have different levels of being watched. And the ways in which we can watch children have changed in a very short span of time. I was pregnant nine and a half years ago, so what you could monitor was really different in comparison to now.

LK That brings up a really interesting thing, which is just even in the last few years the advances in ultrasound technology and how people start monitoring and surveilling their fetuses.

SH That was one of my questions for you. If you felt surveilled during pregnancy through the healthcare system—if you felt like your body was being surveilled in a way that you felt like you lost control over it?

LK I think people who get a ton of ultrasounds are usually people who opt to do it because they think they have more control by constantly seeing pictures. I have friends who say, "I get one every time I go. I have to see it because otherwise I don't think things are okay." It's like because the technology is there, suddenly you have to see it. It actually makes them more nervous because they don't trust in between visits. They just don't trust anymore. It's like once you introduce a camera—we're so used to our baby monitors at night that if I can't use the video monitor, if I can't see what's happening, I don't trust that everything is okay.

EN Right.

LK Our parents were like, "That's crazy, we could only ever hear you and we knew everything was okay." But it does open up—once you have the ability to surveil—and there are people now, I have friends that even got a nanny cam, that surveil their nannies and their childcare people because the technology is available. They are like,

LISBETH KAISER is a freelance copywriter, a children's book author, and a mother of two. She is a graduate of Tufts University, with degrees in English and economics. Lisbeth lives with her family in Brooklyn, New York.

ERIKA NIWA is an Associate Professor in the Psychology Department and Children & Youth Studies Program at Brooklyn College (CUNY). Niwa's work is committed to understanding and disrupting how inequality and marginalization shape the lived experiences of diverse young people. Niwa received her PhD in Developmental Psychology from New York University and a BA in Child Development and Africana Studies from Tufts University.

"I'm being neglectful if I'm not watching my nanny all the time." So because you can surveil, should you? It just adds neurosis.

EN Even by the time that you guys were pregnant with your daughter and your son, your doctors could do things my doctor couldn't, like certain kinds of tests. You could find out the gender and other stuff earlier because you were getting blood tests that just weren't happening when I was pregnant. Three-dimensional imaging in ultrasound had just kind of started, but you had to pay a lot extra to do it and now it's really quite different. Whereas my mom had no ultrasounds and then also she had a child with special needs—there was no way to know. Even still, one of my very close friends, her daughter, who is almost two, also was born with a very rare neurological disorder where there was no way to know.

LK So it's a false sense of certainty.

EN And she tested everything. She was like, "Everything is fine—ten fingers, ten toes. Everything is what it is supposed to be." And then they knew immediately that something wasn't okay. But you couldn't know until they were in the world and you see them in person. For me, as a parent, sometimes depending on where you are, you feel surveilled. Not by the systems, but sometimes by—I don't know if it's internal, this perception of there being surveillance of you or if it's real—but feeling like other parents are watching you or you are measuring yourself against a level of parenting that sometimes is realistic or not. I think that is harder for me as a full-time working parent. I feel that struggle or I feel the gaze of people who are like, "Well, you know, you work full time and so . . ." and they make assumptions about how I should or shouldn't be. And that gaze goes the other way too. For stay-at-home parents they feel like other people make assumptions about whether or not it's "work." Obviously, it is hard work to stay home with a kid. I also feel like I surveil other parents. I see stuff and think "that is not okay" [*laughs*] and then I catch myself.

LK But the word *surveillance* implies observation of someone without consent or without them knowing it. When I think about surveillance with monitors and ultrasounds and nanny cams and—

EN You don't have agency.

LK Yeah. You are watching, but the person who is being watched doesn't know they are being watched.

EN But it's also exhausting to feel like that, at least for me as a parent—

LK It's also diminishing your own instinct when something is off, you know.

EN And also the possibility of constantly checking. I feel like I want to be able to stop myself. We never had a video monitor and I was really happy about it but there were moments, of course, like when they start figuring out how to get out of the crib—

LK So have you yet defined surveillance? Like is it when the person being watched doesn't know they are being watched? Because that's what I think of, as opposed to just observing.

SH Surveillance is so pervasive now that I feel like it's more and more internalized. In terms of surveillance on a more theoretical level, for example, the panopticon, which is what the philosopher Michel Foucault writes about, is a prison in the round where an unseen security guard is in the middle and the prisoners can be watched at all times, but they don't know when they're being watched. The watching is internalized. With children you are constantly trying to teach them all these rules and ultimately these rules are something

that you want them also to learn to internalize. So in the same way that in the prison system the prisoners are learning to internalize surveillance—

LK Doesn't that just bring you back to the God thing? That whole idea that before cameras and everything people told their kids, "God is always watching you." People think, "God is watching everything I do so I better be good." And now we don't have God, now we have Santa. That's who watches them to figure out if they are naughty or nice . . . and we have cameras [*laughs*]. But that whole idea of internalizing morality as something that's extrinsic, not intrinsic. It's not like I need to do what is right because I know it—it's because somebody is watching me.

EN I think that what Lizzy was saying earlier is also really important, which is about agency and power. The prison example is about a power structure and about not having power and the assumption that one can't watch oneself. There are also power structures around whether we think children have power, right? And who has the power over them. It's the same idea about who gets to be the watcher and who is the watched. There is the benevolent watching like, "I'm going to protect you," but sometimes there is a fuzzy line between the benevolent watching and protection and the kind of binding and oppression. That happens to prisoners and that also happens to poor communities and communities of color all the time. It happens to children sometimes too.

SH Something I came across recently in motherhood studies (a new realm for me) is the distinction between motherhood and mothering. Have you encountered that at all in your field, Erika?

EN Yeah, to some degree, but I might not be the person to ask these questions because I'm a developmental psychologist, so I know and read about motherhood, parenting, and children, from a lens of developmental processes. That is one thing and I'm also a childhood studies scholar, so I study the sociological and social construction of childhood and how deeply culturally rooted they are, and mothering is a part of that context.

The stuff I've read more is about constructions of motherhood as they are shaped by white supremacy and patriarchy at the same time. So why, for example, women of color in the United States, especially Black and Latina women, are much more likely to have their children taken from them and entered into different systems in which they are surveilled. It's about who says, "this is the way to parent." Whatever "the way" is. And how is that constructed around messages about race and class and gender?

I think there are large histories of how we talk about these things and they intersect in different ways. And the ways we give agency to some mothers as opposed to others is around how these things play out in a kind of insider/outsider status and what is normal versus not normal and whose experience is being centered. So I'm mindful about surveillance because the truth is mothers of color are surveilled all the time, at least in the United States, especially Black and brown women and poor families.

It is impossible to separate the concepts of surveillance and supervision from power. The origins of both words involve the act of watching (*vision* and *veillence*) defined by place and power—on (*sur*) or over (*super*). We have to actively and relentlessly name/see the ways that power and privilege extend from our closest relationships (as mother and child) up to the institutions and structures and history in which we are embedded.

This conversation took place over lunch.

Her Internet

JENNIFER HAYASHIDA

Do not say to/about my child:
Upload
Swipe
Download
IRL

Tell her about life before the cell
phone and the Internet: the smell
of newsprint and toast, strangers
staring into the middle distance
on the C train. My cat's tail
tangled into the telephone's
curly cord

One ear bud in your ear, one in your child's ear.
Both ear buds in your ears.
Both ear buds in your child's ears.
No ear buds.

My child's Internet herstory:
photo credit, via Twitter, obituary
for her deceased paternal great-grandfather
in the *Herald-Dispatch*
event at LaMama I, event at
LaMama II, *World Journal of
Gastroenterology* [error], birth
announcement in newsletter for Swedes
living abroad, photo credit
The Diatom World [error]

My child, July 2018:
You are a tree.
You have five apples on each arm.
Three apples fall off one arm,
two apples fall off the other arm.
What do you do with the five
apples that are left?
Think of a wise answer.

We Stand in the Gray Spring Light

JENNIFER HAYASHIDA

My children and I stand in the gray light of Swedish spring. They play: one young and fast in circles, one older and slowly, in lines. The snowy dermis of winter has sloughed off and the ground is gravel and faint smears of dog shit. We are paused outside the apartment building we recently moved into, late '70s architecture lining a street named after one of the brightest stars in the night sky.

An older white woman approaches us. Her face is lined, creases criss-crossing as on a soft receipt pocketed for months. The woman leans in and asks if we live there. Always the interloper, I hesitate but say yes, we just moved in. She starts to reply, but her phone suddenly plays a gentle crescendo and she takes the call, which lasts several minutes. My children and I stand in front of her: they and I do not even have to look at each other to know that we will remain in place. The woman ends the call and, without apologizing, simply says, "That was an important phone call."

She leans in again and asks if we know how to get to *Kråkparken*, Crow Park. Without hesitating, my daughter replies that she knows where it is. She turns away from me and towards the woman, starts pointing and explaining. The woman asks her questions, and my daughter continues to direct. Finally I say, why don't you walk with her and show her how to get there? My daughter looks at me and says that she will. She says, "Ja, mamma, det kan jag." Yes, Mama, I can. The two of them walk away together, across all that gravel, and my son looks up at me and says he wants to go too. I reply that we will stay, that his sister can do this on her own.

At one point, before she walks away alongside my daughter, the woman looks at me and asks won't you come with us too, and I reply no, I can't: we are standing outside waiting for friends to arrive. I am eager to see my friend, long for the agonistic friendship between us, a feeling which springs out of a shared not-whiteness in this otherwise very white place. Here, our occasional twinning, however contingent, animates and consoles me.

The woman looks away from me and back down at my daughter. They never think I am the mother, and when they understand that I am, I always seem to disappoint.

As they walk away, I see the woman continue talking with my daughter, curving towards her as they pass the yellow brick buildings and soot-stained balconies. The two of them eventually disappear behind a corner and I think of the large red dumpster in the next courtyard, where my daughter and her friend will later retrieve a table, a suitcase, a chair, and a wood shelf in the shape of a lighthouse. They will set up their dumpster finds in a corner of the courtyard outside our building, and the parent of one of my daughter's friends will be troubled by the repurposing of others' detritus. She will turn to me to say that she is eager for the dumpster to be removed, since it attracts odd characters. As she speaks, I will continue scanning the skeletal trees.

My friend and his daughter have not yet arrived, and my son and I head in the direction of Crow Park. He bikes ahead of me and as we turn the corner we see his sister make her way up the gentle slope from the park. Once we are all together again, my daughter repeats, over and over, that it is private property. "Det är privat mark," she states solemnly, adding that it is locked and you can't get in, save for through a hole some teenagers cut in the chicken wire fence.

Later, my friend and I stand and look as our daughters handily scale the dumpster and emerge with the chair. One of them hoists it over the edge while the other stands on the ground to receive it. They run towards and past us with the chair, laughing. In that gray light, I am seized by a feeling of being watched, but it is me watching the two of us watching our daughters. Me watching others watch us watch our daughters run past us holding a cheap plastic chair high above their heads.

Our daughters neatly arrange others' garbage in a hidden corner of the courtyard, make a place where they can play and imagine that what they have found is theirs. The bony trees have made no progress towards leaves, I hear a window click shut somewhere above us.

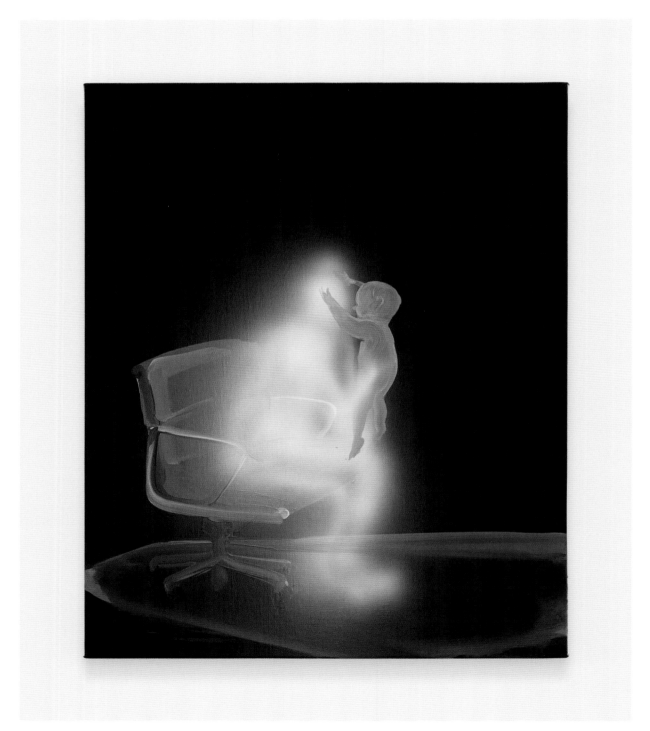

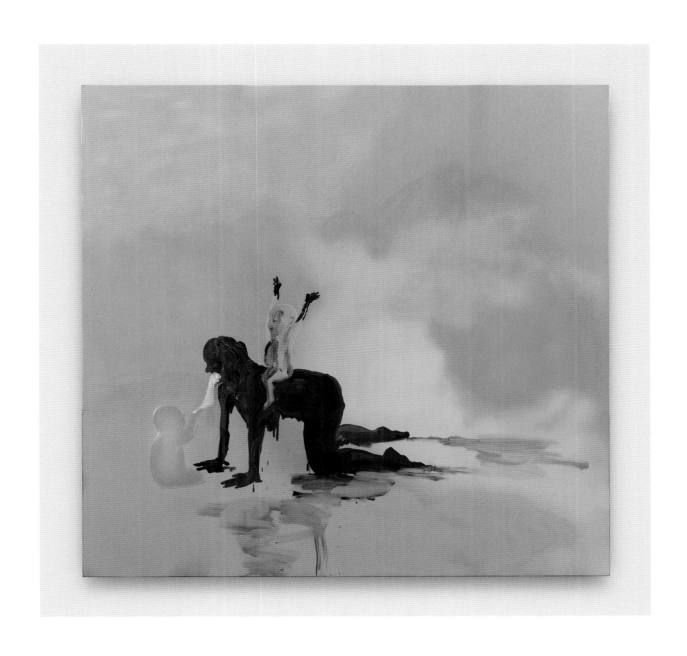

Tala Madani, *Shit Mom (Dream Riders)*, 2019.
Oil on linen, 77" × 80" × 1"

Opposite:
Tala Madani, *Ghost Sitter #1*, 2019.
Oil on linen, 21" × 17⅛" × 1"

SOPHIE HAMACHER
I've been researching and experimenting with different baby monitors, trying to use these baby monitor cameras in different ways and do little experiments with them. Some of them you can't take out of the house and they have to be plugged in with a cable, so I'm doing experiments with a computer, a camera, and a mirror and seeing what I can do in the room. But I haven't gotten very interesting results from it. All of the images look the same.

LAËTITIA BADAUT HAUSSMANN
You mean in terms of image and frame? When were these monitors with videos developed? I'm just thinking about multimedia surveillance in relation to multimedia exhibition because what you are trying in a way is reversing the surveillance tool. But maybe that is getting into another topic.

SH Yes, you are right. I've been thinking about some of the iconic works that reverse the surveillant gaze like Mary Kelly's *Post-Partum Document* that she made in the 1970s. She documents her relationship with her son over the course of several years with drawings, transcriptions, and soiled diapers. She's also recording the first encounters with her own maternity. But to answer your question, the technology is not very old.

LBH Yeah, I think just three years ago the choice was more limited than now. Maybe there were ten items to choose from and only two of them were video monitors. The rest were still only audio. It's strange because I don't understand why you really need the image. If you hear something you just go and check. You don't need to actually have the visibility. It's becoming the new norm for care.

SH One of the top baby monitors on the market right now is called the Nanit, which is this surveillance camera that sits on top of the crib and it monitors— it's similar to the body monitors that you put around the ankle of the baby when it is sleeping—not only how it is sleeping, but it also tracks the heart rate. It is monitoring everything and it sends updates to your phone and it tells you: "Now the baby is crying," "Now the baby needs to be turned around," "Now the baby woke up."

LBH You are informed about everything and it is also telling you everything about the past, since it's being archived in your data. There is a line between precious information in the case of a sick body and something morbid in tracking and recording everything, in anticipating the disappearance of time and, obviously, of life. Take the Nanit, for example, a bestseller, it suggests that any healthy baby be treated like a potentially sick body. Domestic monitoring then turns into an obsessive-compulsive disorder.

SH And you become reliant on this technology, and comfortable with it.

LBH And deeper and deeper in anxiety. Is this mostly marketed to an American public, or European, or Asian, or . . . ?

SH It's mostly for the American market. I recently ran into an acquaintance whose friends have the nanny cams installed in their home. Have you heard of those? Surveillance cameras to surveil the nanny while she takes care of your child. And then the parents are constantly glued to their phones and tracking every move either that the child is making or that the caretaker is making. I don't really know where I want to go with the gathering of all this information. What am I trying to say with it that hasn't been said before? It's kind of pure science fiction.

LAËTITIA BADAUT HAUSSMANN's research is situated at the intersection of several fields including domesticity, psychology, and feminism. Her practice is centered around the concept of design and its history as a social and political expression. She works with installation, sculpture and performance, as well as with photography and graphic design. A graduate of the École Nationale Supérieure d'Arts, Paris-Cergy in 2006, Haussmann was awarded the 2017 AWARE prize (Archives of Women Artists, Research and Exhibitions).

Mary Kelly, *Post-Partum Document: Documentation III, Analyzed Markings and Diary-perspective Schema*, 1975. Perspex unit, white card, sugar paper, crayon, 13 units, 14" × 11" each

LBH What has been said before?

SH Well, moving away from touch, moving away from believing in intuition and knowing when the child is okay or not.

LBH And leaving a space for confidence and development of reason. Maybe the kid is going to be a little too hot, or maybe she is going to turn, or maybe she is going to have a little nightmare but you don't have to go and be there. The fact that the nanny is under surveillance also emphasizes the race and class inequalities. Maybe the nanny is going to be a bit stressed one day. You have to regain a sense of trust in relationships that surveillance tools tend to erase, which actually points back to the power dynamics around race and class. All of these things are about restricting movement, and maintaining the "right" distance is somehow about domination.

SH I think I want to know more about what you think, not so much about the technology or the Big Brother social media stuff, but I want to know what you think about the possibility of there being something like tender or benevolent surveillance. That is more interesting to me.

LBH Tender surveillance is much more related to care. Do you mean, like, kind surveillance? All these technologies are also related to aging populations and general healthcare. Going from healthcare and caregiving to surveillance and restrictive and negative surveillance—all these things are very close.

SH It is about care, but at the same time it is also about distance. All of these baby monitors create a distance that seems unhealthy. If you closely observe and are caring for your child you don't need all of this technology. Doesn't care also have to do with proximity of the body to the other body? With all this technology there is no proximity.

LBH I think there is a forced, even unhealthy, proximity through surveillance tools. Let's say you are in a different room from your child. You are going to have the monitor and you will be regularly checking while you read a book or whatever. So your screen will be lighting up every minute—it's automatically and regularly updating. You cannot get a proper distance because you are constantly tethered to it. It's actually terrifying. In the '80s, parents just left

33

the door of the bedroom open. Or even if you didn't leave it open, the baby was going to cry and then fall asleep again. Now everything has shifted to this close looking at every movement that adds anxiety for the kid and for the caregiver, because you are always thinking, "maybe something is going to happen." Companies are creating the expectation that maybe something is going to go wrong and that is why you need to buy all these things. It's the same system with insurance, a preventive market, purely issued from the capitalist system.

SH You're right. Insuring your investment and your investment is your child.

LBH Of course, because who is going to take care of you when you are old? [*laughter*]

SH Can we think about the positive aspect more? As artists, we are thinking about close observation all the time—that's what we do. Right?

LBH Yeah. I think one of the most important things is being a witness to someone growing up. For me, it's about being in a super privileged position of being a witness to my daughter's life, her development, her first experiences and progression as a human being. It is the most important and precious thing to be there and be able to care or help a little bit here and there, you know. If I think about it in terms of filmmaking—it doesn't feel like a tight focus or a wide shot. It's just like a gaze, this way that we are together. I don't know how to say it. The notion of self-surveillance is also hierarchical. Obviously, I have the power as the parent to keep her safe, or to make sure that she isn't hurting herself by accident. But maybe what is interesting about the reversal is the way that I have to reposition myself in relationship to her life or by the space that opposes danger and the way I have to move and observe or care in a different way than before in relationship to her or my surroundings. Everything changes when someone arrives (as in birth) as everything changes when someone leaves (as in death).

This conversation unfolded during a walk in Central Park, NYC.

Opposite:
Gemma Anderson, *Growing Una and Cosmo: breastfeeding pattern in the first month of life*, 2020. Pencil, watercolor, and colored pencil, 16" × 12"

Family Scanning

HANNAH ZEAVIN

In 1939, the Great Depression still raging, the president of Zenith Radio Corporation, Commander Eugene F. McDonald Jr., commissioned the first baby monitor, designed by the famous American sculptor, Isamu Noguchi. The monitor came in two parts, the Radio Nurse Receiver and the Guardian Ear Transmitter. The receiver tends the baby when the parent cannot, with no risk of falling asleep itself, nor harming the baby while working under the sign of its care; the transmitter springs to action, relaying information instantaneously to the parent over a distance—a gendered parental ideal, augmented through technology.

McDonald was, to put it bluntly, rich, and a father to a young child. Worried that his daughter was a prime candidate to be the next Lindbergh baby—who had famously been kidnapped from his crib seven years earlier—he needed a device that would afford him a form of security the Lindberghs hadn't had. A full staff was not enough to safeguard his little one: the Lindbergh baby's nanny, Betty Gow, had been the first suspect in that case. Although she was cleared, domestic workers were often subject to classed, raced, and/or xenophobic distrust by the families who employed them. Gow, an immigrant from Scotland, would return to Glasgow after her questioning; Violet Sharp, a woman working in the household as a servant, was subject to such intense questioning and suspicion that she ended up taking her own life by drinking poison—she was cleared via alibi postmortem the very next day. McDonald, who likely shared his peers' classist attitudes, didn't want to have to rely on human care. He wanted to be able to put his baby to bed securely at one end of his yacht, and have his wife entertain at the other, without sacrificing knowledge of her whereabouts and well-being.

Fears about disappeared children have determined the way parents monitor and surveil children across the twentieth century and into our present, even as they become background noise: the Lindbergh kidnapping and subsequent media frenzy perhaps inspired the creation of one of the most basic and ubiquitous parental technologies now in use. The baby monitor began its life as a techno-optimistic fantasy of perfect vigilance and perfect control, and it has remained just that—a fantasy. Nevertheless, the promise of extending and augmenting parental nurture and protection has driven the marketing and development of much parenting tech since, which has grown to include monitoring tactics absorbed from, or associated with, more suppressive forms of surveillance. Many of these technologies encode the same class-based suspicions of their predecessors. Today, state-of-the-art parenting technologies are frequently designed to monitor not only children, but those suspected of posing harm, making targets out of bystanders and importing state surveillance—inseparable, as Simone Browne has shown, from a history of racial formation and violence—to the home.

If we look back at McDonald's concerns—yacht not withstanding—we can see that our most extreme fears (kidnapping, death) inflect our most basic, even boring, parenting tech and related activities: flicking on the monitor, putting the baby down for a nap. Surveilling children is part of parenting; contemporary parenting mores have intensified this basic imperative to watch, even as it is outsourced to care providers both paid and unwaged, to automated machines, and their analog counterparts.

The brutal truth is that children are vulnerable, and that this vulnerability is multiple: to their own bodies ("smothering" at midcentury, or Sudden Infant Death Syndrome or SIDS), external influence, and crime. The danger can come from inside (a favorite blanket), outside (an intruder), or someone who crosses the domestic threshold under the sign of care (a nanny or, in reverse, a daycare center). There have been panics about all of these forms of real and supposed danger—some addressed via medicine and pediatrics (as in the "Back to Sleep" campaign of the 1990s that dramatically reduced SIDS risk) or inflamed via media (the "Satanic Panic" of the same decade, in which widespread satanic ritual sexual abuse was alleged of childcare centers and preschools; a conspiracy theory which targeted, in part, queer women of color). Parental fear is nearly universal, but what we fear is not; the primacy of each threat varies by class and race, personal experience and its intergenerational transmission, and history. Children are vulnerable, but not equally so.

In some of these sites of intense parental worry, corporate parenting tech has intervened to supposedly aid and augment parenting, marketing peace of mind. The baby monitor extended parental vigilance, initially for wealthier parents with expansive households, but is now in use by some 75 percent of American parents. Today, more rarefied devices, such as GPS-enabled strollers and kids' smart watches, lovingly track and surveil children; some do this before birth, tracking pregnancy. These gadgets, part of the ten-billion-dollar-a-year parenting tech industry, are frequently marketed at millennial consumers who can afford to spend $399 on a smart baby monitor, or hire a nanny. They address and often encode the same suspicions as did the analog baby monitor a century ago, but with the aid of new surveillant technologies, many of them linked to law enforcement.

The need to know whether a child is safe and well is perfectly natural, which makes the nature of such surveillance appear innocent. Behind the wholesome sheen, however, these technologies conceal the possibility of false positives, disrupted emergency services, and of collaboration with state forces—wittingly or unwittingly—all in the name of keeping children safe. Seemingly private, domestic technologies can dovetail with state surveillance, turning parent-to-child surveillance into a dragnet, one that catches other parents and children in its wake.

Perhaps the most striking example is the nanny cam. Starting in the 1990s, the nanny cam appeared as an extension of closed-circuit television and other home security systems, with a twist: instead of looking to protect the home from the external, the nanny cam turns surveillance inward and blurs it with a family's urge to document a child's development. (It was first marketed predominantly on the Internet as the "Amazing X10 Camera," sometimes with the tagline, "see what you've been missing.") A little camera stuffed inside an innocent teddy bear, its cute, breezy, abbreviated name hides the fact that it is a wireless camera placed specifically to monitor, in this case, an employee doing their job.

The nanny cam records and transmits its data to a parent, who watches either as events transpire or, more frequently, after the fact. The footage is necessarily soundless, because the recording of audio without the consent of the person or people speaking is tantamount to wiretapping in the United States and thus illegal

(additional laws vary state by state). Sometimes the cameras are concealed from nannies; other times, the nannies are informed that their workplace is under surveillance, either because employers are forced to disclose by contract or to preempt "bad behavior."

When the first nanny cams were made available, the industry received a boost through the proliferation of amateur footage, sold to television networks (and later spread on the Internet), featuring nannies "acting out." This "fad" had a disciplining effect, intensifying the pressures that childcare workers were subject to in the course of being monitored—recordings had the potential to become a humiliating spectacle, with no possibility of redress. This media circuit also reinforced parental fears over what was happening when they left the house: the will to know, and the hope that knowledge would provide control and a feeling of safety, led many consumers to all the disquiet they'd hoped to leave behind.

The relationship that many parents have with paid caregivers, both within the home and without, is complicated. Psychologist Daphne de Marneffe writes, "Turning the care of our newborn, baby, or small child over to another, non-familial person, someone we often have known only briefly, is a momentous emotional and psychological act, even if we pretend that it isn't." Joining anxiety and jealousy as part of this psychological matrix are, quite often, sexism, classism, and racism, which date to enslaved women providing care for white mothers and children. In the late 1800s, just as fewer American-born white women were entering the labor market in service positions, middle-class conceptions of who and what a nanny should be were idealized along lines of class and race (towards whiteness, unweddedness, and a middle-class background). Grace Chang and others have shown that this vilification of immigrant domestic workers continues in our present. In the twenty-first century, nearly all families seeking to hire a full-time nanny belong to the upper classes—nannying is almost always the most expensive form of childcare precisely because it promises greater attention to the child, and greater control for the parent.

Nanny cams are only one form of surveillance that remediates the desire to exert greater control over one's children through the control of domestic workers: text messages, asking for a stream of photographs, along with collecting and monitoring GPS data, are all methods parents use to monitor their children and their caregivers. Parents who use paid attention and adjunctive care (as opposed to kinship networks) to cover their work schedules often enact some form of education, monitoring, and indeed surveillance over those who care for their kids, even as they're treated as "part of the family." This digital attachment and interference, though it retethers a parent at work to their child, compromises the privacy of childcare workers, and even other children. Declining to be observed can send already anxious parents into full suspicion and cost care providers their jobs before they begin.

These surveillance tools are poised at the intersection of care and capture; self-soothing devices that allow parents to feel they have done everything they can do, prosthetically, to exert control over their employees, children, their co-parents, and themselves. Care is a mode that accommodates and justifies surveillance as a practice, framing it as an ethical "good" or security necessity, instead of a political choice.

The convergence of parental anxiety and tech access can extend surveillant care into a total system, reaching past the baby, and any employee in the home or daycare center, to the street beyond. Increasingly, technophilic and/or anxious families are turning to websites like Nextdoor and smart home systems like Alexa, Google Home, Nest Cams, and Ring, not only to help with domestic management, but to reinforce the barrier between the outside and the inside, keeping the outside

out. These technologies slip from self-surveillance (when should I reorder my groceries?) to familial surveillance (what is my child watching?) to surveilling anyone who might come into contact with one's children.

Ring, which was acquired by Amazon in 2018, already has millions of individual users; it also has partnerships with six hundred police precincts. It sells itself as family-friendly, necessary for the protection of home and child, and purports to "watch," in the ancient sense of keep vigil. But this vigilance can turn into vigilantism, and aid in, or replicate, policing. Just as the nanny cam records just in case the recording itself will be useful, Ring and other tools like it report to their owners, and sometimes simultaneously to police—even against the wishes of their users.

Ultimately, these technologies do precisely what they claim to prevent: open up new pathways for perforating the domestic and the nuclear family, reinforcing the anxieties they purport to soothe. The Wi-Fi enabled security system encapsulates this irony: all of these cameras can be, and are, routinely hacked. Using two-way audio, hackers have been able not just to monitor people in the privacy of their domestic spheres, but to speak to and harass people there. One parent tore a set of cameras out of the wall after a child said a "scary man" was speaking to her. Several others have reported that some person was demanding payment. The very object that is supposed to watch over the nanny watching over the baby, or to guard the front door, becomes a way in.

Other smart devices meant to protect children can also terrorize parents, and unevenly so. Since silence on a baby monitor is either golden (the baby is down) or terrifying (the baby isn't breathing), these devices use biometrics to augment and automate the vigilance of parenthood and distinguish between the two forms of noiselessness. Devices like the Owlet Smart Sock (introduced in 2007 and still in use) address themselves to the parents who stay up to watch their babies breathe, who check and recheck a silent baby monitor for sounds of stirring. These devices, most commonly a smart camera placed over the crib or a piece of clothing that functions as a pulse oximeter, claim that they will notify you if your baby is losing oxygen— preventing tragedy before it can occur. The device's job is twofold: to help parents monitor the biometrics of their child, and to reduce worry by doing so. But the devices often do more harm than good because they frequently transmit false positives; and pulse oximeters work unevenly, with decreased accuracy when reading darker skin tones. The result: terrorized new parents, who shift the checking compulsion to their devices just as fervently and report a higher incidence of depression and sleeplessness. The false positives even clog pediatric emergency services.

Parents watching their children is an unimpeachable mode of care; surveillance is conventionally and conveniently associated with state power and its abuses. In tracing the history of child monitoring, however, we can see that these two forms of monitoring are less distinct than they might appear. The use of parenting tech to ensure child safety may be read as an individual parent's choice, but the reach of these technologies expands through alliance with state forces (for example, Ring's partnership with police precincts) and by exploiting those prejudices long established in childcare conventions. The uneven yet pervasive usage and advertisement of these technologies—let alone other technologies that proceed under the guise of care, like facial recognition in schools and in homes, in the age of COVID-19—show the lengths that parents are willing to go, the moral and political compromises many are willing to make, and the alliances some are willing to forge in order to feel protected from the universal nightmare of losing a child.

A Conversation with Moyra Davey

MOYRA DAVEY is an artist based in New York whose work comprises the fields of photography, film, and writing. She has produced several works of film, including *Wedding Loop* (2017) as part of her contribution to documenta 14 in Athens. She is the author of numerous publications including *Burn the Diaries* and *The Problem of Reading*, and is the editor of *Mother Reader: Essential Writings on Motherhood*. Davey has been the subject of major solo exhibitions at institutions including Portikus, Frankfurt/Main (2017); Bergen Kunsthall, Norway (2016); Camden Art Centre, London (2014), and Kunsthalle Basel (2010). Her film *I Confess* premiered at greengrassi, London in September, 2019.

SOPHIE HAMACHER
I want to know more about your initial motivation to make *Mother Reader: Essential Writings on Motherhood*. What were the personal, political, and social intentions for you when you started the project?

MOYRA DAVEY
The idea for *Mother Reader* was actually pitched to me by Barbara Seaman at a party. I was talking to her about Jane Lazarre's *The Mother Knot* and other texts I was reading on motherhood and ambivalence, and she said, "Why don't you edit a volume of these writings?" I was immediately thrilled by the prospect of delving into the literature, and it coincided with being at a crossroads with my work in photography. I thought a compilation of texts and excerpts could be a really useful volume for women in my situation, artists and writers struggling with the demands of motherhood. The readership is mostly female, but one man, a writer in India who's become a friend, told me he read the whole book and that through it he came to a new understanding of his mother.

SH The preface to this book focuses on my personal examination of seeing. As a filmmaker and editor it seems sometimes as if my vision changed after becoming a mother, not only because in the early years I couldn't look through the camera because I had to look at my child, but also because filmmaking and editing are so dependent on time, which I had none of anymore. Did you find that your relationship to the camera changed after becoming a mother?

MD It was a big struggle and conflict for me to stay focused on work after I became a mother. As you say, there is no time, and the demands/needs of the infant/child are huge. I don't think my relationship to the camera, at least as it concerns my son, changed until almost twenty years later when he left home. That was the first time I felt compelled to write about separation and loss, and this became part of the film *Hemlock Forest* (2016).

SH You write, "editing became a creative project that intersected more readily than did my photography with motherhood." I want to know why and how it intersected more readily. What was it about editing that worked well and why was photography something that didn't intersect easily?

MD This is related to my first answer. I was due for a break from photography. I wanted to write and work in time-based media, and I credit editing *Mother Reader* with cementing my relationship to literature and henceforth making reading, research, and writing central to the way I work. I might have also somehow felt more "legitimate" (less guilt) doing the editing work, because I had a contract and an advance.

SH Can you tell me about the organization of the book and the motivation behind dividing it into two broad sections titled "Journals, Memoirs, Essays" and "Stories"?

MD Thinking back on it now, I didn't have to do it that way. I could have been much more fluid in the way I organized the texts, but there is quite a range, from academic essays to diaries and notebook entries, and it seemed like the book called for a structure that supported this diversity.

SH A recent short film that I worked on (still images from it are a part of this book) includes an investigation into the material that baby monitor cameras produce. When you think of these types of surveillance images, what comes to mind? What role does the gray scale of night vision and resolution play in the creation or dissemination of content?

MD I never had a video baby monitor, only audio, so I'm not so familiar with those types of images. The one thing that comes to mind though, is the French phrase: surveiller les enfants. That's a typical expression in French for looking after kids—babysitting, playground/schoolyard monitoring etc.

This conversation took place over email.

Following page:
Carrie Mae Weems, *Mourning*, 2008.
Archival pigment print, 60" × 50"

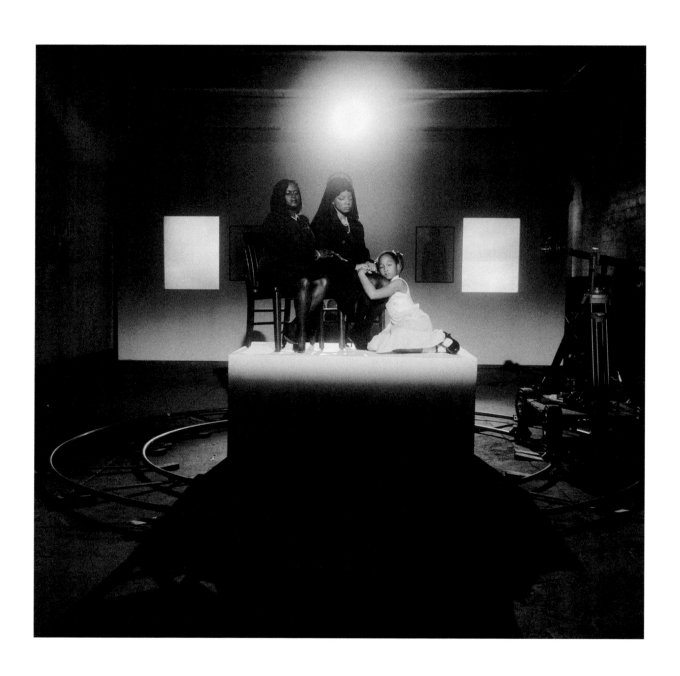

A Conversation with Jennifer C. Nash

SOPHIE HAMACHER

In your recent essay "Black Maternal Aesthetics," you describe Black motherhood as being in a "state of perpetual crisis."[1] That it is "increasingly becoming a site of regulation by the biopolitical state and feminists themselves." How is the regulation of Black motherhood tied to surveillance?

JENNIFER C. NASH

Black motherhood has been regulated in myriad ways—from the construction of Black mothers as overpowering matriarchs in the (in)famous Moynihan Report (1965) to discourses of Black mothers as "welfare queens," "crack mothers," and "babies having babies." Black mothers have been imagined as too young, too poor, too sexual, and thus as deeply responsible for the precarity of Black life in the U.S. My interest in my new work is how Black mothers are being regulated in new ways, in large part because of the important work of Black Lives Matter to make visible high Black maternal and infant mortality rates. Black mothers are increasingly encouraged—and often in heavy-handed ways—to breastfeed, for example, because of the state's interest in compassionately responding to various public health crises, yet even these compassionate interventions can look and feel like a form of scrutiny that other mothers simply don't experience.

SH In that essay you suggest that Serena Williams and Beyoncé Knowles circumvent the prevailing constraints of the Black maternal political role— how do they do that?

JCN The essay thinks about both Williams and Knowles as Black maternal icons, and probes what has made it possible for each to celebrate Black erotic motherhood, Black political motherhood, and Black fecundity in ways that have not previously been allowable or permissible. We see each mobilizing their tremendous capital to make claims about Black life—in the case of Knowles, her visible advocacy for Black Lives Matter, and in the case of Williams, her deep attention to Black mothers' experiences of medical racism in institutionalized medicine. What fascinates me about both, though, is how motherhood has made possible—and even palatable—their politics which might have, in earlier eras, been hailed as too progressive, too controversial, too bold, or even too Black.

SH Comparing Black political motherhood and white political motherhood in terms of maternal ambivalence, you write that "Black motherhood itself, rather than the refusal of motherhood [is a] political act."

JCN I am really interested in thinking about how white political motherhood—which I mean as a genre—has presented itself as a performance of ambivalence about the maternal role, whether breastfeeding, domestic labor, pregnancy, childbearing, or the relentless demands of mothering. For some of the authors I write about, motherhood is imagined as a deep interruption in a thinking, writing, or creative life, as a socially mandated and entirely devalued form of maternal labor. These texts often fashion themselves as breaking a taboo by naming maternal ambivalence. Yet, as I argue in the article, Black maternal





JENNIFER C. NASH is the Jean Fox O'Barr Professor of Gender, Sexuality, and Feminist Studies at Duke University. She is the author of three books: *The Black Body in Ecstasy: Reading Race, Reading Pornography* (2014), *Black Feminism Reimagined: After Intersectionality* (2019), and *Birthing Black Mothers* (2021). She earned her PhD in African American Studies at Harvard University and her JD at Harvard Law School.

[1] Jennifer C. Nash, "Black Maternal Aesthetics," *Theory & Event*, 22.3 (July 2019): 558.

43

ambivalence often takes a different form, centering on anticipated loss and grief as the core of Black mothering, and on the fear of losing one's child—whether from the embodied consequences of medical racism or from state-sanctioned police violence—as the centerpieces of Black motherhood. I try, then, to think about how Black women have come to position mothering itself—rather than a reprieve from it—as a revolutionary act, a radical act.

SH In many ways I feel like I fit into the category of thinking about motherhood as a "deep interruption." This publication includes texts that express both forms of ambivalence (Black political motherhood and white political motherhood), is there a value in considering them together? I feel like this might really be the crux of this entire project. One thing that comes to mind is Alice Walker's writing on motherhood that you refer to in your article, where perhaps she claims both kinds of ambivalence.

JCN I do think that considering white and Black maternal ambivalence side-by-side is useful—and particularly for thinking about the ways there is (or isn't) cultural space for each. For example, there are whole markets around white maternal ambivalence, and there's a way the mainstream (white) maternal memoir is fundamentally about ambivalence—about the unwanted or partially wanted child, or about the changes (or dissolution even) of self that a child can generate for a mother. But the space for Black maternal ambivalence culturally is about the anticipated death of the Black child, particularly the Black son, and not about—with the exception of Walker— what mothering can do to the Black maternal self (beyond open up the Black maternal heart, which seems to be the current romance circulating around Black motherhood now). So what kinds of ambivalence are given space? Who is allowed ambivalence, and of what form? And what other kinds of maternal affects might we grant space for?

SH You critique the recent proliferation of scholarly work that celebrates care as the "paradigmatic Black feminist restorative practice." I want to know more about the politics of care in relation to surveillance. Can surveillance be something that is desired when it is motivated by an interest in care and protection? What does "surveillance as care" mean to you?

JCN I am very interested in my new work in how Black feminist ideas—which are rooted in care, and desire to safeguard Black life—can and do get taken up by the state as forms of surveillance. This is the uneasy position feminists often find ourselves in when we align with the state in the service of safeguarding our bodily autonomy or arguing for our liberties. So, for example, when the state keeps careful track—as it does—of breastfeeding rates by race, and labors to encourage Black and Latinx women to breastfeed, as it does, it might be said to be operating in a caring mode, in a compassionate effort. Yet the result often looks and feels like surveillance and compulsion, as is the case, for example, when the state uses its WIC program to encourage breastfeeding by ensuring that breastfeeding mothers receive more robust nutritional benefits for themselves and their family. This form of care, of compassion, can also feel like compulsion, like the removal of autonomy from women who might want a choice in their infant-feeding practices, but might suddenly feel they have no choice when their families' most basic needs hang in the balance.

SH I noticed in your essay that you often use the words *cloaking*, *visibility*, and *hypervisibility*. Could you talk about how the invisible and the visible are in contention in the United States, and what role visibility or invisibility plays in perpetuating inequality, particularly in relationship to Black maternal politics?

JCN I think visibility—and invisibility—are central to how Black women navigate maternal life. What does it mean that Black children—as children—are invisible? That they are read as adults? What does it mean that Black innocence is invisible, unseen, impossible? What does it mean that Black mothers, in a Black Lives Matter era, are increasingly visible spokespeople for Black life? We can think here about the various Mothers of the Movement who have run for political office, campaigned for Democratic candidates, and appeared in popular culture (as in Beyoncé's *Lemonade* video). These women have become the public face for Black Lives Matter, and have come into political view—visibility—because of their deep and profound losses, their grief, which is now imagined to be national grief, pain, and trauma (so long as it is never cast as anger or rage, both of which are still imagined as unacceptable, as a tear in the fabric of social norms).

SH How has your research come to reflect the current moment—the COVID-19 pandemic and its effect on motherhood? How do you think surveillance shapes and informs caretaking during the time of social distancing?

JCN COVID-19 has affected every aspect of mothering: it has brought renewed attention to the unequal, gendered distribution of household labor and care work as we read journalistic accounts of women struggling to juggle parenting, home schooling, and working from home. It has revealed the reviled status of caregiving and of the most vulnerable populations—here we can think of how the elderly were figured as largely disposable when COVID-19 started to gain national attention, and we were—perhaps are—continuing to shower largely low-paid Black and brown workers in nursing homes, assisted livings, and in medical facilities with gratitude, banners that thank them, and rounds of applause rather than with livable wages, state subsidized child care, and adequate health care. And there has been increased attention to the hospital as a potential site of death for mothers preparing to deliver in hospitals and who are now—as newspapers report—considering home birth to avoid illness and even death. And, of course, the racial disparities that mark both COVID-19 and mothering in the U.S. have intersected to shape the lives and experiences of everyone performing maternal labor.

It seems to me like we are in a moment where it's hard to imagine what's next. What I do imagine, though, is that this moment will remake birth and birthing, including perhaps a demedicalization of birth, and the normalization of what has long been a feminist argument—that birth need not be a medical event at all.

This conversation took place over email.

Following pages:
Sophie Hamacher, *Film Stills* and *Biometrics*, 2021.
Photographs, found images, and ink on paper

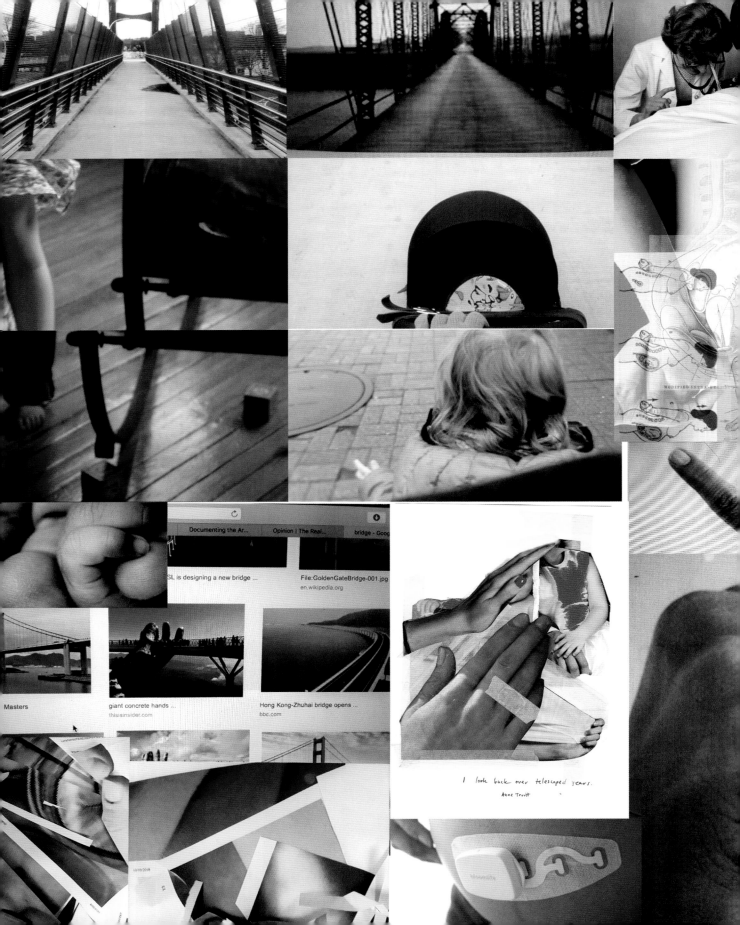

I look back over telescoped years.

Anne Truitt

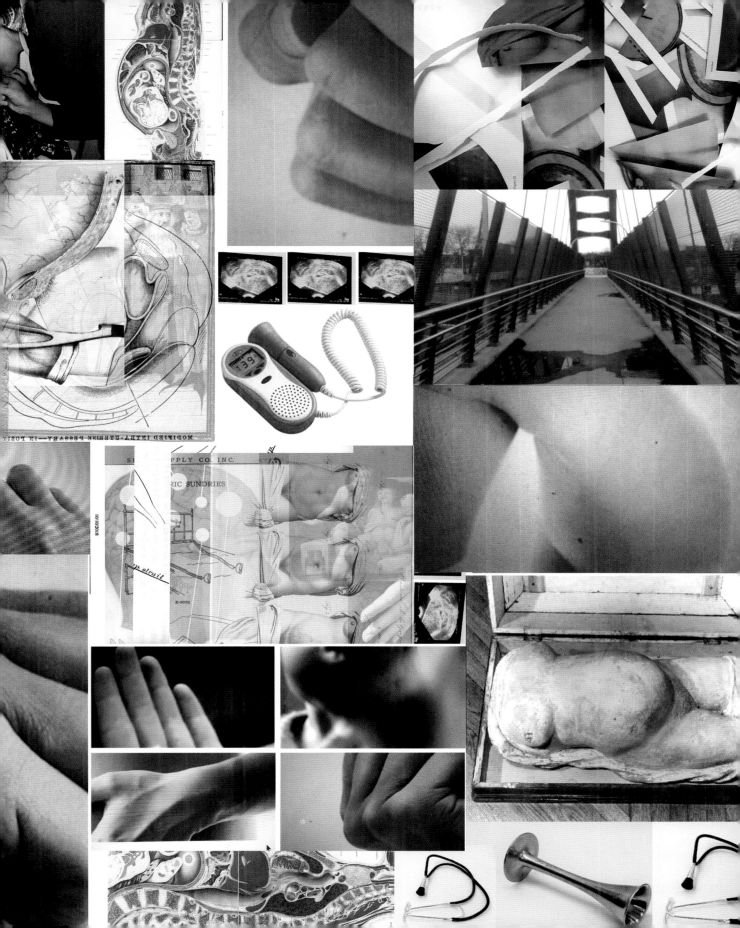

2018-04-20 21:22:03

Color Baby Camera Nightvision Footage

...ts takes our best-in-class top-
...into an Intelligent Sleep Guru.
...luding the sleep score, day
..., sleep tips & advice, stored
...anit camera comes with a

a

b

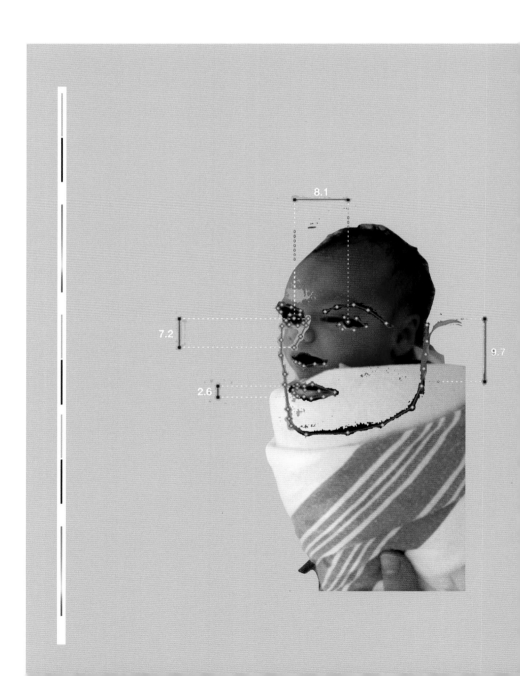

Film Stills
(pages 46–55)

Among the film stills included here is footage that I shot on my mobile phone while pushing my daughter through New York in the first six months of her life. During this time, walking became my new preoccupation and I rediscovered the act with a stroller, making mental maps of my routes. Walking was a multivalent experience. Sometimes it was a negotiation of public space, an adventurous exploration, or an experiment in (self-)control. As mother-walker, I observed both the world and the baby. For me, walking was a renegotiation with myself, my body, my baby, and the city. In my mind, the lines I drew through official maps consisted not only of quiet zones, beautiful streets, parks, and areas better circumvented because of noise or uneven sidewalks, but also spaces of psychological and emotional regeneration, wherein I slowly came to terms with my own occupancy in and by motherhood. The mobile phone camera worked like an extension of my body; it produced mostly shaky pictures that were immediate and intimate.

While walking, I began to notice screens all around me. The stroller canopy usually has a clear plastic "peekaboo" window so you can keep an eye on your child. This window is often called the "viewing port." Like the phone, the computer, and the camera itself, the stroller window was its own screen. Its shape reminded me of the screens found in these gadgets: simulacra screens, simulation screens—maximal screens to minimal screens.

Biometrics
(pages 56–60)

Along with the surveillance that is performed on the maternal body during pregnancy, there are myriad ways in which both mother and baby are systematically tracked and categorized after birth. Companies are now developing new biometric identification systems based on non-contact optical scanning technologies because biometric features (e.g. fingerprint and iris) are difficult to capture for babies.[1] Do we really want to make our human bodies "machine-readable" from birth?

In *Dark Matters: On the Surveillance of Blackness*, scholar Simone Browne argues, "the application of this technology is in the verification, identification, and automation practices that enable the body to function as evidence . . . there is a certain assumption with these technologies that categories of gender identity and race are clear cut, that a machine can be programmed to assign gender categories or determine what bodies and body parts should signify. Such technologies can then possibly be applied to determine who has access to movement and stability, and to other rights."[2] Browne's assertions are persuasive and she systematically lays out the ways race and gender inform how people are monitored and the paradoxical ways in which a person can be surveilled and yet still be rendered invisible.

The increasing absorption and integration of biometrics by the private sector adds to the danger of this loss of human value. The collection, use, and storage of fingers, eyes, faces, voices, and other human attributes for commercial purposes is alarming.[3] Fingers are used as keys to an account, faces and voices are becoming tradable goods, and all of these point to bodies and freedoms curtailed and controlled.

—Sophie Hamacher

[1] Jackie Carr, "Researchers Develop Biometric Tool for Newborn Fingerprinting," Newsroom, UC San Diego Health, www.health.ucsd.edu, September 12, 2018.

[2] Simone Browne, *Dark Matters: On the Surveillance of Blackness* (Durham and London: Duke University Press, 2015), 109–14.

[3] Elizabeth M. Walker, *Biometric Boom: How the Private Sector Commodifies Human Characteristics*, Fordham Intell. Prop. Media & Ent. LJ 25 (2014): 831. https://ir.lawnet.fordham.edu/iplj/vol25/iss3/5.

Policing the Womb[1]

MICHELE GOODWIN

> Making child abuse laws applicable to pregnant women and fetuses would, by definition, make every woman who is low-income, uninsured, has health problems, and/or is battered who becomes pregnant a felony child abuser.
>
> National Advocates for Pregnant Women[2]

In the twenty-first century reproduction translates differently across class and race lines. On inspection, examples abound in this context, but assisted reproductive technology (ART) provides a particularly provocative illustration of my point. In that sphere, liberty and risk translate into a multibillion-dollar industry, where a woman's reproductive possibilities resemble a candy store of options: freedom to purchase ova and sperm in her local community or across the country and world, in vitro fertilization, preimplantation genetic diagnosis, intracytoplasmic sperm injection (ICSI) of ova, embryo grading, cryopreservation of ova, assisted hatching embryo transfer, day-five blast transfers, and more. This dizzying array of options is mostly unchecked by federal and state regulations, leaving physicians and their wealthier patients to coordinate pregnancies according to personal choices.

Technology facilitates a degree of leisure associated with some of these practices, as a few options described above are easily coordinated from the comfort and privacy of home. Functionally, then, with the click of a computer button, an intended parent may purchase sperm, rent a womb, buy ova, and select a clinic to assist in the harvesting, implantation, or embryo development processes. For wealthy women (infertile or not), reproductive privacy and freedom are tangible concepts in uninterrupted operation. Noticeably, there is little, if any, state regulation or interference in this domain, despite considerable risks, poor health outcomes, and miscarriages associated with some of these medicines.

By contrast, recent criminal prosecutions targeting destitute pregnant women illuminate another reproductive space, where the threat of state intervention through punishment and extralegal retribution overarch pregnancies and compromise the physician–patient relationship. In this alternate reproductive realm, public regulation trumps expectations of privacy. Undeniably, in the United States a poor pregnant woman's reproductive options are deeply constrained and contested. For example, a woman's poverty and drug dependence or use during pregnancy might result in heightened legal consequences, including the threat of life imprisonment, birthing while in jail, and even shackling during labor, depending on the state in which the pregnant woman resides.

[1] This is an excerpt from the preface to *Policing the Womb: Invisible Women and the Criminalization of Motherhood* (2020).

[2] Tiloma Jayasinghe, staff attorney, responding to felony child abuse charges brought against Cynthia Martinez by New Mexico prosecutors in a press release by National Advocates for Pregnant Women, "Supreme Court of New Mexico Strikes Down State's Attempt to Convict Woman Struggling with Addiction During Pregnancy," May 11, 2007, https://www.nationaladvocatesforpregnantwomen.org/victory-in-the-new-mexico-supreme-court/.

A poor woman determined to carry a pregnancy to term often unwittingly exposes herself to nefarious interagency collaborations between police and physicians, quite possibly leading to criminal prosecution, incarceration, and giving birth while in highly unsanitary prison conditions, sometimes without the appropriate aid of hospital physicians and staff. But make no mistake, all women should be wary of the political mobilization against reproductive health, rights, and justice.

Today, it is not uncommon for a headline to feature a tragic story about a woman giving birth alone in a jail, without the aid of anyone, let alone medical staff. This is what happened to Diana Sanchez as she screamed and "writhed on the small bed inside her cell . . . gripping the thin mattress with one hand," as she tried frantically to free a leg as the baby was crowning. A *Washington Post* headline captured her experience this way: "'Nobody cared': A woman gave birth alone in a jail cell after her cries for help were ignored, lawsuit says."[3]

Sadly, these are not outlier incidents, but rather what has bled into the soil of reproductive politics in the United States, which now uses pregnancy as a proxy for punishment, particularly against poor women. The depth of state-sanctioned cruelty targeted toward poor pregnant women seemingly has no boundaries in contemporary American politics. Gone are the days when Prescott Bush, the father of George H. W. Bush, served as treasurer of Planned Parenthood or Richard Nixon signed Title X into law, which provided reproductive healthcare for the poorest Americans.

A range of laws now police and criminalize behavior during pregnancy. These include fetal protection laws (FPLs); laws that criminalize illicit drug use during pregnancy—fetal drug laws (FDLs); child abuse laws pertaining to fetuses—maternal conduct laws (MCLs), which seek to criminalize otherwise legal conduct that may cause risk to pregnancies, including cigarette smoking, alcohol consumption, falling down steps, and refusing bed rest. The emergence of such legislation offers an important opportunity to present a counternarrative to the provocative accounts offered by legislators advocating the use of "sticks" to discourage certain prenatal conduct.

Importantly, what legislators seek to reduce—the incidence of babies born with low birth weight in their states—is tangled in race and class profiling, which detracts from an evidence-based approach to reducing fetal health harm. On inspection, prescription drug use, domestic violence, and assisted reproductive technology measure significantly (and more so) in the incidence of fetal health harm and the rise in neonatology treatments and costs. The policing of women's reproductive conduct and the absurdity of lawmaking in this regard is an important policy matter. *Policing the Womb: Invisible Women and the Criminalization of Motherhood* weighs the social, economic, and health costs associated with punitive state policies that effectively harm all pregnant women and their interests.

[3] Allyson Chiu, the *Washington Post*, August 29, 2019.

A Conversation with Irene Lusztig

SOPHIE HAMACHER

Your film, *The Motherhood Archives*, is a cinematic history of childbirth. In the film, you repurpose educational films and medical training films in order to question the patriarchal institution of motherhood and its history. This propaganda material surrounding childbirth has a lot to do with surveillance. Surveillance of the mother-to-be. I want to know more about the footage that you found during your research that was left out. You mentioned a number of behavioral psychology films that didn't make it into the final cut. Can you tell me more about them? Are most of them about the surveilling of children or of mothers? What do you think is the difference?

IRENE LUSZTIG

I remember feeling surprised while I was pregnant by the many tangible ways that my pregnant body was treated like public property—strangers often touch pregnant bodies and offer unsolicited advice—which felt in tension with the intimate and private experience I was having with my own changing body. I think you're right that the surveillance of mothers and children are deeply intertwined, beginning nowadays with ultrasound imaging, genetic testing, fetal heart monitoring, and the many other visual and medical technologies of surveillance that have become a routine part of pregnancy. The ultrasound and the baby monitor are definitely on a continuum. There are also, of course, political dimensions to things like ultrasound surveillance, as increasingly realistic fetal renderings have been weaponized by the anti-abortion religious right to prioritize the well-being of fetuses over the well-being of women.

I didn't really differentiate between different forms of surveillance and indoctrination as I was gathering archival materials for my project—in my research phase I cast a really wide net and was interested in anything that might count as a training film or might hold an embedded ideology about motherhood. Once I started editing, I felt like I had to stake a narrower field than all of motherhood, and childbirth felt like a rich site for working through the questions of control and surveillance that interested me—but I could easily have located these questions in many other maternal sites—feeding, charting the color and consistency of your baby's shit, elimination diets, sleep training schedules, etc. I did manage to smuggle a few post-pregnancy images into the film, like the little montage of women sterilizing milk bottles—I love all the incredibly weird sci-fi images from training films about bottle feeding where the mothers look like diligent, futuristic lab scientists.

In terms of surveillance films from my collection that I wasn't able to fit into *The Motherhood Archives*, there are many, including numerous historic films about infant care and feeding. I spent some time watching 1930s lab films made by child development psychologist Arnold Gesell. Gesell built a special clinical crib placed in a photographic surveillance dome that was meant to hold babies for observation so that their growth and behavior could be filmed and analyzed frame by frame (actually the image of the female "archivist" loading film reels who frames *The Motherhood Archives* is a researcher in Gesell's lab).

IRENE LUSZTIG is a filmmaker, visual artist, and archival researcher. Her film and video work mines old images, technologies, and objects for new meanings in order to reanimate forgotten and neglected histories. Much of her work is centered on public feminism, language, and histories of women and women's bodies, including her debut feature *Reconstruction* (2001), the feature length archival film essay *The Motherhood Archives* (2013), the ongoing web-based *The Worry Box Project* (2011), and her performative documentary feature *Yours in Sisterhood* (2018).

Another fascinating film from 1959, *Study in Maternal Attitude*, puts a bunch of moms in a playroom behind one-way observation glass so that doctors can study their body language and how they express themselves. My favorite "outtake" is a film from 1967 called *Mother Infant Interaction*, which documents a behavioral psychology experiment where one hundred mothers were invited to feed their infants, sitting next to a giant timer behind one-way observation glass.

Sylvia Brody and Sidney Axelrad, [Mother infant interaction]: [form of feeding at six weeks], 1967. Film (black and white, sound), 47 min.

The mothers are timed, scored for things like "empathy level," "control level," and "efficiency," categorized as one of seven maternal "types," and a clinical male voiceover speaks over each feeding mother to elucidate what she is doing wrong. Is she too controlling? Does she overpredict the needs of her infants? Is she overconfident? Not affectionate enough? Bored? Rushed? Agitated? One mother is criticized for wearing a hospital gown out of fear of soiling her dress (because concern over one's own appearance is apparently not okay for a mother). Another is judged to be mean and distant because her infant is strapped into a seat. The film concludes astonishingly that "few mothers, unfortunately, have the emotional maturity to be good mothers" and goes on to claim that babies of bad moms have developmental lags, have tantrums, are fearful, don't have pleasure, and have disturbed object relations. I love the blunt way this film makes explicit all of the judgment and blame that is attached to mothers and that somehow all of this is connected to quantifiable data around feeding infants.

SH The argument you make in the film about labor pain and its historical development has stayed with me. After giving birth the "natural" way with no pain killers, I am not convinced at all that it was the best way. I empathize with the women who were advocating for painless births at the beginning of the twentieth century after learning about "twilight sleep" from your film. I think you were able to uncover a lot of hidden histories surrounding pain, human rights, and childbirth. Can you talk about how mothers have historically been blamed and made to feel like failures?

IL I think the argument the film tries to make in its attempt to trouble, defamiliarize, and denaturalize our cultural ideas about the natural and authentic can definitely be used to think about many other aspects of motherhood—breastfeeding, sleep philosophies, vaccination debates, the desirability of handloomed indigenous baby wraps and hand-mashed organic baby food, and so on.

There is, of course, a long history of mother-blaming—in the 1940s Americans were told that overprotective mothering (leading to a cult of American motherhood or "momism," as outlined by Philip Wylie in his bestseller *Generation of Vipers*) had ruined the moral fiber of American men and, at around the same time, that emotionally distant "refrigerator mothers" caused autism in their children. It was enlightening to me to learn in my research that the origins of maternal education in the early twentieth-century progressive era were directly linked to efforts to improve the hygiene of poor, slum-dwelling women and basically came out of moral panic around exploding populations of urban immigrants (not unlike the racist history of birth control). The mother who needs training and education is inherently a bad, ignorant, and failing mother.

SH Before our interview I sent you the article "Motherhood in the Age of Fear," which recently came out in the *New York Times* about parenting and surveillance. This article is about women being harassed and even arrested for making rational parenting decisions.

IL The *New York Times* article reminded me of the viral news story from a few years ago when a child snuck into the gorilla enclosure at the Cincinnati Zoo. The gorilla had to be killed to save the child's life, and the mom, who happened to be a Black woman, was hideously criticized for her failure to watch her child and held morally accountable by hundreds of thousands of gorilla fans for the death of a gorilla. I'm interested in the ways that mother blaming is tied to race and class. And I think a lot of parents my age, who grew up in the '70s, definitely feel that sense of loss of the unsupervised, unstructured freedom that we remember from our own childhoods.

SH On the one hand, I think that mothering is about surveillance—we are constantly watching our children—and on the other hand, I'm fascinated by mothers surveilling their children with technology and have been researching this kind of technological surveillance. But really there are three forms of surveillance: the mother watching her child, the child being watched by an "all-seeing eye," and the mother being watched. How do you understand surveillance as care after making your film, becoming a mother, and being continuously interested in the subject of motherhood?

IL Surveillance as care is an interesting and complicated idea when it is embedded in so many other more insidious forms of surveillance. It's true that we learn how to be mothers through a practice of deep and embodied everyday watching and listening, especially during the period before an infant can verbalize its needs, so that's right that there are overlapping spaces of surveillance—corporate, societal, and intimate—at play together.

SH Looking at a list of baby monitors on the market this year, I'm interested in how "peace of mind" is marketed through the capacity for constant monitoring. Fear sells products seemingly on an ever-increasing scale and the market is ever pervasive. Is this something you came across in your research as well? In your film, the scenes of packing the suitcase perhaps serve to reference the products one needs to become a "successful mother." Can you tell me more about those scenes?

IL Marketing to anxieties about security and control isn't unique to motherhood—there are lots of industries that monetize our everyday fears, from household security systems to survivalist companies that sell lifestyle objects for future post-apocalyptic times, to the new companies that sell school shooter door barricade products for teachers (an unnerving Internet rabbit hole I've explored recently). Because childbirth and motherhood are experiences that are ultimately impossible to predict or control, the promise of products that offer order, security, and predictable futures are appealing. The packing of hospital suitcases—featured in almost every single prenatal education film I viewed in my research—feels like one of many examples of a preparation ritual to stave off the frightening unknown.

SH While working on this project I was interested in investigating baby monitors as cameras. I tried out different surveillance cameras/baby monitors and tried to use them in different, alternative ways. It turned out this was kind of a gimmick because all the results look the same and the images you can make with them are not so interesting. But I like the idea of turning the baby monitor back on itself and appropriating the surveillance apparatus to alternative ends. What do you think about this?

IL I like the idea of repurposing that visual technology to a different end. A couple of artists I know—Jill Miller and Kristy Guevara-Flanagan—have made work about mothering using GoPro cameras, appropriating the extreme sports vernacular of hands-free shooting in extreme fisheye wide angle to talk instead about the extreme physicality of everyday mothering. I think Kristy's use of the GoPro to make a durational film about maternal labor is especially compelling—I love that it pushes the GoPro to capture spaces of boredom, isolation, repetition, moments when nothing is really happening—it makes a very different argument about what it might look like to visualize the "extreme" and about what constitutes an event—and I love that the camera is foregrounded as a witnessing character inside the narrow confines of this intimate, domestic, mostly housebound drama of interactions between mother and daughter. So yes, I definitely think imaging technologies can be appropriated to make new forms.

SH One article I've read invokes a Foucauldian perspective in conceptualizing and analyzing modern motherhood, suggesting that the pressure to be perfect is frequently instilled mother-to-mother through interaction, or in Foucauldian terms, surveillance. What has your experience with other mothers been? How influential is self-surveillance and surveillance of others in perpetuating ideals of motherhood?

IL I think, again, we see that idea in the early twentieth-century origins of maternal education, where middle class white women formed civic-minded clubs to uplift, educate, and correct other (less privileged) women. Women certainly do a lot of disciplining and policing of each other, judge and evaluate each other, and generally uphold damaging and patriarchal structures in many different arenas. This is not unique to mothering. But motherhood is definitely one of the most fraught and judgmental spaces where every decision is an opportunity to fail or make a mistake, and the stakes of failure (ruining your child) feel unusually high. Personally I see this kind of scrutiny less in my own life now that I have an older child and

am thankfully beyond the early new baby support group days where I am thrown together with random moms that I don't like or feel judged by. I have chosen my mother friends sparingly and carefully, and my friendships with women who are mothers are a source of support.

I did have an interesting experience the first time I showed a work-in-progress version of *The Motherhood Archives*. I was in a yearlong fancy fellowship where I had to present what I was working on to the other fellows—a group of generally accomplished thinkers and scholars—and I showed one of the 16mm "conversation" sections of the film where

Irene Lusztig, *The Motherhood Archives*, 2013. Video (color, sound), 91 min.

Kristen talks about not enjoying her pregnancy, feeling anxious about childbirth, and wanting the reassurance of a medicalized birth with a C-section. Kristen was also part of my fellowship cohort, so she was in the audience at this screening as well. Many of the women in this audience had an incredibly negative reaction to my film. The post-screening conversation had a kind of emotional intensity that was completely different from the kinds of cerebral academic discussions prompted by the other presentations of my fellowship colleagues. People asked intrusive and personal questions and seemed very concerned that I didn't show "the joy of childbirth" in my film and that the critical tone of the film seemed very "negative"—which is actually an incredibly strange response from a group of academics who are trained critical thinkers (somehow childbirth tends to be treated as an exceptional category that we aren't supposed to think critically about, which ultimately is part of why I wanted to make the film that I made). But the strongest negative reaction was to Kristen herself, whose open ambivalence on screen seemed to touch a raw nerve. Kristen reported that for several weeks after my screening, over lunch and in the hallway, people continued to ask her aggressive and uncomfortable questions. One woman asked Kristen why she even had children if her attitude was so bad. Another asked if she regretted having her daughter, as if not enjoying childbirth threw Kristen's entire parenting experience into question.

I think there is a lot of pressure to keep our most difficult maternal narratives contained, and this in itself has motivated a lot of the work that I've made around motherhood. When my son was born, the first project I made was an online archive of anonymous maternal anxieties (*The Worry Box Project*), which was part of an effort to create a counternarrative, to make space for stories that are not about perfect motherhood or the miracle of childbirth. And I later made a short film, *Maternity Test*, where I invited actors to collectively read aloud a story about a traumatic C-section composited from anonymous mothering.com forum posts—I like the idea of taking those middle-of-the-night online maternal confessions—that are always stories about failure and shame and falling short—and inviting people to embody and listen empathetically to them.

SH Writing in the *Brooklyn Rail*, in an article titled "Neo-Maternalism: Contemporary Artists' Approach to Motherhood," Sharon Butler writes, "The accepted wisdom among the first generation of feminist artists who disdained baby-making was that women who

reproduce spend at least a year or two making idiosyncratic, excessively inward-looking 'baby art' and then, if they are lucky, eventually get their wits about them and return to their previous, more serious work." What do you think about this statement? Do you feel addressed? Why do you think there is still a stigma about mothers making work about mothering?

IL There is definitely still a stigma about creative work that centers motherhood. It was extremely difficult to get *The Motherhood Archives* programmed in the film world, and I heard over and over again from programmers that childbirth is an uninteresting topic, and that feminism, women's issues, and women's bodies are "niche" concerns for "academic feminists" or something their "wife might find interesting." People were really not shy about sharing these opinions. I know from other artist and writer friends working on childbirth and maternity-focused creative work that this kind of discrimination is pervasive. Maternity (and maybe aging as well) is still among the least visible, least acceptable margins of feminist work—maybe it does have to do with visibility, that when you are home with an infant it's hard to advocate for that work out in the world. There's definitely still a widespread perception that work about motherhood is sentimental, indulgent, narrow, narcissistic, domestic, and boring; that it's not an experience worth considering or thinking critically about, and that it therefore could only possibly be interesting to other new mothers.

That said, encountering a lot of rejection forced me productively to find and activate my own networks for feminist maternal art. I worked to learn about and connect with other artists making and showing work about motherhood. I organized a symposium and gallery show at UC Santa Cruz, where I teach, on intergenerational feminist maternal art and writing. Over time and through this kind of work, I've become part of an international network of mother-artists. Finding and building these robust networks over time has been rewarding and important work for me. Recently it has felt like there's more and more momentum, energy, and visibility around building space for creative work about motherhood, from Natalie Loveless' *New Maternalisms* shows to Christa Donner's Cultural ReProducers group to Deirdre Donaghue's M/other Voices group in Rotterdam to the *MaMSIE* journal in the UK. Nowadays I feel like I am hearing about new initiatives, groups, shows, and organizations all the time—but maybe it's just that I am paying better attention or am better connected.

SH Tell me about the film series that you curated called *Mothering Every Day*. Which films did you include and how has the reception of these films been?

IL *Mothering Every Day*—a screening program co-curated by myself and filmmaker Kristy Guevara-Flanagan—is a good example of the kind of DIY maternal feminist exhibition practice that I've been talking about. The idea to put together a show about everyday domestic labor came out of many conversations about the difficulties of getting work about motherhood programmed in the film world. Kristy is actually in *The Motherhood Archives*—her interview is the ending of the film. We met for the first time that day when she was nine days away from her due date and I was inviting women to be recorded on 16mm film speaking personally about motherhood. After that we stayed in touch as I finished my film and had an incredibly difficult time getting programmers to show it, and then she made her GoPro film *Mothertime* and experienced exactly the same struggle. So, most simply, we created the program as a visibility project, to foreground film work that centers maternity and to pool together our networks and resources to promote the program. The program includes *Mothertime*, my

short video *Maternity Test* (the "audition" project based on mothering.com forum posts that I mentioned earlier), and work by Sasha Waters Freyer, Jeny Amaya, and Farheen Haq. It was important to us also to create an inclusive program (many of the maternal art shows and gatherings that I've been invited to participate in have not felt very diverse). Jeny's film *Mama Virtual* feels like an especially important and timely contribution to the program. Jeny is a young Latinx filmmaker from Los Angeles, and her film is about Central American women who mother virtually—mothers who have come to the U.S. to work and live thousands of miles away from

their children, whose everyday mothering practice is lived through touch screens, Skype calls, phone cards, and international money transfers. It felt important to us to remind viewers that the time, affect, and care of maternal labor can take many different forms.

This conversation took place over email.

Irene Lusztig, *The Motherhood Archives*, 2013. Video (color, sound), 91 minutes

Keeping Watch

SARAH BLACKWOOD

On the twenty-eighth day of my first son's life, I spent around forty-five minutes hooked up to a breast pump that mechanically extracted small amounts of liquid from my body while he slept. Sometimes I might get as much as two shot glasses worth of breastmilk, but mostly, it was a thimbleful. When he woke, I took the pumped milk and poured it into a sterilized plastic bottle (it looked like a flask) that was attached to a rope, which I then looped over my head so it hung sort of high, just about even with my clavicles. A very thin tube ran out from the flask, which I attached to my nipple, using surgical tape. I put my son's mouth on my nipple and the tube together so that, conceivably, he could get milk out of both my breast and this strange contraption (nursing advocates call it a "Supplemental Nursing System") at the same time. Then, I watched as he grew flustered from getting milk from neither. When the frustration reached a fever pitch and he was close to wailing, I gave up and poured the remaining precious breastmilk back into a bottle. He sucked it down in thirty seconds or so, and then I got back up, poured an ample amount of formula into the bottle, and he settled into my arms, calm, comfortable, loved, and nourished. That's when I wept.

This was the twenty-eighth day, but it was also the thirty-second, and the fortieth. It was three-quarters of an ounce, or sometimes just a half. I recorded all of it on paper: a mess and maze of numbers, ounces, and calculations. The day that he consumed fifteen-and-a-half ounces of breastmilk—oh, the joy, the joy, the completely internal joy! To whom could I confess any of this desperation? I kept my hospital-issued "Breastfeeding Diary" close at hand; my husband looked askance at it, recognizing an albatross when he saw one. But what could he do? He was on the shore while I floated way out in a vast sea. The sea was powerful, nearly unimaginable; it swamped me. I clutched my papers and my systems and my data—all the data!—tightly. I must stay alert! Danger loomed all around, my baby and I might drown at any second. That alertness and devout attention to the tiniest of details may have looked like pathology to others. To me, though, it felt more and more like love and care.

What's the line between pathological self-surveillance and care for a newborn? Is there one? They are so small, vulnerable, absurd, so clearly susceptible to being swept away at any time. They are antediluvian remnants, reminders of our own precarious mortality, our fragility. They suggest we—a modern, secular, independent people—contemplate whether or not we are held dearly in any god's good graces. I felt my body had betrayed me during my son's difficult birth, and it was betraying me again by refusing to nourish him. I devoted myself to the archaic labor of sign reading: like a Calvinist I rummaged through my heart and the world, looking for portents that everything would be okay, or omens that I could organize into some kind of *meaning*. I brought my newborn to a lactation

consultant's multi-million-dollar Cobble Hill brownstone. She ritualistically laid him on an ancient analog scale before and after I nursed him. She hummed intently and handed him back to me. He definitely gained a few ounces! There, at last, was some data. There were signs, but what did they mean? She left that for me to deduce.

After the Puritan Anne Bradstreet's house burned down in the 1660s, she wrote a poem that captured the futile work of sign reading in the face of womanly grief. When the poem, "Verses Upon the Burning of Our House" opens, she describes the terror of being awoken to the night watchman's cries of "Fire! Fire!" and almost immediately turns the terror into information:

> I blest his grace that gave and took,
> That laid my goods now in the dust.
> Yea, so it was, and so 'twas just.
> It was his own; it was not mine.

At the poem's open, Bradstreet interprets the fire, and loss of all her earthly posses-sions, as evidence of God asserting his will: regularly scouring his people, testing them. Many Puritans made meaning out of a brutal existence by concluding that God challenged those he loved best. But that was a hard-hearted doctrine and Bradstreet had her doubts. As the poem unfolds, it reassesses its own framework. She dwells on "the Ruins" of her home as she later walks by and worries in re-membrance of her "pleasant things"—a trunk, a chest, a table. She grieves over the memory of candlelit conversations and intimately evokes "the bridegroom's voice" of her husband that once echoed inside the walls. She chides herself for wallowing, but the poem, by its end, spins out of her own control. She loved her house, she loved her husband, she loved her children and trunks and linens and candles, and she's willing to go straight to hell for being unable to let them go.

Watchfulness has never been able to tame grief, and yet I don't entirely regret my own descent into its surveillant madness in those postpartum months. The watchfulness didn't *do* anything, didn't prevent anything, didn't provide me with any information worth possessing. The watchfulness, rather, was one element in the wasteful, grief-stricken, and chaotic process of attachment. Modern technologies of motherly surveillance—the apps and charts and advice industry—are clean-lined and doctrinal. They assert that information and clearly outlined guidance is what new mothers need. Numbers, tracking, data will come together and work as evidence of good, or at least adequate, mothering and care. Technological motherly surveil-lance is a fantasy of efficiency and sterility. But the psychic state of watchfulness so many mothers find themselves in is metastatic, fecund, beyond.

I don't keep logs or charts any longer, but I still keep watch. I watch my children's faces carefully when they come home from school, trying to make sense of what I see there. I stand off to the side and watch them play and fight with one another and their peers, certain some social catastrophe will arise that somehow both stems from my lack of guidance, but also requires my wisdom and care. I watch myself and dread, constantly, that I'm doing everything wrong and failing them. They grow and thrive and I worry, usually alone. None of it is really about them. It's about me and how tightly I want to hold on to them. How much I know the world and its mysterious governing forces won't let me, and how willing I am to go straight to hell with my wanting and loving—with my stubborn, idiotic charting of a singular blasphemous truth: that they are my wealth on earth, abiding.

Sabba Elahi, *the suspect is my son*, 2018. Machine
embroidery on felt, series of 5, 18" × 18" × .75" each

Sabba Elahi, *the suspect is my son*, 2018. Machine
embroidery on felt, series of 5, 18" × 18" × .75" each

Maternal Surveillance and the Custodial Camera

LISA CARTWRIGHT

As the COVID-19 pandemic escalated in March 2020, a U.S. federal court judge ordered that children be released from the detention centers where hundreds of migrant families seeking asylum were being held awaiting hearings. The response to this ruling by Immigration and Customs Enforcement (ICE) was to herd several hundred detained parents, mostly mothers, into sudden encounters, requesting signatures authorizing ICE to send their children, many infants and toddlers, away to homes and shelters.[1] In 2018, ICE "family separation" had been met with vociferous public outcry. In June 2018, an injunction was passed against the practice, and most Americans believed the policy was put to rest. But by January 2020, the judicial tide had quietly turned. News of a U.S. court ruling authorizing the practice was buried by an avalanche of impeachment reporting that also eclipsed attention to the 2019 novel coronavirus. By bringing family separation back as parental "choice," ICE implemented, as the *Washington Post* put it, a Hobson's choice. Family detention is in itself a gratuitous act of cruelty in a pandemic during which prisoners are being let free in a humane measure to avoid mass outbreaks. To continue to detain asylum seekers and offer parents the "option" of family separation to protect their children from a possible outbreak is to ignore a century of research confirming the irrevocable damage such separation inflicts on children and families, and is to willfully inflict this damage in the guise of parental choice.

There is much to say about the ongoing human rights violations enacted by the family separation policy, and about the lasting impacts on incarcerated children in particular. This essay attempts to contextualize the conditions of visuality that structured the crisis as it unfolded around U.S. child detention centers in the late 2010s, leading up to the COVID-19 pandemic. Interpreting this era of child detention through the framework of the camera and visuality, this essay brings together strands of thought that have circulated more or less separately in visual studies. Surveillance is a concept rarely taken up to consider its constitutive impact on children and their development, apart from analyses of home and childcare center monitoring technologies. As we will see, the conditions of child detention along the U.S.–Mexico border have been marked by policies to control and limit the tracking and photographing of incarcerated children. This systematic erasure is telling with respect to the status of surveillance as a mechanism of control and state power.

This essay proposes the concept of the camera as a custodial agent that bridges familial visuality and state surveillance, and posits that these modalities are mixed and co-produced in complex ways. It does so in order to get at the visual logics and the tangle of forms of containment, recording, and tracking—familial,

[1] Editorial Board, "Migrant children are still confined and vulnerable. It's a gratuitous act of cruelty," *Washington Post*, May 25, 2020, https://www.washingtonpost.com/opinions/migrant-children-are-still-confined-and-vulnerable-its-a-gratuitous-act-of-cruelty/2020/05/25/8884fc4a-9bb5-11ea-a2b3-5c3f2d1586df_story.html.

public, and governmental—that have structured family separation as a political strategy, a profound social crisis, and a tragedy for the individual family and child. It considers the possibility of camera surveillance as a tactical modality of agency and resistance. The right to be recorded and the right to be counted is tied to child survival, but the right to be seen affords a degree of specificity to the condition of being that numbers and records can elide. Interpreting family separation and the detention of the child through a theory of lens-based surveillance may help us to think more analytically about how the gaze and its technologies have operated in institutions engaged in family separation, and may also reveal how state surveillance always falls short of its own reach by design, creating for itself a lack of evidence through which rights and subjecthood are precluded.

Missing or underreported data conceals what is missing at the heart of the detention center: not more accurately surveillant technology, but the child, who is not seen or counted, and whose absence makes accountability moot. Rendered missing as well is the custodial parent whose right and obligation it is to perform surveillance, to watch over their own child. This right and obligation is mandated and protected by the UN Convention on the Rights of the Child.[2] An approach to surveillance through the figure of the camera as metaphor and model of the gaze in U.S. government family separation begins to make evident the operation of surveillance as it plays out across the family, the state, and humanitarian public media.

Zero Tolerance, Zero Pictures

In 2018, the U.S. government supplemented Homeland Security immigration prosecution procedures in place since the G. W. Bush administration's 2005 implementation of "Operation Streamline,"[3] separating families, including those who had crossed the border legally, from October 2017 onward, and instituting in April 2018 the most infamous of the "zero tolerance" immigration policies. With the U.S.–Mexico border as its focus, the Department of Justice directed U.S. attorney's offices to accept for criminal prosecution all suspected illegal border-crossers, many of whom were asylum seekers, on grounds of illegal entry. Zero tolerance's enforcement involved, among other practices, the specific choice to prosecute parents traveling with children (a group previously rarely criminally prosecuted) over those traveling alone. The government insisted that separating children from their parents was merely an outcome of policies prohibiting the criminal or immigration detention of children.[4]

During this specific 2018 "zero tolerance" policy's span, an estimated 3,014 of the approximately 12,000 children in families apprehended by the Department of Homeland Security were sent to newly assembled child detention centers, tent camps, and institutions run by the Department of Health and Human Services. The parents were placed in criminal detention centers elsewhere, in many cases thousands of miles away, while they awaited prosecution. Although the policy was putatively reversed by a federal court ruling that stipulated a July deadline for family reunification, by mid-August more than five hundred of these children, six of them under the age of five, were still being held separately in government custody.[5] Separation of children from their parents at the border continues through the time of this essay's revisions (summer 2020). The government's own records show a count of 1,100 such separations had occurred in the current period by the end of 2019. The figure came with the proviso that these and other reported numbers were likely to be undercounts.

[2] United Nations Human Rights Office of the High Commissioner, "Convention on the Rights of the Child," November 20, 1989, https://www.ohchr.org/en/professionalinterest/pages/crc.aspx.

[3] A U.S. Department of Homeland Security and Department of Justice initiative begun in 2005 that drastically increased immigration prosecutions and made illegal reentry the most commonly filed federal charge. See Joanna Lydgate, "Assembly-Line Justice: A Review of Operation Streamline," policy brief, The Warren Institute, University of California, Berkeley School of Law, January 2010.

[4] "Q&A: Trump Administration's 'Zero Tolerance Policy,'" Human Rights Watch, August 16, 2018, https://www.hrw.org/news/2018/08/16/qa-trump-administrations-zero-tolerance-immigration-policy; U.S. Department of Justice, "Attorney General Announces Zero-Tolerance Policy for Criminal Illegal Entry," press release, Justice News, April 6, 2018, https://www.justice.gov/opa/pr/attorney-general-announces-zero-tolerance-policy-criminal-illegal-entry.

[5] Amrit Cheng, "More Than 500 Children Are Still Separated. Here's What Comes Next," ACLU, August 21, 2018. https://www.aclu.org/blog/immigrants-rights/immigrants-rights-and-detention/more-500-children-are-still-separated-heres.

A U.S. Inspector General report published in late 2019 describes technologies used by the Department of Homeland Security to "record and track" separated children and their movement as insufficient and flawed.[6] The report attributed this failure to the fact that the agencies involved lacked the mechanisms needed to accurately account for separated migrant families throughout the period in question, a problem characterized in the government report as "information technology deficiencies."[7] This essay takes as its opening this "information technology deficit," which was identified as pervasive across Customs and Border Control, Homeland Security, and Health and Human Services, and interprets it as a lack in which a particularly critical role is played by the figure of the camera, a recording and tracking technology that goes unnamed among the "IT deficiencies" described in the report. Cameras have been broadly present in and iconic of state surveillance systems since the turn of the century. But where children are concerned, zero tolerance has meant zero pictures.

With the implementation of "zero tolerance" in 2018, the Trump administration in effect made public a social experiment in child welfare that had been underway at least since October 2017, an experiment in maternal deprivation the likes of which has not been seen outside child refugee crises created by natural disasters, epidemics, and warfare. In their coverage of family separation, journalists were quick to note research that the U.S. government administrations involved seemed bent on ignoring.[8] This research, conducted by psychologists and psychiatrists during the twentieth century on child refugees, orphans, and children in hospitals and prison nurseries, shows that separation of infants and children from their mother or other established primary caregiver between birth and school age negatively impacts development in dramatic ways and carries the potential for causing lasting physical and psychological harm, even among those children who endure separation for relatively short periods. Children separated from their primary caregiver remain at risk of developing health problems long after reunification, and impacts may be multigenerational, felt by children raised by adults who had been subject to caregiver separation during childhood. That the ego formation of the young child whose primary custodian is taken away is affected in complex and irreversible ways has been shown beyond the shadow of a doubt.[9] Putting surveillance in dialogue with child ego formation and the familial gaze, as the second half of this essay does, and suggesting surveillance may play a necessary role in development within the family in ways that we have previously missed, may help us to discern when and how techniques of the state and the family intersect, and how these institutions are increasingly co-produced. This occurs within an optics that, I propose, finds its matrix somewhere inside the camera, a technological object that is also, like the camera obscura, a place—a room or a center in which the human subject may be held, such as a detention center. Cameras and photographs, I am suggesting, occupy a blind spot inside the theory of information that grounds current logics of surveillance.

Erasing the Custodial Camera

The camera has long held an important place as custodian of human rights. Even before the time of Jacob Riis, the Danish immigrant to the U.S. who used photography to document conditions of family life inside New York City tenements and factories in the late nineteenth century,[10] the camera has been used as a journalistic agent to document and expose conditions of inequity and suffering otherwise hidden from public view. Soon after the "zero tolerance" policy was implemented, journalists, lawmakers, members of the caring pro-fessions, and volunteers sought entry to child detention centers with the goal of witnessing and extending care to the thousands of children detained apart from

[6] "DHS Lacked Technology Needed to Successfully Account for Separated Migrant Families," Report of the U.S. Office of Inspector General, November 25, 2019, https://www.oig.dhs.gov/sites/default/files/assets/2019-11/OIG-20-06-Nov19.pdf.

[7] "DHS Lacked Technology."

[8] Melissa Ealy, "The long-lasting health effects of separating children from their parents at the U.S. border," *Los Angeles Times*, June 20, 2018. https://www.latimes.com/science/sciencenow/la-sci-sn-separating-children-psychology-20180620-story.html.

[9] The literature on this topic is extensive. The 2018 statement of the American Public Health Association (APHA) opposing family separation practices contains extensive footnotes to this literature, including the landmark UN Convention on the Rights of the Child, which mandates that nation-states allow parents to perform their parental responsibilities. APHA, "APHA Opposes Separation of Immigrant and Refugee Children and Families at U.S. Borders," Policy Number: LB-18-01, November 13, 2018, https://www.apha.org/policies-and-advocacy/public-health-policy-statements/policy-database/2019/01/29/separation-of-immigrant-and-refugee-children-and-families.

[10] Jacob Riis, *How the Other Half Lives* (New York, 1890; Project Gutenberg, 2014), https://www.gutenberg.org/files/45502/45502-h/45502-h.htm.

their parents. Government agencies allowed only a handful of observers into the detention centers, restricting what these visitors saw. Efforts to use the camera as witness were met with intense resistance. The camera was systematically excluded from the list of technologies that government agencies permitted journalists and professional observers to bring into centers.

Tents as prisms; children under reflective space blankets at border detention facility in McAllen, Texas, June 17, 2018. Drawings by Samuel Hinsvark, 2020

Among the few observers admitted was Colleen Kraft, president of the American Academy of Pediatrics, who issued an Academy statement against the separation policy.[11] Media outlets widely circulated an interview aired on *CBS This Morning* in which Kraft describes a visit to a Texas facility holding children twelve years old and younger during which she was prevented from speaking to or comforting the children she encountered. She was allowed only to silently look. Kraft describes a toddler younger than two who she witnessed "sobbing and wailing and beating her little fists on the mat." When Kraft called the system "a form of child abuse," she joined countless lawmakers and members of a national and global public audience in condemning family separation as cruel and inhumane, as a violation of children's human rights.[12]

A report of July 2019 reveals the "filthy, overcrowded" conditions of children, some as young as five months old, held in the Border Patrol Agency migrant detention center at Clint, Texas, a site where scabies, shingles, and chickenpox were rampant, and "the agency's leadership knew for months that some children had no beds, no way to clean themselves, and sometimes went hungry."[13] But it does so through words, not images. Aerial photographs and diagrams, shots taken from a distance of a few newly arrived boys in lineup, their backs to the camera as they exit a bus outside the facility, and shots of protesters outside the gates make up the visual documentation for this detailed exposé. The situation has not changed as child detention centers become hot spots for COVID-19 outbreaks, yet remain for the most part outside media coverage.

Media reports expressed concern over the fact that separated and institutionalized migrant children were "heard about but rarely seen." The government responded with specially authorized and sanitized photographs showing facilities with no faces visible.[14] Camera restrictions, withholding of access and distribution of curated images have been justified by reference to privacy laws put in place, ironically, to protect children from public exposure. In response to criticism about the restriction on cameras, officials cited a 2015 Administration for Children and Families program management policy document for the Office of Refugee Resettlement (ORR) and other federally funded care providers regarding requests for tours and interviews

[11] Colleen Kraft, "AAP Statement Opposing Separation of Children and Parents at the Border," American Academy of Pediatrics, May 8, 2018, https://www.aap.org/en/news-room/news-releases/aap/2018/aap-statement-opposing-separation-of-children-and-parents-at-the-border/.

[12] "Pediatric doctor says separating families at border is 'a form of child abuse,'" *CBS News*, June 18, 2018, https://www.cbsnews.com/video/pediatric-doctor-says-separating-families-at-border-is-a-form-of-child-abuse/.

[13] Simon Romero et al., "Hungry, Scared, and Sick: Inside the Migrant Detention Center in Clint, Tex.," *New York Times*, July 9, 2019, https://www.nytimes.com/interactive/2019/07/06/us/migrants-border-patrol-clint.html.

[14] David Bauder, "Media Fight Access Restrictions On Child Detention Centers," *AP News*, June 26, 2018, https://www.apnews.com/3dd7308f483c4d6b9221030b4f1b57f8.

of facilities where undocumented children were being held without their parents. The document states, "it is ORR's policy to decline requests by the media to interview youth," and to turn down media tour requests "when children are present," ostensibly to maintain the "privacy, well-being and security of the child," and also to ensure "minimal disruption"—not to the child, but "to the program."[15]

Let us consider the camera, then, in its capacity as an instrument that models custodial surveillance as this modality circumscribes and decommissions visuality, and which is deployed not just as an institutional tool to be implemented or restricted, but also as a technology that has familial, private, and maternal capacities, and is in some ways developmentally necessary. The camera may be understood as a custodial instrument when it is used to protect the child by witnessing and circulating evidence of the child's circumstances of living, and also when it is wielded on the one hand to place the child under surveillance and on the other to restrict public knowledge of the child's plight. "Unmanning" the humanitarian camera, it is proposed, is a strategy of state surveillance in which the witness or guardian, like the guard in Jeremy Bentham's panopticon tower,[16]

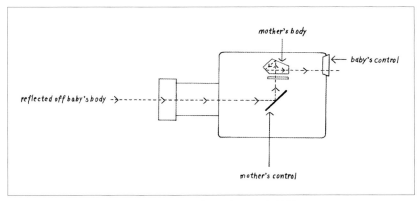

Prism as technology of detention. Drawing by Samuel Hinsvark, 2020

is rendered invisible in the optics of care inside the detention center, the camera in which the child is projected and detained. The camera's elimination from public documentation of the child in detention is drawn out in its parallels with the elimination of the mother from the space in which the child's development is, in effect, detained, put on hold by the conditions of state surveillance. To be watched is a constitutive condition of the child's emergence into subjecthood, and thus surveillance should be theorized in its mixedness, and in its co-production with the emergence of the child subject inside the familial gaze, as a constitutive operation of the family camera, and as an operation of the domestic sphere, as well as in its operation as a technique of state power that forestalls and derails the child from its progression to agency.

Unmanning the Custodial Camera

Considered in relationship to the familiar notion of "unmanned" technologies,[17] federal agencies' practice of banning cameras while substituting government-authorized photographs and videos of the interior spaces of child detention facilities may be seen as an attempt to automate the relationship of government to press. Agencies like Health and Human Services sought to institute a supply and demand chain of photographic media without the involvement of the photojournalist as intermediary and interpreter. In the case of an unmanned

[15] Office of Refugee Resettlement, "Children Entering the United States Unaccompanied: Section 5: Program Management," March 20, 2015, https://www.acf.hhs.gov/orr/resource/children-entering-the-united-states-unaccompanied-section-5.

[16] Jeremy Bentham was an English philosopher, jurist, social reformer, and founder of utilitarianism who introduced, among other ideas, a set of proposals for prison management reform and architectural redesign that involved contract management and a plan that featured centralized control over cells through optical and audio surveillance from a central guard tower into which prisoners could not see, making it possible to leave the tower unstaffed. As prisoners could not be certain if and when they were being watched, they were therefore more likely to conform to expected behavior. Bentham's Panopticon Penitentiary went unrealized but variations on it were apparent in prisons such as Philadelphia's Eastern State Penitentiary (1836), Cuba's Presidio Modelo (a four-panopticon system built from 1926–31), and the Netherlands' penitentiaries at Breda (1886), Haarlem (1901), and Arnhem (1886).

[17] For an early discussion of the concept of unmanned surveillance technology see Ryan Bishop and John Phillips, "Unmanning the Homeland," *International Journal of Urban and Regional Research* 26.3 (September 2002): 620–25.

automated technology such as the drone, operation of the technology is rendered an invisible activity, insofar as control is exercised from a distance. Human agency in the documentation of the detention centers was similarly evacuated from these photographs in that they were credited to the faceless federal agency. Moreover, human subjectivity was stripped from the image itself, which was doubly "unmanned" by the removal of people—children, that is—from the scene of the take. Doubly stripped of human agency, these photographs were, essentially, structured through a core logic of surveillance, a system in which the act of looking and the take are automated so that agency may be obscured. Public witnessing of state surveillance systems became a matter of great significance to the welfare of children, whose bodies remained hidden from sight behind the legal screen of privacy protection. Unauthorized images by citizen journalists were leaked, as when a video shot by a former detention center employee aired on Rachel Maddow's MSNBC program.[18] Many accounts described the sites as prison-like and conveyed the experience of the children inside through sound. On widely shared audio recordings they could be heard crying out for their mothers, begging for release, and being silenced by facility staff.

Unmothering the Custodial Camera

The government photographs of child detention centers that circulated rarely showed staff. In these child centers, mothering is notoriously transient and sparse, performed by low-paid, ever-changing staff in shifts. Children look after one another with greater constancy and reliability than any employees. The watchful mother is replaced not by the staff, the guard, the fence, and the locked door, but by other children, who parent their peers. What is the fate of the nascent subject that no longer has a consistent set of adult eyes, a reliable structuring gaze, through which to progress through normative phases of subject formation?

D. W. Winnicott has described the secure and consistent space of caregiver–child interaction as a holding environment, a situation that fosters cohesive ego development.[19] In the detention center, the child is stripped of its mother— is unmothered. The institution is, we might say, an unmothering machine— an apparatus in which the child is held, but ironically is held within the gaze of a system that renders consistent human sustenance and touch, as that which is always present, palpable as that which is sorely missing, as the excruciating lack that the space is designed to produce. To hold the child in separate detention is to tear apart its maternal camera obscura, its critical holding environment in which it experiences the safety and sustenance of being the object of the maternal gaze.

The detention center is, by contrast, a space of planned chaos, a holding space with no organizing core. The child is "unmothered" by the detention center not just once, but over and over as the watchful system imposed by the state reveals itself to be unmanned, as the employee who appears does not stay long enough or reappear again soon enough, or is replaced by yet another stranger. The detention center is, in effect, a machine for unmothering the child while continually watching it, lest it act out or try to get free.

The Custodial Space of the Camera

The camera is not only a small instrument we hold in our hands. It is also a room, a camera obscura or dark chamber the child may enter, or be made to enter, and in which it may be held—comforted or detained. Inside the detention center the child is both constantly watched and kept out of view of the public, which may see photographs of the holding space, but not of the child body it holds.

[18] David Bauder, "Media Fight Access Restrictions On Child Detention Centers," *AP News,* June 26, 2018.

[19] D. W. Winnicott, "The theory of the parent-child relationship," *International Journal of Psychoanalysis* 41 (1960): 585–595.

What kind of a child body is invoked in the architectural space of the detention center as camera obscura? Frédéric Yvan recalls that Sigmund Freud, in his work on dreams, described architecture as the most characteristic image of the body.[20] Yvan describes the mirror stage and Michel Foucault's ideas about identification to build upon Freud's idea: "The scene of identification," he explains, is for Foucault "the appearance of the mundane scene of the subject." Visibility of the subject "is inseparable from its appearance on the world stage," from "the inscription and the participation of the subject in the scene of the world."[21] Yvan describes the young child who closes its eyes to hide from the world, or who conceals itself from the other by hiding behind objects that are within the other's field of view.[22] I suggest that children increasingly live, from early infancy, in such conditions of surveillant visuality, learning to hide in plain sight. Surveillance is widely theorized as a modality that serves the interests of state, military, and industrial power. It is undertheorized, though, in its appearance in the spatial systems of the family and the home, where expectations of care for the very young child involve constant watchfulness, inspiring a market in nursery monitoring devices. We require more, and more nuanced, theories of surveillance to better understand how this visual modality informs and structures the child in its relationship to power. We require this more nuanced sense of surveillance structures not only to better understand what goes on inside the normative home (if such a thing exists), and inside the space of state detention, if only to see how these structures are negotiated and resisted by children who are made to live inside them, and who find the means to survive.

Yvan follows a Lacanian paradigm, suggesting that the passage to the world stage takes place through the mirror. This concept may be flawed but has been one of the few models through which the child's relationship to visuality, self, and power has been theorized in detail. Its account of subject formation, outlined in psychoanalytic terms by Jacques Lacan in 1936,[23] suggests that the acquisition of agency by the child entails learning, between six and eighteen months, to negotiate visibility through encounters with a reflection of its own body. The concept turns on the idea that this recognition of self in the image is in fact a misrecognition: the child imagines the body it sees to possess a degree of self-control beyond its actual developmental capacity in life. I propose that child development in a surveillance system comes with its own "mirror stage" of sorts, its own developmental milestones in the child's acquisition of agency. Becoming a subject in a surveillant society involves learning to navigate the custodial gaze that structures life in infancy and early childhood, which means learning not only to identify oneself in a reflection and imagine oneself as autonomous, but also to negotiate ways to escape that gaze and the data it captures, to hide in plain sight, and to elicit in this game allied peers, other children to serve as decoys and relays. Surveillance, a modality justly condemned in critical theory for its implementations in the service of government and military power, is a necessary condition of survival. It must be negotiated, not simply revealed, for the subject to survive being held within its grip. Surveillance increasingly is the ground zero of childcare policy and ethics, a memorial space in which absence (of the custodial parent, the primary adult caregiver) is perpetually mourned by the child. The empty center, the missing mother, as it were, grounds the contemporary child's emergence into survivable human subjecthood.

To illustrate the architectural-visual structures that give shape to the scene of identification, Yvan describes hide and seek, a game in which children learn to control their appearance to others by hiding. I propose this as an alt-mirror stage of sorts. Yvan notes that in some cases children "hide" in plain sight by closing their eyes and then insisting that they cannot be seen. We might see this a bit differently, though. By closing its eyes, the child insists that the seeker cannot see.

[20] Frédéric Yvan, "L'image du corps et la scène architecturale," *Savoirs et clinique* 1:10 (2009): 68–76, https://www.cairn.info/revue-savoirs-et-cliniques-2009-1-page-68.htm#no19. Citation is from paragraph 1. Yvan is referencing Freud's *The Interpretation of Dreams* (1900).

[21] Yvan, "L'image du corps," paragraph 3.

[22] Yvan, "L'image du corps," paragraph 5.

[23] The concept, coined by Henri Wallon, was first outlined in psychoanalytic terms by Jacques Lacan in a lecture of 1936. See Jacques Lacan, "The Mirror Stage as Formative of the I Function as Revealed in Psychoanalytic Experience" (1949) in *Écrits: The First Complete Edition in English*, trans. Bruce Fink (New York: W. W. Norton & Company, 2006).

It is as if the child has said, "by refusing to see you, I refuse your ability to see me." An unstated rule of this variation on the game is that the child may exaggerate (misrecognize) its own power over the function of the other's body, just as in the mirror stage the child exaggerates (misrecognizes) its power to make its own body act and move. The willful refusal of the other's power to see is a critical moment, I propose, in the nascent subject's rehearsal of emergent agency in exercising remote control. By denying the other the power to see, the child asserts its own power and right to choose when, how, and whether to be seen, watched, and recognized. It asserts its right to refuse to be held in the gaze of the other, even as it knows it has already been detained. Playfully misrecognizing itself as remote coordinator of a surveillance system and misrecognizing the seeker/guardian as predator who may be remotely deterred from its finding mission, the child rehearses the skills of self-protection in a surveillant society. Hide and seek becomes an early version of survival in the malevolent forms of surveillance the child is bound to encounter, sooner or later, when it is, as it inevitably will someday be, separated and detained. To hide in plain sight is to internalize the surveillant gaze of the other, but to internalize that gaze is not simply to act according to its presumed will (like Foucault's docile bodies or the panopticon's guard). It is to manipulate the coordination of the other, to become familiar with the mechanics of surveillant control. The motor coordination of the child on display in the mirror is the fine digital art of the blink, the tap, and the swipe. The body controlled by these antics is not its own.

Miran Božovič makes the case that in Bentham's panopticon prison model the guard is in fact present, but his attention is divided between the prisoners and the task of bookkeeping, the light for which renders him visible to prisoners who look upon the tower. But this light renders him visible only as an indistinct dark spot.[24] Because the prisoner cannot make out the guard's eyes, much less whether the guard is turned toward or away at any given moment, the guard is, in effect, invisible to the prisoner. In this account, it is not just the prisoner but also the guard who cannot see. He turns his gaze away from the window and toward information, the files. He is the camera, and he is also the computer. He needs to focus on the many details of information management required by his job, by the state. The tower is constructed not only so that he may watch without being seen, but also so he may manage information. Because information management requires so much attention, the prisoner may hide in plain sight. The surveillance system will always fail, because it demands not only more and better information technology, but also human attention to the process of sorting things out, which includes the design of the structures and algorithms that track and anticipate the subject's next move.

The Custodial Camera and the Familial Gaze

The familial gaze is a concept introduced by Marianne Hirsch to describe the role of the camera, photography, and the photo album in the constitution of the family. Hirsch discusses the familial gaze in the context of her own migration and exile as a child during the Second World War and the Holocaust.[25] To understand the camera within the familial gaze we might look back to documentation of other situations of family separation. In the 1930s and 1940s, the Viennese psychologist Katherine Wolf and René Spitz, a psychoanalytic psychiatrist, used motion picture cameras to film infants in the first year of life inside orphanages and prison nurseries, where children had been separated from their mothers. Operated in the absence of primary caregivers, these cameras were used as observational tools of surveillance.

[24] Miran Božovič, *An Utterly Dark Spot: Gaze and Body in Early Modern Philosophy* (Ann Arbor: University of Michigan Press, 2000), 108. Like Lacan's winking sardine can, it is this object, the dark spot, that constitutes the inmate as the object of the field of the gaze. Lacan wrote that the can was "looking at me at the level of the point of light, the point at which everything that looks at me is situated, and I am not speaking metaphorically.... This is something that introduces ... depth of field, with all its ambiguity and variability, which is in no way mastered by me. It is rather it that grasps me, solicits me at every moment, and makes of the landscape something other than a landscape ..." Jacques Lacan, *The Four Fundamental Concepts of Psychoanalysis*, trans. Alan Sheridan (New York: W. W. Norton, 1998), 95–96.

[25] Marianne Hirsch, *The Familial Gaze* (Hanover, NH: University Press of New England, 1999).

The films Wolf and Spitz made from this footage show us the experiences of infants and toddlers for whom a mother (a consistent primary caregiver) has never been present, and also those who once had the attention of a mother but were removed from her care. Through these film recordings and their own observations, Wolf and Spitz demonstrate the tragic failure of the ego to form in children who, in the absence of a consistent caregiver, turn first to rage and then to despondency, lying still in their cribs and refusing to interact with staff or to eat. It is the children who had known caregiving, Spitz explains, whose descent into despondency is most pronounced. In some cases, their research articles explain, this trajectory was not reversible and ended in the death of the child despite access to adequate food and shelter.[26]

All of the prison nursery children they studied in whom depression was identified shared one factor: the mother was removed from the child somewhere between the child's sixth and eighth month "for unavoidable external reasons."[27] No equivalent caregiver substitute was provided. Over a four- to six-week period after the loss of the mother, these infants regressed, withdrew, and became unresponsive. Growth ceased. The manifestation of depression, Spitz wrote, is "unmistakable to the practiced eye"[28] and so obvious that "even the lay person with good empathy for children has no difficulty in making the diagnosis, and will tell the observer that the child is grieving for his mother."[29] Although the measurable impact on the mother-starved prison-nursery infants was not as severe as that of the orphanage children, who died at higher rates, the filming of the psychiatric syndrome of depression identified by Wolf and Spitz in these camera studies gave Spitz ample material in which to observe over and over the dejected look, the turning away of the infant's gaze from the approach of the researcher, and the absolute withdrawal and apathy emoted by previously cheerful infants when held apart from their mothers.

The mirroring process fails to occur in much of the footage Wolf and Spitz recorded, demonstrating that the space of child detention and state surveillance is set up precisely to hold up the process of agency formation in the human subject. It is possible to think of the orphanage and the prison nursery as institutions that are, like the prison and the detention center, unmanned, unmothering. The detention center, I have proposed, is an unmothering system in which the child is stripped of a caregiver whose loss it is perpetually made to rehearse. The camera, like the staff member or the researcher who watches the child, is never good enough as a custodial substitute even when it documents with accuracy the conditions of the child. Their look cannot mitigate the losses produced by the surveillant system.

At the end of a film compilation entitled *Grief* (1947), Spitz holds a despondent toddler. He turns to the camera with an imploring look and performs a grimace, miming the emotion that he could no longer elicit from the child, whose affect is by this point flat, expressionless. She ultimately turns her face away. The child makes herself invisible in plain sight, her expression extinguished by family separation.

Here we find not only the child succumbing to its loss, but the institutional caregiver or, in this case, the researcher, the guard who is prohibited from exercising care and saving the child, and who instead makes a film. Through the film, data proving the cause of the child's plight might at least report and make publicly known the outcomes of family separation and child detention. Spitz wears a grimace—a face that, at this time after the Second World War, is the expression of a grief that is not just the child's or his own, but his entire profession's, as health workers witness the lasting consequences of family separation due to warfare and genocide.

[26] These findings are presented in R. A. Spitz and K. M. Wolf, "Anaclitic depression: an inquiry into the genesis of psychiatric conditions in early childhood, II," *The Psychoanalytic Study of the Child 2* (1946): 313–342.

[27] Spitz and Wolf, "Anaclitic depression," 319.

[28] Spitz and Wolf, "Anaclitic depression," 326.

[29] Spitz and Wolf, "Anaclitic depression," 328.

Frame from Rene Spitz's film *Grief,* 1947.
Drawing by Samuel Hinsvark, 2020

There is something chilling and desperate about using a camera as witness and mirror to accumulate data in a space where the sequelae of family separation tragically unfold unchecked. Historically, cameras have the power to hold, to convey. They are, in use, containers of the fragile ego that constitutes the young child. I have suggested that the child today lives, from its birth, in a state of surveillant visuality that entails constant monitoring. But in our era, it must learn to hide in plain sight, to deny power over its body. To hide in plain sight is to foreclose the internalization of the surveillant gaze, to put into action remote control and to insist that one should at the very least count. Hide and seek is our new mirror phase. It is a game that involves distributed agency, a team, and recognition of the opposition. If the child's passage into the visible world takes place on the stage of the mirror, then we should look to the interior of the camera to consider the ways in which agency may be negotiated inside surveillance's chamber, a space that holds the potential for its own failure.

Opposite:
Sheida Soleimani, *Noon-o-namak,* 2022.
Pigment print, 60" × 40"

Noon-o-namak is a portrait of the artist's mother during her time in hiding as a political activist in Iran in the 1980s.

84

["Closed to traffic"][1]

CLAUDIA RANKINE

Closed to traffic, the previously unexpressive street fills with small bodies.
One father, having let go of his child's hand, stands on the steps of a building
and watches. You can't tell which child is his, though you follow his gaze.
It seems to belong to all the children as it envelops their play. You were about
to enter your building, but do not want to leave the scope of his vigilance.

[1] This is excerpted from *Citizen: An American Lyric* (2014).

A Conversation with Melina Abdullah

SOPHIE HAMACHER

I started this project thinking about the ways that the close observation of children that is so important within families might be thought of as a form of surveillance and how this watching relates to the surveillance of families from the outside. As a civil rights activist, scholar, and mother, could you talk about how you understand surveillance in the context of motherhood and mothering?

MELINA ABDULLAH

When I think of surveillance, I immediately think of the state and being surveilled by the state. I've never thought of it in the context that you raised. I've never thought of my monitoring or supervision of my children as surveillance. I guess you could call it that, but it takes on a different connotation. I absolutely monitor my children's social media. I absolutely attempt to guide them in terms of their use of communications and that kind of thing and I supervise them in the home and outside the home, but I don't think of it as surveillance. Surveillance for me is where permission is not granted by the subject. Not that my children have to grant me permission, but the relationship between mother and child is a very different one than the state surveilling us. And I think that when we talk about Blackness and surveillance we have a long history, especially among Black activists, of being surveilled by the state. So even my children—my youngest is eight—are very conscious of state surveillance.

SH When you speak of state surveillance I immediately think of Michel Foucault and his seminal text *Discipline & Punish: The Birth of the Prison*. He suggests that we internalize the rules and values of social institutions and thereby do much of their work for them by controlling ourselves and watching ourselves. In this same context I read about the term *new momism* which implies mothers monitoring and surveilling one another. I've been having conversations with other mothers to find out what their perspectives on surveillance are and how they think we are being told to mother, and how mothers are often blamed or made to feel like failures. Could one go so far as to say that we teach children rules in order to teach them to surveil themselves? What do you think?

MA I mean I think it is still connected, especially for Black folks, with questions of a state apparatus. So, why are we trying to monitor ourselves and monitor our behaviors, right? For Black mothers, and I don't speak for all Black mothers, but as a Black mother I understand that my children are criminalized. They are criminalized. They are surveilled. They are repressed and oppressed and I think that there is a concern among most Black mothers, every Black mother I know, that children modify their behavior to minimize the possibility that they become subject to a state apparatus. So I might ask my child—I have a middle child who is a free spirit—I might ask her to modify her behavior when she is in public because even though that is her and she should have the freedom to be who she is, I am more concerned about her safety. She can be all of who she is when we get to our house where she is able to be freer. There is a tension and modification of behaviors based on surveillance but it is not something in general where it comes from within a familial structure. I think it is something where we understand that

MELINA ABDULLAH is a recognized expert on race, gender, class, and social movements. She was among the original group of organizers that convened to form Black Lives Matter and continues to serve as a Los Angeles chapter leader. She is also Professor and former Chair of Pan-African Studies at California State University, Los Angeles. Abdullah is the author of numerous articles and book chapters, with subjects ranging from coalition-building to womanist mothering.

we are in opposition to a state that targets us. So part of what we do as protectors of our children, from the outside we might ask them to modify their behavior but also that they be self-centering in their behavior and it's not fair and it's not free. It's not freedom to request that they do that, but we need them to do that.

SH I read that you are a mother to three children. When you say you want to protect your children from the state apparatus, what does that mean for you specifically?

MA I wrote a piece called "Womanist Mothering," it seems like it kind of folds into what you are talking about. In that piece, I talk about Western standards of motherhood and how it's oppressive especially to Black mothers. So this notion of what you are bringing up, of mothers being blamed for everything, this notion that mothers—at the time I wrote it I was married, but I'm not anymore—even the internal structures of families can be oppressive. It's really important that we push back against Western standards of how a family should be constructed; this idea that the parents and primarily the mother are solely responsible for the children, and that we can't either develop as full and complete women and mothers or develop our children as full and complete human beings if we are solely responsible for them. What I encouraged in that piece was for us to restructure and kind of go back to more African-centered models of family where we invite others to help us parent and raise our children. You hear a lot about "well, it takes a village." So, what is your village? My daughters have other young women who were kind of my spirit daughters who I know through work or teaching, who are really assigned to them to help guide them. One of them, for my older daughter, is a public speaker and a poet and a professor and she is fantastic and beautiful and she is twenty-eight. So she is a lot more fly to my fifteen-year-old than I am. For my middle child, it's really important because she is artistic, she is funny, she is really comedic, and the woman who is working with her leads a Black women's improv troupe and can connect with her on that artistic level.

SH It sounds like you have built a beautiful community. It seems to me that the reason a lot of these kinds of communities are hard to develop is because of the capitalist system and the way the market works and the way we are kind of kept away from each other, especially in the United States, where there is this indoctrinated and dogmatic way of thinking about the individual as opposed to the community. I feel like it is so hard to circumvent that because of the way our society is structured. How does one circumvent it or reinvent it?

MA I don't think it's that hard. I think it just takes a lot of courage. A lot of these women who have become my spirit daughters are either in the Black Lives Matter (BLM) movement with me, or have been my students, or both. So, what you are saying about capitalism, and the kinds of rules that are invented by capitalism, would suggest that when your student doesn't have a place to live you should refer them to the university crisis center and maybe they'll help them. But I'm not doing that. What I say is, I have an extra room so come sleep at my house. I've had one student stay a year and half and what that becomes is an extra pair of adult hands in the house. It's not that hard when we think about the places where we have power. We have power over our own resources. We have power over our own time. We have power over our own beliefs. My children feel safe because they have a whole community that looks after them. I think it's really not that hard when we are willing to raise our standards and be vulnerable ourselves. What spaces do we occupy where we can disrupt capitalism, where we can say that everything doesn't have to be an

exchange between a worker and a consumer? We can do those things, but we just have to think about how. Yesterday, Black Lives Matter held what we call Black Sunday. For the last four years, we've been trying to get people to not buy from corporations between Black Friday and January 1st and to spend their dollars intentionally with Black-owned businesses that benefit the community. We also work with an organization that has a free store built on this principle of Black mutual aid where, instead of giving all our stuff to Goodwill, which then sells it back to our community, we just have a free store once a month. People donate what they don't need anymore and people in need come and pick it up. It's not only a beautiful sharing of resources, but a way of building community which takes me back to the whole mothering piece. So now you know all these people that you see once a month at the free store. Now you know who does story time for kids and you can think of how to exchange resources with them.

SH Adrienne Rich, in her iconic book *Of Woman Born*, from 1976, makes an important distinction between motherhood and mothering. She talks about motherhood being the institution of motherhood, controlled by the patriarchy—

MA Right.

SH And mothering has to do with caring for and raising children. I'm wondering which writers and thinkers have inspired or influenced you in your own work on mothering and your political work?

MA Alice Walker's essay on mothering has been influential. I think, more than published authors and more than most who are thought of as thinkers, I'm most influenced by the mothering of my mothers, my own mother, my grandmother, and the mothers before them—that is who influences me the most. What were the practices that we had in my neighborhood? Every Black neighborhood has othermothers. Patricia Hill Collins writes about this but I didn't need to read Patricia Hill Collins to know that we had othermothers in our neighborhood, because we had Ms. Rose on my block, because my mother's house was one of those houses that all of the neighborhood kids would visit. I think the thing that has been most influential has been the wisdom of the Black mothers with whom I've had the privilege of sharing space and being mothered by. And the Black women who were in my circle who were mothering alongside me and with me and sharing in some of these practices themselves. I think they've been the most influential.

SH As one of its founders, could you speak about the issues surrounding surveillance and motherhood in the organization Black Lives Matter?

MA We were very intentional in building Black Lives Matter as a womanist organization. There are a few of us who built Black Lives Matter who are single moms and we were influenced by the experiences that we heard about in the Black Power movement and the Civil Rights Movement where Black women were doing a lot of the work and also having to exist privately as mothers. So I think about women like Jo Ann Robinson, who was a college professor and deeply involved in community work when Mrs. Rosa Parks launched the bus boycott by refusing to give up her seat. There is this story of how Jo Ann Robinson heard about what happened, that she was grocery shopping and someone ran up to her in the store and said Mrs. Rosa Parks has just been arrested, and Jo Ann Robinson continues to shop for her family, goes home, cooks dinner, puts her children to bed and then has all these other women meet her at her office on campus. Over the course of the night, these women assembled

and mimeographed flyers and posted them at all the bus stops. That is a beautiful story of commitment. It is beautiful that she was willing to do that work, but it's *not* the kind of movement we are interested in rebuilding. We don't want to be like, you still have to do your grocery shopping, and you still have to cook dinner, and you still have to put your kids to bed all by yourself whether or not you are married, and then not sleep, so that you can go and make these copies.

We were intentional in building Black Lives Matter as a womanist organization, which to us means early on we had to push back against some people who weren't parents, both men and women, because several of us had small children. We would be at meetings and the children would be running around and to a lot of the folks they were a disruption and we had to say, "No, kids are welcome in every space as long as it's not dangerous." And even if there is something that we are doing that is dangerous, we engage in this kind of collective parenting practice and all of the moms at BLM have security plans, so if something happens to the mom—like I've been arrested six times—they know what to do with my kids. People know where my kids are, how to pick them up from school. We have legal measures in place so that if anything happens to me, my children are cared for by a select group of collective parents. We built the organization in a way that the children also know that they have a voice in the organization. As a mom, I'm taken care of because it's not me on my own, I don't have to panic in the same way. Once I was arrested and thought it was going to be an in-and-out arrest. I thought I was going to—at most—spend the night in jail, but I wound up doing four or five days and I live in a place where I don't have family. Initially, I was very concerned, but we had built a process where everybody kind of pops into position and makes sure that my children are taken care of. That allows me to engage in what I believe. I believe that the work I do with Black Lives Matter is part of my purpose in life. It fulfills me. If I wasn't able to do it, it would be harmful to me and my spirit and to who I'm supposed to be in this world.

Building Black Lives Matter as a womanist organization is hugely important to me and to the other women and other moms in BLM, but it is also super important for our children. Sometimes in meetings we go around the room introducing ourselves and I say, "I'm a founding member of Black Lives Matter," and one day my daughter said, "I'm a founding member too." And she is. All of my children are. They have been there from the beginning and we also built it so that children have a voice. They are encouraged to offer their ideas, they are encouraged to incorporate themselves into whatever it is we are doing or planning. About three years ago, my oldest daughter formalized the Black Lives Matter Youth Vanguard and they came up with their own campaigns. They are not just our kids, they are human beings with voices and great ideas about how to change things. I call it nonhierarchical matriarchy structures where mothering and women are central.

SH I've noticed that the American media often gravitates to showing the face of suffering by showing the mothers of the victims of violence inflicted on Black communities by the state. Mothers are also most often those who go on public speaking tours and campaigns to draw attention to the continued injustice, culminating in the group Mothers of the Movement who want to spread awareness of the crisis that is police brutality.

MA Yes. So you see mothers are on the front line, the mothers of people who have been killed by police—mothers and grandmothers actually. There are also some fathers that are very active, but it is a lot of mothers and grandmothers. I guess what you are bringing up for me is the power of

Black mothering. We have this womanist mothering model that empowers the mother to live in her purpose because she has this new familial structure—a familial structure that enables her to live in her purpose while still loving, caring for, and raising her children alongside a much larger body that is also responsible for the care of those children. There is a power that comes with that for her and for the children. We also don't want the work that we are doing to end with us. It needs to continue. The point is that the power of womanist mothering is really a threat to the state, it is a threat to white supremacist patriarchal heteronormative capitalism, because that kind of hegemony oppresses me, and so if I am empowered, I am working to dismantle that oppression. If my daughter is empowered, she is working to dismantle that oppression.

This conversation took place over the phone.

A Conversation with Lauren Whaley

SOPHIE HAMACHER

As a radio producer and journalist specializing in reproductive health, who is also a childbirth photographer, can you describe how you understand the relationship between motherhood and surveillance? Where and in which capacity do these two terms overlap most for you?

LAUREN WHALEY

The word *surveillance* immediately evokes the image of Bentham's panopticon for me. But, as a health care journalist, I rely on "surveillance" to tell stories. That is, data collection. How data are collected and what data are collected informs the public's understanding on an issue. Take maternal mortality, for example. One public health expert told me that we need only look to data on mothers and children to measure a nation's health and prosperity. Well, in 2007 the federal government completely stopped publishing its annual count of pregnancy-related deaths due to incomplete reporting by states. Basically a paperwork issue that speaks volumes about our priorities. Late in 2018, Congress passed bipartisan legislation that will, in part, encourage states to start collecting data on why mothers are dying during pregnancy, birth, and the year after pregnancy. States will send that data to the Centers for Disease Control and Prevention (CDC), which will in turn help states make changes to help women. One source told me that these data could prove to be an important catalogue of women's health in the U.S. Or, if states do nothing, the legislation will just be lip service.

Questions I always try to keep in my mind as I'm recording or photographing or writing are: What is my relationship with my subjects? Am I exploiting them? Am I empowering them? Ultimately, I want to be respectful, fair, and accurate.

Of course, I know even speaking about surveillance like this—concerning data—is easy for me to say not only as a journalist and observer, but also as a white woman. People of color have far different stories to tell about how their pregnant bodies have been policed during pregnancy, birth, and postpartum. And how they and people who look like them (including their children) are surveilled by our society, whether that means sexualized, demonized, policed. As a white woman with two white sons, there is no way for me to possibly know or feel what that must be like.

SH I want to know more about your process of documenting intimate moments of childbirth. Could you describe your process of finding clients and how you envision your relationship with them? Have you ever had a client refuse the documentation once her labor began? What, for you, is the relationship between surveillance and photographic documentation?

LW I should say here that childbirth photography right now is a side project for me. There are many other birth photographers who are full-time. I operate primarily in the journalism space as a storyteller. Although, that may change in the coming years as my own young kids grow and I am able to handle a more full-time, on-call life.

As far as finding clients, I find them through word-of-mouth, through midwives, doulas, doctors, and other childbirth photographers who are increasingly talking about "community over competition."

LAUREN WHALEY is a photographer, radio producer, and print reporter specializing in topics related to reproductive health care, mental illness, and health disparities. She is also a childbirth photographer. She received one of eight U.S. 2017–18 Rosalynn Carter Fellowships for Mental Health Journalism to produce a year-long series on maternal mental health. In 2016–17, she was a Knight Science Journalism Fellow at the Massachusetts Institute of Technology.

With social media, including local "mommy groups," pregnant people are increasingly aware of the option to have their childbirth documented, and are often actively seeking a documentarian.

As far as a client choosing not to be documented once labor starts, that has not happened to me yet. But one of my first clients had actually agreed to be interviewed on microphone and photographed for a public radio story, and then backed out of participating in the story just before her birth. She still wanted to be photographed and signed a contract that said I could share the images of her birth on my website. She ended up being a repeat client, and I attended all three of her son's cesarean births. She even flew me across the country for the third son's birth, as I was living on the opposite coast at the time.

For me, the difference between surveillance and my documentary photography is one of consent. As a childbirth photographer, I am working for the birthing person, performing a supportive service for them. They have not only agreed to be photographed, as any of my photojournalism subjects would, but they have actually requested it. They're paying money for it. I am working for them, and hoping that I am able to do justice to one of the most powerful and vulnerable moments of their lives when they meet their baby for the first time. It is a deep honor that I do not take lightly. My style is fly-on-the-wall, and I try to document the story as I would a photojournalism assignment, so maybe I tend more toward surveilling the scene. It has none of the dystopian flavor—nor power dynamics—that the word *surveillance* conjures for me.

There's also one more distinction I want to make which is that observing and telling stories as a photojournalist or print reporter or radio producer is different than being hired to document a family's childbirth. And perhaps more to your question, there is more surveillance in the former. I have been accused by editors of being too compassionate for my subjects, of being too much of a cheerleader for the folks I feature in my stories. So, for me, there is often an internal tension of how I get to the truth of a piece, and at what cost, especially if people's stories and lives are laid bare. I heard a great quote on this recently that resonated with me. David Grann said on a recent episode of the podcast *Longform*, "Reporters are supposed to be dispassionate. And I think you have to be dispassionate in terms of how you evaluate evidence and information coming in. But I don't think you always have to be dispassionate in dealing with people."

SH You told me that although you wanted to document the birth of your second son you didn't want to hire a childbirth photographer yourself. Can you tell me a bit about why you didn't want to hire someone else and about the process of documenting your own child's birth?

LW As a photographer, I think I was too worried about the performance element of the event. I was worried that I would be thinking about how the birth photographer saw me, or where the light was, or how my older son was acting. If I had a trusted friend who was also a birth photographer, I would have considered it. Of course, I wanted the pictures but without the added stranger in the room. And birth is all about relaxing, letting the uterus do the work, opening up—literally—and trusting. It's the ultimate vulnerability, and an empowering, wild ride. I couldn't picture who could be there with me besides my husband, my midwives, and my older son that would allow me to be how I was going to be.

Following page:
Lauren Whaley, *A mother washes her newborn after giving birth in a birth center in Los Angeles*, 2013.
Photograph, dimensions variable

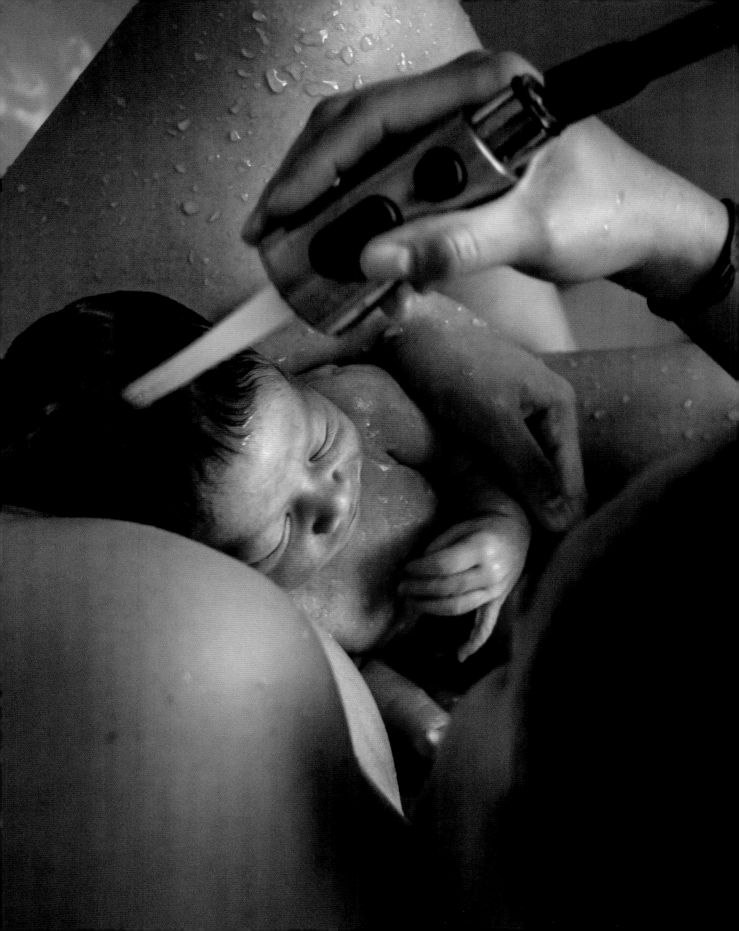

We had planned in advance to record, setting up audio and video systems to capture the precious moment. We had two GoPros, a camcorder on a tripod for the crowning moment, a Zoom H4n recorder for audio, and three cell phones. I was hoping to do for myself what I do for the families that hire me.

My labor ended up being three hours from first contraction to baby coming out. The midwives made it, but only just. My son touched his brother's head as he was coming out. And the only proof we have that it happened is a vertical cell phone video that our babysitter took as the baby was being born. The two GoPros and camcorder immediately ran out of batteries or didn't even turn on. Our visual documentation was a failure. The audio recorder did work but I haven't had the courage to listen to it yet.

SH You recently wrote an article for the Center for Health Journalism about a new survey that "paints a dire picture of challenges Black moms face in the healthcare system." What does that survey tell us about medical racism in this country?

LW In that survey, which was called "Listening to Mothers in California,"[1] Black mothers reported not being heard by their health providers and said they experienced discrimination during childbirth. They also experienced higher rates of anxiety and depression during and after pregnancy than white women.

Black women in the U.S. are three to four times more likely to experience pregnancy-related deaths than white women. Black babies are twice as likely to die before their first birthday than white babies. Researchers repeatedly point to the racial discrimination that many Black women experience as leading to detrimental health effects, including increasing the risk of premature birth.

Black women are literally getting sick and dying. And not being listened to about it.

Just look at Serena Williams, one of the greatest athletes of our time. A Black mother who described how her medical team did not listen to her when she literally self-identified potentially fatal blood clots in her own lungs the day after giving birth by emergency cesarean section. If that happened to Serena Williams, what is the experience of an average Black mother?

In that survey I wrote about, 82 percent of Black women surveyed agreed that "childbirth should not be interfered with unless medically necessary," and the report showed that 42 percent of Black women gave birth by cesarean section, compared to 29 percent of white women.

Black women were also more likely to have repeat cesarean births: only 8 percent of Black women had vaginal births after cesareans, compared to 16 percent of white women.

A remarkable moment for me in that reporting was when I interviewed a nursing professor and social scientist who studies reproductive justice. She pointed out that the three principal investigators from the study were white. And that the questions the survey asked and how the questions were asked had major blind spots. So even though the study itself was documenting how Black women are not listened to, the study methods were also flawed in their lack of representation.[2]

[1] Carol Sakala, Eugene R. Declercq, Jessica M. Turon, Maureen P. Corry, "Listening to Mothers in California," National Partnership, http://www.nationalpartnership.org/our-work/health/listening-to-mothers-ca/report/.

[2] Lauren Whaley, "New survey paints dire picture of challenges black moms face in health care system," Center for Health Journalism, September 28, 2018, https://www.centerforhealthjournalism.org/2018/09/26/new-survey-paints-dire-picture-challenges-black-moms-face-health-care-system.

SH In your work as a journalist you also specialize in mental illness and reproductive health. Can you tell me about the kind of surveillance that you are most often confronted with when you are covering these stories? What role does surveillance play in motherhood and mental illness specifically?

 LW Well, stigma against people with mental illness is well-documented and still pervasive in our culture. It's such an issue that former first lady Rosalynn Carter sponsors a fellowship—one of which I received in 2017—to train journalists how to cover mental illness with the stated goal of destigmatizing it.

 For mental illness, motherhood, and surveillance, that all came into sharp relief on a national stage in 2018 when a California mom tried to get postpartum depression help for herself with her baby at a clinic and a nurse called the cops. She and her baby were escorted by law enforcement to a local ER.

 Advocates are trying to create more inclusive systems for families to get better health care, including mental health care. And there is legislation aimed at providing training and specialist help to care providers, who may not have the training nor time to help families in these situations.

 Maternal mood disorders are now being talked about more by celebrities, which is helping destigmatize the issue. But there's a lot of work to be done.

This conversation took place over email.

SOPHIE HAMACHER
The film *How to Make a Rainbow* that you starred in and produced is a portrait of you and your daughter that takes place during your gender transition. Over two years of filming, your daughter goes from calling you Papa to Mapa and then Ma. Could you talk about your thoughts on motherhood?

JADE PHOENIX MARTINEZ
Motherhood has been a saving grace in my life trajectory. In many ways, becoming a parent is what spurred on my gender transition. As parenthood became a reality for me and I was faced with new challenges in my life, I knew that I needed to be the best version of myself to become the parent that I needed to be for my child. As I journeyed inward, to do the important work of healing my own childhood wounds and break the generational trauma passed down from my own parents, I found myself in the midst of a healing journey that showed me who I really was. Parenthood and motherhood was the first time in my life that I felt comfortable in my body. Embracing motherhood specifically opened my world to something more true and honest in my lived experience, more closely matching my inner understanding of myself and my place in the world.

SH Can you talk about your experiences with motherhood and surveillance? How have you personally experienced surveillance as a mother? As a trans mother of color?

JPM I think I've noticed surveillance mostly early on in my transition, before I was able to "pass" as a woman, like when I would be out at a park with Alaizah and other kids and parents stared at me trying to figure out "what" I am. Some kids even asked straight up, "Are you a boy or a girl?" I think cis people do not realize how naturally they fall into gender policing, and that anyone outside of the norms is looked at with suspicion, as if we are criminal in relation to the social contract and we are somehow breaking it. Add to that the fact that I have brown skin and tattoos and I have all the makings of a "suspicious" person.

SH I want to know more about your decision to allow your life, your transition, and your child to be observed with a camera and be made into a film. Were there boundaries that you drew around what could and what could not be filmed? What was at stake for you as producer and subject of this project?

JPM My decision to allow my life to be observed with a camera wasn't a hard one at all. In fact, I think the word "allow" in the question puts me in a passive role in the creation of the film. It wasn't something I "allowed" to happen as much as it was an intentional collaborative decision between the director and I, with whom there was already a sense of trust and a creative relationship at its foundation. As a public figure, speaker, performer, and artist, the chance to create a film that I knew would be able to tell my story in a unique and broader way was a no-brainer. I did have to make it clear with the director of the film, as we were going, that I was just as much a collaborator as I was a "subject." There was a lot of discussion between the director and I about what that would look like and as a result, we ended up kind of bending the rules of what we think "classic" documentary film is supposed to

JADE PHOENIX MARTINEZ
is a queer, trans femme, woman of color, first generation Filipinx-American, parent, LA-based performance artist and poet, motivational speaker, activist, and educator. Jade's work is a poetic expression rooted in the multiple identities she holds and how they intersect with her day-to-day fight for a collective liberation, while boldly creating art and cultural content with the hope of bringing queer and trans stories to the center of today's current social, political, and cultural landscapes.

Ryan Maxey, *How to Make a Rainbow*, 2019. Video (color, sound), 16 min.

look like. I had a say in everything that would make the final cut. This film is also a source of income for me and my daughter as we screen it with school campuses and organizations across the country.

SH Since the beginning of the COVID-19 crisis, I have been reading and collecting articles about the gender disparity caused by the effects of the pandemic. From the *New York Times*' "How Coronavirus Exposes the Great Lie of Modern Motherhood" to the *Atlantic*'s "The Coronavirus Is a Disaster for Feminism," these articles all lament that mothers are held responsible for every aspect of their children's well-being while still having to work. Have you experienced this disparity during the pandemic? How does surveillance shape and inform caretaking during this time of social distancing?

JPM The gender disparity you speak of hasn't really been much of an issue in our home since COVID-19. As a two-mother household, we balance each other out so well in our strengths and weaknesses when it comes to parenting. We have clear communication and generally gravitate towards the aspects of parenthood and home-building that resonate with each of

us individually and benefit the collective. I can see how this may be difficult for mothers in cisgender heteronormative marriages/partnerships, and how the norms of gender roles would upset the status quo when it becomes unsettled in a situation such as a pandemic. The fact that our gender norms have already been completely shattered as a family due to my transition also gave us the freedom and flexibility to navigate how to adjust our lives around the immediate changes in our home environment. In many ways, that flexibility, which we already operated from, is what keeps us afloat now. It is what has me hopeful for what is to come instead of defeated. I believe the gender disparity you mention is more so just an exposure of the ways gender norms for cis heteronormative folks have reached their limits, exposing masculinity's most toxic traits and leaving women and mothers with a greater burden of being the nurturing homemaker and the competent breadwinner too.

Surveillance in this time of COVID-19 and social distancing feels secondary to the need to survive. It is so prevalent, to the point that its existence in our lives is almost assumed to be necessary. And while I don't believe that to be true in an ideal world, my pragmatism begins to grow the older I get, the more I ponder what I will be able to leave to my child, and the life I want to live.

SH When you say surveillance seems secondary to the need to survive, are you suggesting that we give up the right to privacy in the interests of safety? Like, let's track everyone on their phones so we can get better at tracking the virus? Can you describe the prevalence of surveillance in your life? I'm thinking both of domestic and institutional forms of surveillance.

JPM I feel like the right to privacy doesn't even actually exist in our current state, or that it is more of an illusion of a right. Perhaps there are loopholes about us "consenting" to all the different ways we give up our privacy, or the illusion that no surveillance is done without our consent. Our phones can trace us every step we take. Our chat histories can be easily accessed once we are people of interest to the state. So in a way, we are always passively under surveillance until the state begins the active surveillance of any individual. Instead of spending all my energy fighting the fact that I believe I am passively surveilled at all times or seeking to end it, my day-to-day needs for survival, which entail social media, cell phone usage, Internet usage, and all the other ways surveillance is built into our daily lives, are necessities. So I wouldn't say the right to privacy is sacrificed when public fear is intensified, but rather there is no "right to privacy" when all our rights can be easily stripped away if someone is deemed an appropriate target of surveillance.

This conversation took place over email.

On Disobedience[1]

MAI'A WILLIAMS

All mothers have the potential to be revolutionary. Some mothers stand on the shoreline, are born and reborn here, inside the flux of time and space, overcoming the traumatic repetition of oppression. My mothering has been under surveillance since before my daughter was born. Being young, Black, working class, and pregnant taught me early on that my mothering was not a process that society was celebrating, instead it was seen as a burden on an anti-Black, hypercapitalist world. My very existence is disobedience to the powers that be.

At times, we as mothers choose to stand in a zone of claimed risk and fierce transformation, on the front lines. In infinite ways, both practiced and yet to be imagined, we put our bodies between the violent repetition of the norm and the future we already deserve, exactly because our children deserve it too. We make this choice for many reasons and in different contexts, but at the core we have this in common: we refuse to obey. We refuse to give in to fear. We insist on joy no matter what and by every means necessary and possible.

[1] This text was published in a different form in *Revolutionary Mothering: Love on the Frontlines* (2016).

A Conversation with Nurcan Atalan-Helicke

SOPHIE HAMACHER

You've written about the role of surveillance within food programs in Turkey and how they specifically target women. When I mention the words *surveillance* and *motherhood*, what first comes to mind for you?

NURCAN ATALAN-HELICKE

Control, patriarchy, and guilt. It is also learning about and mainstreaming gender norms, and recreating them.

SH I started this project thinking about the potentially benevolent aspects of surveillance. It strikes me that motherhood itself is about surveillance because close observation is how we learn to care for our children and also the way children themselves learn. Do you agree with this? How do you understand surveillance? Does it only have a negative connotation or can it also be positive?

NAH I believe that surveillance always has a negative connotation. When I was pregnant, I was always surprised to respond to questions about my body. My body was no longer mine, but perceived merely as a vessel for the well-being of the child. After birth, particularly due to the special needs of my child (my daughter was born with bilateral sensorineural hearing loss), I was subject to questioning about my habits during pregnancy and the birth itself (whether I did something wrong) to rule out anything that could be related to hearing loss. The genetic testing to confirm that both my husband and I had a recessive gene, which was the cause of our daughter's hearing loss, was only done when my daughter was nine months old. This test made all the questioning unnecessary, yet we were subject to it each time we visited the doctor. (By the way, we visited the doctors twenty-six times in her first year, saw ten different "experts." My daughter had one minor surgery at ten weeks old, which was also unnecessary, and two sedations before the age of one.)

In terms of learning, I believe that in the age of social media and the Internet, while we observe others to learn to take care of children, others also watch us to judge how we take care of our kids. Thus, it works to mainstream different habits or trends (e.g. helicopter parenting), and one feels odd if one doesn't conform to those trends. Humans are not the only animals who intensively protect, nurture, and train their young for survival skills. This relationship involves intimacy and close surveillance because the young cannot take care of themselves. The care of offspring is about the future, but I believe cultural norms make this "care" evolve into "attachment" in such a way that neither parents nor children can let go. Our mothering intuition, the instincts we share with these mama animals to take care of the young, are no longer the main driving force when we are taking care of children. It is rather a mixture of trends, popular culture, and political economy (of baby gear and baby care) that shapes how we surveil ourselves.

SH You're working on a chapter in a book titled *Environmental Activism and the Maternal*. Your chapter is called "Access to Healthy and Clean Food in Turkey: Food Activism and Mothers' Concerns about Shopping for Change." How did you become interested in this topic?

NURCAN ATALAN-HELICKE is an Associate Professor of Environmental Studies and Sciences at Skidmore College. Her research draws on political ecology and political economy literature, and seeks to explain structural factors that affect access to knowledge and resources and, consequently, the resilience and sustainability of food and agricultural systems. Her research has been published in interdisciplinary peer reviewed journals such as *Agriculture and Human Values*, *Journal of Environmental Studies and Sciences*, *Global Environmental Politics*, and *Gastronomica*.

NAH I'm an interdisciplinary social scientist. After working for Turkey's leading rural development agency in the Southeast Anatolia region bordering Iraq and Syria on environmental education and rural development, I worked with nonprofit organizations and their environmental education and cultural rehabilitation projects funded by international organizations. I was in graduate school in the U.S. when the 2007–2008 economic crisis and food crisis happened. At that time, I was writing a dissertation on how small farmers make their decisions about seed saving and cultivation, particularly ten-thousand-year-old wheat varieties, amid global economic policies and national legislative changes. My fieldwork has always been with small farmers in rural areas, and this is a new area of research for me.

I grew up in Turkey, and my family still resides in Turkey. I came to this project while I was doing research on Islam and genetically engineered food. I came across material prepared by both secular and Islamic organizations in Turkey that make women/mothers responsible for choosing "clean" and "healthy" food. In this case, women are asked to avoid "genetically engineered food." Despite their differences (secular vs. devout Muslim) in values, these secular and Islamic organizations focused on mothers as if women had the power to choose non-genetically engineered food, which these organizations defined as "clean." Yet, there is no labeling of genetically engineered food in Turkey. My findings also show that women do not do the food shopping, and even working women often do not have the power to decide how their salaries will be spent.

SH How did you go about finding your subjects?

NAH I did focus groups with mothers in two different cities in summer 2015, to reach out to women who define themselves as secular or devout Muslim. I used word-of-mouth and Internet mothering groups to recruit participants. I reached out to my family, friends, and colleagues to help organize the meetings. They reached out to their own friends, opened their homes, and helped me find kid-friendly places to organize the meetings and arrange child care. I provided snacks during focus group meetings, and child care, although I did not compensate for the time of the participants. The conversations ended with my small presentation on what genetically engineered food is and its regulation in Turkey, and answering participants' questions. Focus groups are used in feminist research. Sharing experiences works as an empowerment tool (women realize they know more than they are often told) and as a bonding opportunity (women realize they have more similarities across class, ethnicity, religious lines than they are often told). In Turkey, the secular–devout Muslim divide has been ingrained in social and cultural norms since the establishment of the country in 1923. However, it has been accentuated under the current pro-Islamic government that has been in power since 2002. Indeed, the current government has attempted to redefine the role of women in society on different occasions and encouraged every woman to make three babies to show patriotism for the country. These remarks have polarized the society between the supporters of the government and the secular critics. In the focus groups, I wanted to assess whether there were differences in concerns about access to clean and healthy food among secular and devout women, and how feeding the family creates anxieties that intersect with class, ethnicity, and religious lines in Turkey.

SH What were your findings about the impact of surveillance on these women tasked with feeding their families?

NAH My book chapter talks about this in detail. Here is a list to summarize some of my points:

Kitchen work or feeding the family is gendered. Even in economically developed, secular, less patriarchal societies, feeding the family is still perceived as women's work. Thus, the working woman is subject to an increasing burden while making choices for feeding the family.

Studies done by marketing, business, and food studies scholars show that women and men make different food choices. It can be due to earlier involvement of females in food activities in the kitchen helping moms, compared to males, which involve a more direct and knowledgeable contact with food. The assumption is that such habits and preferences are further enhanced by the traditional roles of motherhood and family caregiving that affect women's sustainable consumption practices— women are more likely to choose organic food and spend more money on "healthy" food.

Women are held morally responsible by the state, religious authorities, and doctors to raise a healthy generation. Particularly with the obesity epidemic research, there is a growing emphasis on women's shopping practices and how women (mothers) are feeding their families. Celebrity chefs, public pedagogues, moral entrepreneurs, have risen to increasing prominence in recent years and provide culinary guidance, lifestyle advice, and aim to address the alleged deficit in consumer knowledge. These experts in the media also make women responsible for the body size of their children.

The internalization of intensive mothering norms and helicopter parenting under neoliberalism has also created mothers that are labeled as "eco-moms." In mothering blogs and other online platforms, mothers share recipes and child care advice, but they are also subject to peer-surveillance. They are subject to mom-shaming; they feel the pressure "to keep up with the Joneses" in these mommy play groups, intimidated into buying the newest breastfeeding machine or the healthiest baby food.

Surveillance of mothers is not uncommon and there is a growing literature about surveillance and breastfeeding, mothering, mental health, and surveillance. What is new and different is the extension of these surveillance mechanisms into everyday life through food, and the internalization of some of these mechanisms by women that leads to stress, guilt, and anxiety.

SH *Moral entrepreneur* is a new term for me! And it so aptly describes the way that there can be a consumer demand for authorities to shame us. I'm interested in the internalization that you speak about. What has your experience with other mothers been? Have you felt your relationship with other mothers to be supportive or do you feel watched?

NAH We were lucky when our daughter was growing up. From the time she was three months old, until about three years old, we attended parent-support meeting groups. There was a state-level parenting support system for hard-of-hearing/deaf kids. Unfortunately, many of these programs in the U.S. were abolished following the financial crisis and ended in 2010 or 2011. We were able to meet with other parents whose kids are deaf or hard-of-hearing (at different ages) and be accompanied by a psychologist. These were called playgroups, and part of our daughter's speech therapy sessions. We learned a lot from observing other parents and their interactions with their kids, the kids' interactions with each other,

talking with other parents (mainly mothers) and a psychologist afterwards (during the first twelve months). I never felt judged and it was a great opportunity. Our interactions with our daughter were also watched by other parents and the speech therapist. I felt it was supportive. We were living in Columbus, Ohio, until our daughter was three years old. There was a large Turkish immigrant community, and there were at least five mothers whose kids were born around the same time our daughter was born. It is common among Turkish women to get together during the day while their husbands are working, have tea, eat cookies and pastries. We would meet with these mothers every other week. The kids would play and interact, and as mothers we would share their developmental stages or our concerns. We could also observe each other and interactions with other kids. I did not feel judged in this environment either. But as I explained, we had to visit the doctors several times to figure out the reason for our daughter's hearing loss. Hearing loss can be linked to heart failure, kidney problems, and blindness, and doctors wanted to rule out these reasons. So our daughter did go through several tests while I was visiting different doctors, or we were visited by social workers to rule out whether I did anything wrong during my pregnancy. It was very intimate and invasive. At three months, our daughter was fitted with hearing aids. For a baby with moderate hearing loss in one ear and moderately severe hearing loss in the other one, having hearing aids meant being in a disco. So, she did not move any of her limbs for three weeks. It was scary but the doctor said it was normal! For a baby, three weeks is a long time not working on gross motor skills. So, at five and a half months, when the social worker came to our house to test her development, he wrote that she was "delayed" because she couldn't roll. We explained that she is a big baby—97th percentile—who had a surgery at ten weeks, one sedation and brain MR imaging at five months, and is still adjusting to hearing aids. However, the social worker's observation was shared with her daycare center and all other doctors. I was really upset at that point and cried because I believed that nobody was listening to us. They were just surveilling her based on their lists of what a normal kid should do, and expecting us to follow up based on their assessments.

SH It sounds like the other mothers were a source of support and it was the "caring" professions that judged you and wouldn't listen. Jumping back, how influential do you think media outlets are in perpetuating a need for perfection in mothering/parenting?

NAH I have read parenting books, blogs, and social media regularly since 2014 for my research on access to clean and healthy food. I look at cultural and religious nuances, as well as how norms about good mothering are used to perpetuate traditional gender roles. For example, feeding the child organic and healthy food can be an excuse for keeping mothers out of the job market or increasing the double burden on women and keeping their workload in the kitchen. Standards about perfection also create anxieties and guilt among mothers. In cases where these are internalized, they can also be used by ideological political systems to maintain traditional gender roles. My research is about Turkey, and examines the interaction between Muslim conservative government policies and mothering. However, if you are in the United States, you may be familiar with stories of "tradwives," a group of young white wives extolling the virtues of staying at home, submitting to male leadership, bearing lots of children, and perpetuating these ideas through the Internet and social media about a certain perspective on white nationalism. These stories also point to the emphasis on traditional gender roles and how they are used by different ideologies to keep women out of power, both in economics and politics.

SH And what about the role of self-surveillance and surveillance of others in perpetuating these ideals?

NAH Women internalize norms about perfection and feel guilty or anxious all the time. They often feel overwhelmed when/if they don't make the right choices for their kids. For example, in feeding their children healthy food, mothering blogs and social media perpetuate ideas about what counts as healthy food. However, these do not take into account budgetary constraints, time constraints, or access to food through markets. Particularly under our current capitalist environment, motherhood is commercialized, and women feel judged if they are not buying the right products. All women want to purchase the best products to be a "good mother." Yet it is not easy to make the right choices, and buying the right products is an ever-changing goal. Thus, in my work, I believe that there is no right choice. Every choice comes as a "heavy burden." What surveillance of mothers does is to make these burdens invisible, and blame the individual for failing to ever make the right choices.

This conversation took place over email.

Following page:
Laura Fong Prosper, *MATER*, 2020.
Video (color, sound), 4:30 min.

The Terrible Two

MAGDALENA KALLENBERGER

Extracts of nightly monologues by a temporary single mother. Her son was born in 2014 in Cairo. The father left in the summer of 2016. During the following years, the mother used a messenger app to send news and updates to the father, who rarely responded in a timely manner due to the time difference and his tight work schedule. The communication tool became a self-monitoring device to document and record the daily activities and sleeping routine of the two-year-old and consequently the effects on the emotional state of the mother. As Franz Kafka wrote on November 7th, 1921, "The inescapable duty to observe oneself: if someone else is observing me, naturally I have to observe myself too; if none observes me, I have to observe myself all the closer."[1]

Protagonists: The mother, the father (F), and the two-year-old son (S or Mr. S)

Sunday, April 2

> I have been up 4 times with Mr. S.
>
> 04:44 am

> How can I recover like this?
>
> 04:45 am

> Maybe I have to be more strict with him. I had so many crazy dreams and it sometimes frightens me, that this is our life.
>
> 08:22 am

> And then the desperation of these art world people and my friend saying it might be better for me if I don't work full-time at the university anymore and instead focus on my own stuff teaching will not get me anywhere. A new job blah blah—all these things are frightening when you are sick. And I got skinnier again because I am not eating much, which is partly because of the medicine, but mostly because of stress I assume.
>
> 08:29 am

[1] Franz Kafka, *The Diaries of Franz Kafka, 1914–23* (London: Secker & Warburg, 1949), 200.

The Terrible Two – Magdalena Kallenberger

Thursday, April 6

S. is stealing my sleep for the last 2.5 hours. I could kill him.

03:50 am

He's been up since 1:15.

03:50 am

You are so lucky that you are far away.

03:51 am

Such a fucking nightmare. If you were any closer, I would say you have to come immediately and take over. It is 9:30 am and I just left the house, the class starts in 30 minutes and the university is super far away. It seems like I lost my wallet on the way from the car to the house yesterday and the security guy just said: it is gone. Fuck. All my money, plus all cards, university card, credit card etc all gone. I don't know if I will be able to enter campus at all. And Mr. S. drove me crazy all night, so I would be really happy to hand him over and hide in a room until I got some sleep and my wallet is found.

09:36 am

Thursday, April 20

I don't think we could have picked a worse time for me to take care of him alone than between the ages of 2–4. Maybe directly after birth, but definitely this time alone is far too long.

08:05 am

Friday, April 21

There is absolutely zero expression for how much I hate it to be alone with Mr. S. It takes all my energy and I cannot stop crying from being so worn out. When we were on holiday my digestion was completely ok, since we are back—nothing. A clear sign that it is just NOT good. And I am sorry for Mr. S. It is not his fault.

07:36 am

Magdalena Kallenberger, *The Terrible Two*, 2019. Photograph, dimensions variable

We have been up for 3 hours and there is still an hour to go until the babysitter comes. I have to go to work. Kills me.

07:47 am

BTW. I don't need advice on how to manage better—I need a father who does his part of the job: personally, financially and emotionally. That's what's wrong, not me.

03:24 pm

That's why I really don't want to talk to you anymore—just makes me upset. Every fucking single time.

03:33 pm

Mr. S just passed out after 3h of tantrums.

06:12 pm

Maybe I should start smoking weed again to relax or to knock myself out after he is done?

06:12 pm

Today in the supermarket: even I was embarrassed for having such a dirty child, not listening at all, not wearing shoes, wild, screaming on the floor.

06:16 pm

Wednesday, April 26

Since June there was barely any minute where we talked about my job and still you think you know what's going on? That's embarrassing. Should be embarrassing for you.

07:54 am

No need to talk anymore.

08:22 am

Thursday, April 27

So no call. Everything in your world is far too important.

01:43 am

S. did not sleep half of the night, neither did I. He wanted to be held from 1–4am till I freaked out and put him back in his bed. Now he is still sleeping, but I have to go to work and "make a good face."

07:58 am

So thank you for not being there for us. I definitely should soon be ready to understand that I am on my own. The year since you left was pretty much fucked up.

08:01 am

Thank you F. for making that clear through your actions and non-actions.

08:02 am

I don't understand what made me believe for such a long time that you are committed to us.

08:11 am

Sunday, April 30

Are you awake?

12:42 pm

S. is so super difficult, I still did not manage to send him to nursery, because I just cannot get his clothes on.

12:43 pm

F., I know, you have the end of the semester stress, but S. and I are not a good combination these days. It is kind of toxic and I see changes in my behavior and his that are not good. Today, didn't get him to the nursery until 1:30, because I could not put any clothes on him. If he does not get what he wants, he beats himself. Where does this come from? I guess I am yelling and screaming too much. It is just not good. And this crazy lack of sleep, being close, having body contact with me all the time or resisting anything I say, drives me (and him) CRAZY. It is just not a healthy development for either of us.

01:34 pm

109

Monday, May 1

> S. is asleep, we are home, and had a good day. But my nerves are fried and I immediately freak out if he does not listen. Remember in what kind of bad shape my friend M. was with her son last year? Because of no sleep, him being difficult and his father never present. You even had to jump in because her son did not listen to her? That's me now. After we arrived at her place I was crying and had to rest on the sofa for a while to recover.
> It's this special age. The terrible twos. So difficult.

9:08 pm

In the first two years as a new mother, writing mutated into a method of survival and a self-monitoring tool in the struggle to stay sane and combat the fear of drowning and losing myself. In these online monologues, the absent father transformed into an idle, vestigial, hypothetical addressee, who got awarded the role of both the accused and the only witness assigned with the unbidden task to observe and presumably intervene in these scenes. In this regard, writing became a self-surveillance device to document and gather evidence in case of a presumably (un)announced crime or act of (self-)violation to be performed and executed at an impending point in time.

Following pages:
Sophie Hamacher, *Drawing on the History of Gestation* and *Hands and Body Parts*, 2021.
Found images, ink, and tape on paper

Tab. IIII.

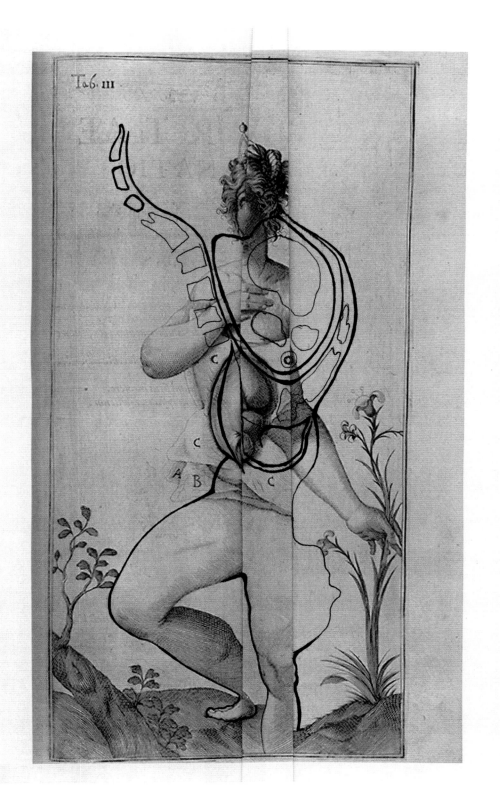

Tab. III

y an

cl
lack
techniqu
d emotion
gt for

hange in 1
e instrumen
leep regulatio
y monitors/su
ur approach to
ed?
monitor rather th

1/2

feelings or the signs
are

3/27/2019

MR1
ima
L

10/10/2018

...lISH7ZKB3DN4lPfxkb7ogrc32

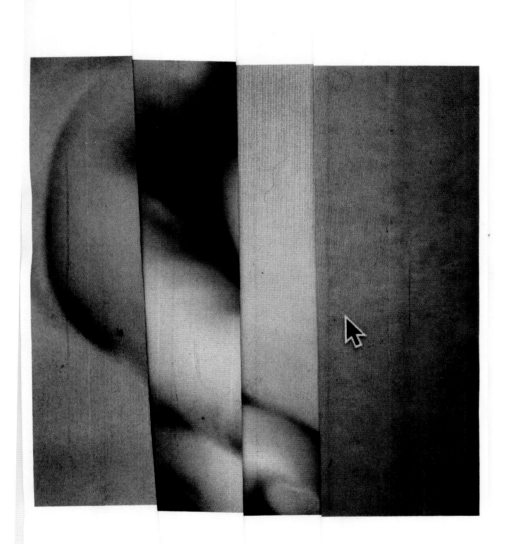

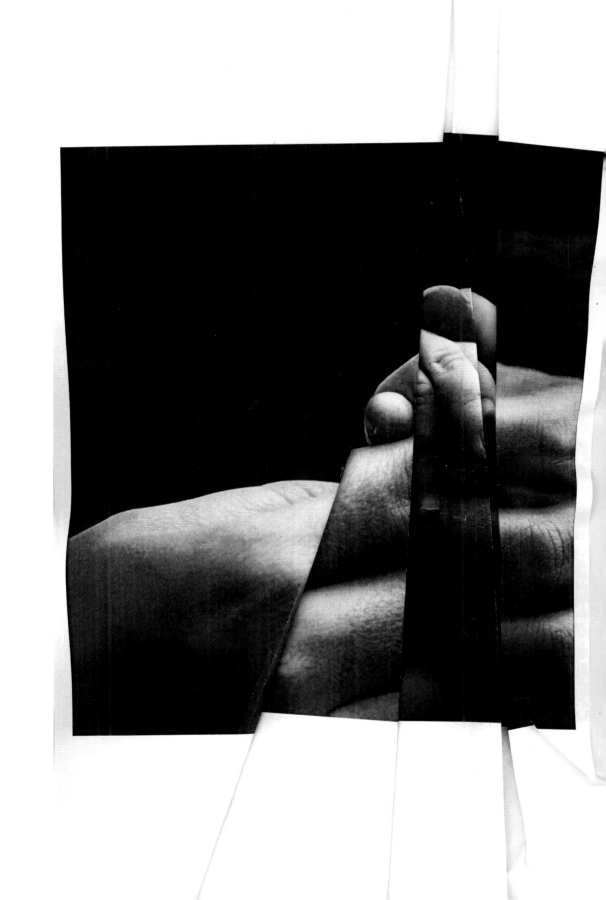

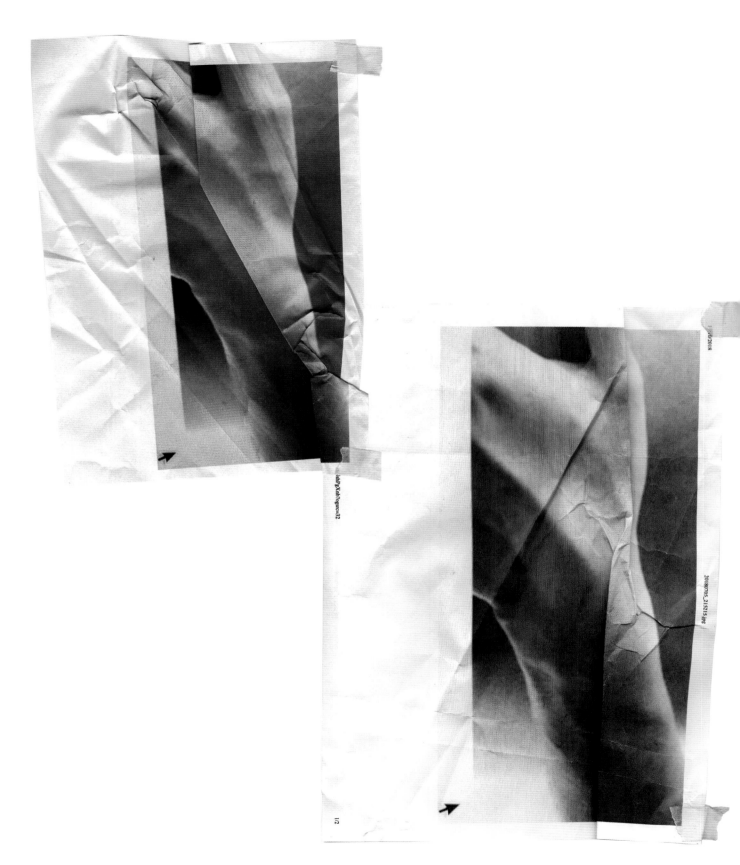

Drawing on the History of Gestation
(pages 111–117)

A number of sixteenth- and seventeenth-century midwifery manuals trace their origins back to Soranus, a second-century CE Greek physician.[1] Historically, the female *gravida* (pregnant) figure was generally depicted sitting or standing with an opened abdomen that revealed a fetus and placenta. In other cases, diagrams depict a floating uterus on its own: a snapshot illustrating the reproductive system and baby's development without reference to the mother in which this arrangement and organism are hosted. The male body was used to explain the rest of the totality of standardized human anatomy and was employed in anatomical representation of disease, malformations, and illness. Until the eighteenth century, the female body was never really examined at length in Europe, at least not in the medical realm.[2] Pregnancy and childbirth were considered to belong to the domestic sphere: women gave birth in their homes and were attended to by other women—midwives, family, and friends. This changed when, in the second half of the eighteenth century, two obstetric atlases published in England were instrumental in moving childbirth from the domestic to the medical realm. Art historian Lyle Massey offers an illuminating description and analysis of these atlases: "Stark, brutal, and fetishistically naturalistic, these eighteenth-century obstetric images medicalized and pathologized childbirth in an unprecedented way."[3] The way in which these representations of the maternal have been accepted and regulated throughout Western medical history is linked to the ways childbirth has been controlled, mechanized, and pathologized.

The images I am working with here are drawn from Spiegel's *De Formato Foetu Liber Singularis* (1626), Jan van Riemsdyk's drawings in William Hunter's *Anatomia Uteri Human Gravidi* (1774), Jacques Fabien Gautier D'Agoty's *Anatomie des parties de la génération de l'homme et de la femme* (1773), and *The Stages in Pregnancy as represented by the growth of the womb* by Jacques Pierre Maygrier (1822–27). My interventions represent a quasi-dissection; the act of folding, refolding, and unfolding is a restitching of the female body, and a reconstruction of its landscape.

Representations of the mother in medicine have been dominated by white Western epistemologies. During the process of working with these representations, I was often struck by how thoroughly patriarchal domination had been written onto the understanding and depiction of female bodily processes and how these images coincide with the development and growth of European colonial economies and their supporting racist ideologies. The process of reexamining the history of maternal representation reveals how entangled it is with social, economic, psychological, and political realities.

Hands and Body Parts
(pages 118–122)

When I type the word *motherhood* into a Google image search, I am presented with thousands of Hallmark-style impressions: adult hands holding tiny hands, tiny fingers clutching *mommy* fingers, *mommies* holding babies silhouetted against sunsets, adult hands forming hearts while clasping tiny feet, pink hearts, hands on hands on pregnant bellies, noses touching. Most are trite and cliché representations of love. Sometimes a Mary Cassatt painting also makes the list. The trope that strikes me is the persistent hands: hundreds of hands, tiny and large, all serving as ambassadors for an experience of care, intimacy, and ultimately love. The violence in these images lies in their exclusions—their claim to portray the entirety of the experiences of motherhood. Am I meant to identify, connect, and agree with these representations? They are featured because of an algorithm that is supposedly tailored to me based on my Internet habits.

My images here are about surveillance, but they also *are* surveillance of the act of searching through the Internet and being surveilled by its algorithms. The origin of these images, the fact that the source of my archive is the Internet, is as important to me as the screen and its pixels and the degradation of the image. Sometimes a mouse is left hovering, often the printouts are streaky or faded due to low ink or toner supply. Then, I fold and wrinkle to distort, to shroud, to cloak.

—Sophie Hamacher

[1] Lyle Massey, "Pregnancy and Pathology: Picturing Childbirth in Eighteenth-Century Obstetric Atlases," The *Art Bulletin* 87, No. 1 (March 2005): 75.

[2] Massey, *Pregnancy*, 75.

[3] Massey, *Pregnancy*, 73.

Looking at our mothers[1]

IMAN MERSAL

What is it you see, or don't see, in a picture of a mother who belongs to you? Put another way, how do you see your mother in her picture? Is she visible and clear; can you truly grasp her? Do you see her differently because she carries with her a history or memories or a weight or details that others will not see as they page through your family album, or press "like" on Facebook or Instagram simply because the image is "beautiful" or "amusing" or "comprehensible"?

The response to questions such as these will be as various as the individuals who answer them, but why do I assume that it is always easy to find our mothers in their portraits? Is it not possible that the history and memories and details we share with them are a burden, functioning as a sheet or curtain that hides them from us? Isn't knowledge—as per the dictum of early medieval Arab mystic al-Niffari—a veil?

Roland Barthes questioned what he knew about photography and his answer was as follows:

> I observed that a photograph can be the object of three practices (or of three emotions, or of three intentions): to do, to undergo, to look. The Operator is the Photographer. The Spectator's ourselves, all of us who glance through collections of photographs—in magazines and newspapers, in books, albums, archives . . . And the person or thing photographed is the target, the referent, a kind of little simulacrum, any eidolon emitted by the object, which I should like to call the Spectrum of the Photograph, because this word retains, through its root, a relation to "spectacle" and adds to it that rather terrible thing which is there in every photograph: the return of the dead.[2]

Following Barthes a step further I would suggest that, as you look at an image of yours, an image of motherhood that concerns you personally, you are neither operator nor spectator, you are not the child in the photograph nor the mother that holds the child on her lap. You are the relationship that links you both, the relationship that is erased or hidden or even excluded from the picture itself.

Your portrait with your mother is a moment, a moment entangled with your personal narrative about her: the liminal stage of unity and separation from when you were inside her, then your birth, then the love or conflict or parting (or whatever it may be) that follows.

[1] This is an excerpt from *How to Mend: Motherhood and its Ghosts* (2018).

[2] Roland Barthes, *Camera Lucida: Reflections on Photography*, (New York: Hill & Wang, 1981), 9.

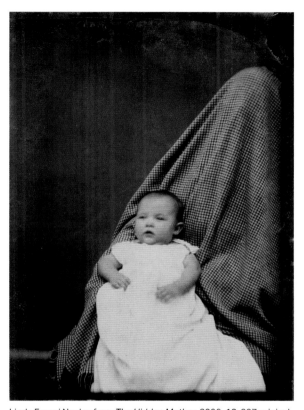

Linda Fregni Nagler, from *The Hidden Mother*, 2006–13. 997 original tintypes and albumen prints

In images from the dominant narrative we confront the mothers of other people: conspicuous, clear, standardized, comprehensible. In their portraits, our mothers cannot be standardized or banal. And though images of the instrumentalized mother can provoke us to take another look or even stare at times (the image's symbolism, the presence of an accompanying narrative, its oddity), our mothers require a journey in the opposite direction if they are to be seen.

It is a journey towards what has been excluded from the image, what it has failed to hold, what cannot be given or displayed within the frame. In other words, "my mother," in her picture, cannot be standardized or banal, visible or invisible. I know that, in that moment, she was there before the lens, spectrum and spectacle, but my knowledge of her outside the frame conceals her from me. Unlike those mothers hidden behind a sheet or curtain it is not easy to find her outline. She requires a journey inside, a journey to save her from becoming a ghost or a silhouette, to save her from the absence that is the proposition of every image.

In view of the response just made, how do we explain this to the American people?

You have been going all around the country speaking against aliens occupying jobs and now we might be stuck with 150,000 or 200,000 people which would tend to aggravate that problem, even though we admit them with the most humanitarian purposes in mind.

General CHAPMAN. Well, sir, if we could get rid of the illegals, it would open up a considerable number of slots. Well, we would have to do it on humanitarian grounds, and a sense of obligational grounds to these people, well recognizing that the impacts, if the numbers are very large, could be very serious. It would cost a lot of money for HEW to support them as they did the Cubans, initially.

Mr. EILBERG. You recognize the inconsistency involved if this committee, through the exercise of parole, is about to admit that large number of aliens, even though they are being paroled, and the inconsistency of the established situation even though the bulk of so many of those are illegals.

The following is a transcript of the text in the laser cut detail above, which is excerpted from U.S. congressional hearings of the 1970s:

In view of the response just made, how do we explain this to the American people?

You have been going all around the country speaking against aliens occupying jobs and now we might be stuck with 150,000 or 200,000 people which would tend to aggravate that problem, even though we admit them with the most humanitarian purposes in mind.

General CHAPMAN. Well, sir, if we could get rid of the illegals, it would open up a considerable number of slots. Well, we would have to do it on humanitarian grounds, and a sense of obligational grounds to these people, well recognizing that the impacts, if the numbers are very large, could be very serious. It would cost a lot of money for HEW to support them as they did the Cubans, initially.

Mr. EILBERG. You recognize the inconsistency involved if this committee, through the exercise of parole, is about to admit that large number of aliens, even though they are being paroled, and the inconsistency of the established situation even though the bulk of so many of those are illegals.

Hương Ngô and Hồng-Ân Trương, *The opposite of looking is not invisibility. The opposite of yellow is not gold*, 2016. Installation with framed archival pigment prints, laser cut prints

The Evanesced:
Embodied Disappearance
[Shifting Spectators to Witness]

KENYATTA A.C. HINKLE

The following is a meditation of sorts on the harms of surveillance and its role as a conduit within my artistic practice—especially as it pertains to missing and murdered Black womxn, high infant and maternal death rates, and the residue that this tremendous loss of lives leaves in its wake. This meditation is inspired by the loss of Korryn Gaines and Kira Johnson, and keeps in mind the immense pain of Diamond Reynolds, who witnessed the murder of her partner by a Minnesota police officer while filming it live on Facebook. I ask what it means to be both hypersurveilled and undersurveilled. I use the term *undersurveillance* to point to the blind eye our society turns towards its most vulnerable populations, especially Black femme sex workers and mothers, in their quest for justice and preventative care. I ask how this juxtaposition can be used within the white cube of the gallery or museum as a call to action, to raise consciousness and to shift audiences from spectators to witnesses. Within this body of work, the year 2016 in American history becomes a character, a reaper of sorts, and a marker of the past, present, and future.

The Hypersurveilled: Methodologies of Countersurveillance

> I walk alone except for the eyes that join me on my journey. Eyes that do not recognize me, eyes that examine me for a tail, an extra teat, a man's whip between my legs. Wondering eyes that stare and decide if my navel is in the right place, if my knees bend backward like the forelegs of a dog. They want to see if my tongue is split like a snake's or if my teeth are filing to points to chew them up. To know if I can spring out of darkness and bite.[1]

Since I encountered it in 2008, this quote by my all-time favorite author, Toni Morrison, from her novel *A Mercy*, has become a major framing device, not only for my investigations as an interdisciplinary visual artist, but for many of my lived experiences as well. As my work concerns itself more and more explicitly with the hypersurveillance of Black femme bodies, I have leaned increasingly into Morrison's description of the fine line between fetishism, repulsion, and desire that our bodies continually walk.

I have spent over a decade developing language to talk about the surveillance of Black femmes in my artistic production and my lived experience of this

[1] Toni Morrison, *A Mercy* (New York: Knopf Doubleday, 2008), 135.

hyperpolicing reaches back even further. When I was pregnant with my child, my awareness of my body as a contested site of mystery and spectacle became profound. On several occasions I was denied access to public bathrooms, or to a seat in a crowded Starbucks. During an ER visit for a bladder infection that developed two weeks after giving birth, the attending nurses required me to take a pregnancy test despite my vehement protestations that I could not be pregnant. The lack of care that I experienced as a Black pregnant femme exemplified these forms of hyper- and undersurveillance. These consistent experiences created a charged tension throughout my maternity about how I could expect to be treated and what kind of society the Black child I carried would have to enter into. My child would either be constantly scrutinized as a potential threat to society or assumed to have magical athletic prowess and brute strength. As a Black man one is either hypersurveilled for criminality and athletic ability or undersurveilled for physical, mental, and spiritual well-being. Within my work I examine how Black womxn fall into these same constructs and are forced to navigate these expectations of performative roles.

My practice is entrenched in something I like to call "The Historical Present," in which one cannot imagine the future without deeply examining the impact of the past on our current moment in time. I am interested in how the notion of "the gaze," so ubiquitous in art history and feminist theory, pertains to Black femme bodies and the objectification, control, and fetishization to which they have historically been subjected. Working with found colonial postcards, archival images of unknown femme figures, and documentation of my own body, I try to construct a new space for viewership while shifting the unhealthy power dynamics of surveillance within which the Black femme body is placed. I interrupt colonial photographs, allowing their "subjects" to stare back at the viewer rather than be passively consumed. Within my work, I ask, what does it mean to emerge from erasure? What does it mean to dwell in a body that is simultaneously hypersurveilled and undersurveilled?

2016 was a year marked by the spectacle of Black and brown deaths, replayed over and over via social media, and by the massive outpouring of grief for so many lives impacted by hate crimes, legal kidnappings, and state-sanctioned violence. As I watched police officers escape punishment for actions that were caught on camera, I learned in a much deeper way the role of surveillance in our lives as Black subjects of the gaze—that our ability to take up technology and to document would not bring about the witnessing that we intended. I remember getting into a disagreement on Facebook with an elder who said that it was important for these images to be circulated, for us to see Alton Sterling's body on the cover of the *New York Post* in order to show the reality of our nation. But why deny Alton his dignity in death, I argued, just to expose the violence that so many of us already know for ourselves?

The continued circulation and spectacle of Black death was not born from contemporary usage of social media platforms. Beginning in the late nineteenth century, in the heat of the call for anti-lynching laws, white supremacists began commissioning photographers to document lynchings. These images were then distributed on postcards as emblems of white power. Here mass distribution only served to commodify the torture of the already hypersurveilled Black body while desensitizing white viewers to the visual evidence of injustice. The images of the 1955 murder of Emmett Till, however, show that Black people were able, in some instances, to circulate counter images to reverse the spectacle of white supremacy. Mamie Till-Mobley galvanized an entire nation by holding an open-casket funeral for her fourteen-year-old son, Emmett Till, after he was murdered by white supremacists in Money, Mississippi, for allegedly whistling at a white woman.[2]

[2] Carolyn Bryant, the white accuser of the fourteen-year-old Emmet Till, has since admitted to fabricating the incident. Richard Pérez-Peña, "Woman Linked to 1955 Emmett Till Murder Tells Historian Her Claims Were False," the *New York Times*, January 27, 2017, https://www.nytimes.com/2017/01/27/us/emmett-till-lynching-carolyn-bryant-donham.html.

Till-Mobley had photographs of Emmett's mutilated body printed in *Jet* magazine, where they would circulate all over the nation, bearing witness to the horrors of racial injustice in the South and effectively giving birth to the Civil Rights Movement. It seems as if, after witnessing this gruesomely murdered child in a casket, we exhausted the power of witnessing the boundlessness of white supremacist hatred. Photographs thereafter morph into almost replicating the racist violence and psychological damage, even when the intention is still to bring awareness. Till's photograph exposed the aftermath of a violent injustice that Black people in the south knew too well. Contemporary documentation of Black death in real time, played out via social media and within the news, creates a numbing effect and actually continues to re-trigger people who are the targets of the injustices instead of informing us that yes, this brutality continues. In 2016, I kept asking myself, "Awareness for whom and why?"

Now that military and surveillance technologies have been integrated into our daily lives, I wonder how the spectacle of Black death will change. I wonder how the capture and replication of moments of violence and duress feed sentiments about the disposability of Black bodies. Does the daily onslaught of horrific images make us less or more hesitant to capture on camera—to become both subjects and instruments of the hypersurveillance machine?

I am haunted by the cell phone footage that Korryn Gaines, a twenty-three-year-old mother from Baltimore, posted to social media showing the persistent harassment she faced at the hands of the police. In addition to documenting each time that she was pulled over for a traffic violation, Gaines live-streamed a six-hour standoff with Maryland police officers at her home in 2016. Instead of trying to de-escalate the situation or disarm Gaines, police wrongfully fired first, murdering her in front of her five-year-old son, Kodi, whom they also wounded in the shootout.[3] What happens when surveillance captures society's careless treatment of Black mothers?

Korryn's parenting was repeatedly questioned by the officers who stopped her, saying she shouldn't argue with them while her children were in the back seat. On social media she was demonized as a bad mother in the name of respectability politics, including by other Black people wanting to show that staying in line with the hegemonic status quo would have kept her safe.

I think about Diamond Reynolds, who broadcast the murder of her partner, Philando Castile, via Facebook Live. Like Korryn, Philando had a history of being excessively surveilled by police, having been stopped forty-six times between 2002 and 2016. Unlike Korryn, Philando was "respectful" in his interactions with police and careful to follow protocol. Yet he was still murdered in front of his family during a traffic stop for a broken taillight; after he was misidentified as a suspect in a robbery, he was shot while reaching for his wallet to produce a permit for a gun he had in the car.[4] Despite Philando being a legal gun owner in an open-carry state, the officer who shot him was found not guilty of all charges. The officer was not held responsible for endangering the lives of Diamond and her four-year-old daughter, who was sitting in the back seat, inches from where several bullets that passed through Philando's body were lodged.

It was important for both Korryn and Diamond to use their own methods of surveillance to document police wrongdoing and draw attention to the perpetual fear in which they lived. While their footage did galvanize our communities to come together in protest, it has yet to bring about a lasting societal reckoning over the lack of care shown to Black children and their parents. I am left with many

[3] Although the family of Korryn Gaines was initially awarded a settlement of $38 million in damages due to the wrongful use of excessive force in February 2018, that decision was overturned a year later by a Baltimore County judge citing the immunity of police officers from liability in civil court for the performance of their duties.

[4] Cheryl Corley and Eyder Peralta, "The Driving Life and Death of Philando Castile," *Morning Edition*, NPR, July 15, 2016.

questions. When evidence is dismissed and justice is not served, how effective can surveillance technology be when the camera is turned upon the perpetrators of white supremacist violence? Can countersurveillance transform us into witnesses or does it render us spectators? With Black bodies already deemed disposable, how can these technologies protect us? Do they protect anyone at all? What is the purpose of collecting data when that data cannot reliably be used to seek convictions? How is it used to blame us for our own deaths? How does this evidence or lack thereof leave us unrested, criminalized, and forever trapped within the continuous moments of our erasures?

The Undersurveilled: On Being a Ghost & Ghosted

As I grieved throughout 2016, a major shift began to occur within my practice. In August of that year, Lonnie David Franklin Jr. was convicted of killing ten womxn in South Central Los Angeles and sentenced to death. That same summer, I learned of Franklin's case from a documentary by British filmmakers Nick Broomfield, Barney Broomfield, and Marc Hoeferlin. Franklin, known also as the Grim Sleeper, is believed to have murdered more than one hundred womxn between 1984 and 2008. Much of the documentary focused on how Franklin was able to murder so many womxn in plain sight, preying on his victims and the community at large. *Tales of the Grim Sleeper* included interviews with Franklin's neighbors and friends, as well as with the sole survivor of his attacks.

Franklin would murder womxn and discard their bodies in alleys near his home for all to see. His targets were womxn who no one would come looking for—those surviving from sex work and addicted to drugs during the height of the crack cocaine epidemic of the mid-1980s. The lack of care for these Black mothers, sisters, aunts, and cousins, and the disbelief in their pain, meant that for decades there was no one there to ask questions, to send a squad car, to take a report, to set up security cameras on the block. The film uncovered the effects of hypersurveillance in marking Black femme bodies as criminal and sexually deviant, and of a complete lack of surveillance in regards to their well-being and safety. The more I learned about the failure of police to protect these womxn and their community, the more overwhelmed I became.

I kept thinking about all the ways that we become complicit in our own erasures when there is no expectation that justice will be served. Not only did the police department fail to protect over one hundred Black womxn from being disappeared, but the community itself turned a blind eye to the abductions. I thought about my own complicity and challenged myself in my work to become a channel, oscillating between the two polarities, hypersurveilled and undersurveilled.

In thinking about our own complicity in these erasures, I ask, how can we use surveillance without internalizing its function as a tool of systemic control? My work is aimed at revealing these tools, this authoritative gaze, exposing its power and how it fails to protect the vulnerable. I am also interested in what happens when we become this authority. What do we do with the information that we gather? Do we use it for justice on behalf of those who cannot seek it for themselves, or do we suppress it and uphold systematic positions of abuse and neglect? Foucault's suggestion that we, the surveilled, "become the principle of [our] own subjection" suggests the latter; the gaze cannot be reversed within the panopticon to look upon the guard. As someone who lives this reality, I disagree and use my art as a mirror that can capture the guard's reflection.[5]

[5] "He who is subjected to a field of visibility, and who knows it, assumes responsibility for the constraints of power; he makes them play spontaneously upon himself; he inscribes in himself the power relation in which he simultaneously plays both roles; he becomes the principle of his own subjection." Michel Foucault, *Discipline and Punish: The Birth of the Prison* (New York: Random House, 1977), 203.

Usually, the act of surveillance is associated with powers of the state, with criminality, racial profiling, and related ideologies of safety and dystopia. While I understand that many argue against surveillance as a tool for public safety because of the history of who has been deemed dangerous, I have also observed that anti-surveillance arguments within communities usually come from people who do not struggle with daily visibility. The question really is: how can we transform outdated and racist modes of surveillance and use them to ensure safety for all civilians? Here I am arguing for the technology that is usually used against Black femme bodies (to speak of their "inferiority") to instead be used in contexts where surveillance is expected as a tool of public safety (as when serial killers target Black femmes). It is a plea for the parameters of surveillance as a tool to be questioned and contended with, asking which bodies are afforded the benefits of state surveillance under the guise of safety and security, and which bodies are relegated to being ghosted.

The Evanesced: Embodied Disappearance

Lonnie David Franklin Jr. had amassed an archive of over one thousand photographs of his victims. I learned about this archive while I was living in Los Angeles and working on *The Uninvited* series, in which I interrupt the colonial gaze in erotic photo postcards of West African womxn that were distributed throughout Europe. In 2010, I conducted research in the Getty Museum's immense collection of colonial postcards and I was dumbfounded to realize that both Franklin and the Getty had amassed roughly the same number of photographs of Black femmes. One set of images was a civilian's private collection and the other was the property of a globally prominent archive, but both were created and used as instruments of power, dominance, and erasure.

I developed *The Evanesced* series in response to a commission by the California African American Museum's then deputy director and chief curator, Naima J. Keith, for a solo show in the spring of 2017. We met and discussed how haunting the case of the Grim Sleeper was and how I wanted to make work about these two parallel archives of unknown femmes. My extensive listening to early risqué dirty-blues songs by Black femme musicians also inspired my practice at this time. Precursors of hip hop, figures such as Lucille Bogan, Ma Rainey, Julia Lee, and Dinah Washington proudly sang about being queer, being sex workers, and being on the periphery of respectability. They also sang about Black womxn's relationship to mainstream standards of femininity and desirability during the Reconstruction and Prohibition eras. I began making my own paint brushes at this time, to speak to the resourcefulness of Black womxn in American history, and I would dance to this dirty-blues music and channel these drawings that I call "un-portraits."

The Black and Missing Foundation reported that in 2014 there were over sixty-four thousand Black womxn missing in America due to various forms of abuse, human trafficking, and domestic violence. I was astonished by this number, and every day I continue to learn about even more predators who target Black womxn. There is absolutely no way for me to know every single girl or woman who has been disappeared and for me this creates an insurmountable feeling of loss. In order to make a new body of work that spoke to these cases of rampant erasure, I no longer wanted to work from the archive of Lonnie David Franklin Jr., which was essentially collected as trophies of disappearance. I didn't want the womxn to be shrouded in victimization because I knew that there was so much more to their lives than how they ceased to be.

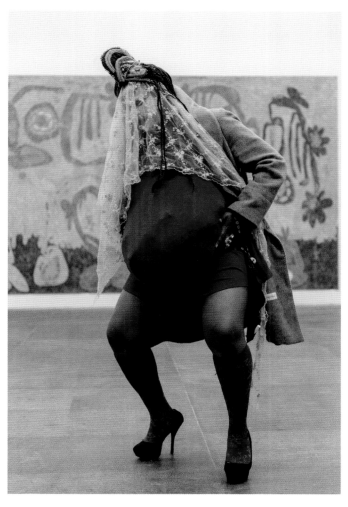

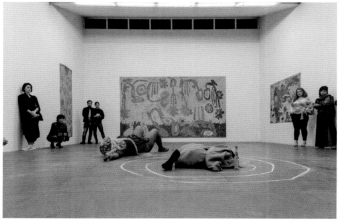

Kenyatta A.C. Hinkle, *The Evanesced: Embodied Disappearance* [Los Desaparecidos], 2018.
Performance at Páramo Galería, Guadalajara, Mexico

So, operating in a mode that has become near and dear to my practice, I went searching for the unknown and the unknowable. I began channeling the presences of these femmes, without judging whatever and whoever came out on the page, through the interplay of dance and drawing with handmade brushes. In a way, this gesture has become both of making and unmaking, of retrieving and receding from the gaze, and of being a body that is codified and framed through surveillance and these abuses.

The idea of being actively undersurveilled has become a beyond powerful vehicle of truth for me. Through becoming and accepting being a ghost (that can travel through walls across geographies, times, and contexts), I am able to take up space in ways that were previously unimaginable. This embodiment of movement and channeling also led to the creation of live performances in which I wanted to shift the audience's role from spectators to witnesses. The audience sees a Black femme body become a shapeshifter and an eradicator, taking up justice for itself beneath and inviting the gaze of others while remaining wholly unbothered by being both seen and unseen. I decided to use all of the assumptions already projected onto my Black femme body that have been codified for centuries, as a medium and a bringer of justice. But instead of justice for the living, I began seeking it for the dead. I also conceived this work in relation to the #SayHerName movement, which calls attention to police violence against Black womxn, girls, and femmes and "demands that their stories be integrated into calls for justice, policy responses to police violence, and media representations of police brutality."[6] My work began to talk about an *ethics of care*, as described by Sylvia Wynter and other Black feminists.

Thus far, within *The Evanesced* series, I have produced more than two hundred "un-portraits" and a suite of performances titled *The Evanesced: Embodied Disappearance* which have taken place at museums, galleries, and art spaces in Los Angeles, San Francisco, and Guadalajara, Mexico. Each performance has a theme, a mood, and an evocation as the spine of the work. In December of 2018, I performed *The Evanesced: Embodied Disappearance* at Páramo Galería in Guadalajara, in conjunction with the exhibition *New Suns* curated by Kris Kuramitsu.[7] The performance focused on the parallels between the high infant and maternal mortality rates of Black womxn in the United States and *los desaparecidos*, the thousands of children and adults from various cities throughout Mexico who have been "disappeared" in recent years. It was a meditation on giving life and life being usurped by unreconciled forces.

A spectator is one that watches, does not intervene, and gives an account from their memory that has more to do with their own expressions of power or being inconvenienced. A witness is one that recounts their memory on behalf of the victim in the name of justice. Within my performance work, I have developed a practice through which I aim to shift my viewers from spectators to witnesses. Not only is my role that of channel and witness, but I aim to counteract the design of the white cube by transforming it into a space of witnessing.

I seek to create a dynamic of unexpectedness and improvisation in which I often enter unannounced, wearing layered garments, not speaking to or making eye contact with the audience. I am a living ghost. I enter, I conjure with or without their energy or their gazes. Sometimes the spectators/witnesses circle around and sometimes they stay close to the walls, wanting to be undetected and for me not to engage them. In one performance, I made all of the visitors leave the gallery one by one with the gentle touch of my hand to allow for the dead to be able to take up space in the empty gallery. Often, when I am slated to present *The Evanesced: Embodied Disappearance*, I have no clue what I am going to do, who is going to come

[6] The #SayHerName campaign was launched in 2014 by the African American Policy Forum and Center for Intersectionality and Social Policy Studies, both think tanks of professor Kimberlé Crenshaw. "About #SayHerName," the African American Policy Forum, www.aapf.org/sayhername.

[7] *The Evanesced: Embodied Disappearance* has been performed at the California African American Museum, the Hammer Museum, Los Angeles Contemporary Exhibitions (LACE), the San Francisco Arts Commission, and the Charlie James Gallery in Los Angeles, among others.

through, and what the audience is going to witness. We are unpacking everything together as I crawl on concrete floors, stomp in high heels, snatch wigs off and replace them, or lie in the middle of the floor in a pool of my own sweat and exhaustion, conjuring, upturning, unnerving myself and the audience. It is a battle of being hyperseen and unseen, a bevy of eyes and emotions.

I often enter with a task in mind that is renegotiated through improvisation and the energy in the room. Within this suite of performances, I sometimes draw a spiral with white chalk on the ground as I respond to a sonic score that could involve prison work songs recorded by Alan Lomax from Parchman Farm in the 1940s, Zora Neal Hurston's voice, or some dirty-blues. The gallery becomes a context for me to take up heightened non-neutral space, I become a ghost underneath the gaze while interrupting it as a shapeshifter. I become both guard of the ideals of the gallery, as a charged space for concentrating on art, and a channel for the stories of the evanesced from within and now outside of our society. I become a ghost that has to be contended with, in which visual surveillance is mediated and must be reflected upon.

A Call for Surveillance in Relationship to Health and Preventative Care

For the performance in Guadalajara, I chose to focus on the alarming mortality rate of Black womxn during childbirth. I had become engrossed in the story of Charles Johnson IV, founder of the maternity health advocacy group 4Kira4Moms, whose wife Kira died while giving birth to their second child in 2016 (the year that continues to haunt me). Johnson spoke before the U.S. Senate on September 27, 2018 in support of the Preventing Maternal Deaths Act of 2018, describing the extreme negligence of doctors at Cedars-Sinai Medical Center, Los Angeles, in responding to complications that arose from his wife's routine C-section. Ignoring his pleas and her worsening condition, they repeatedly delayed a necessary CT scan and Kira bled to death eleven hours after delivering their son, Langston, with three liters of blood in her abdomen.

From this case, I learned that Black womxn are 243 percent more likely to die from pregnancy or childbirth-related complications than white womxn. I began to find thousands of stories about Black mothers dying in labor or losing their babies due to the irresponsibility of healthcare providers who do not believe Black womxn's pain. I cannot help but think about Kira Johnson and her husband, pleading to have her body scanned in a society that regularly uses surveillance technology without permission in the name of safety and theft prevention. Many Black womxn activists are calling to be cared for in the same way that white womxn and their children are cared for. What if the same resources that go into "protecting" assets, institutions, and ideologies went into the care and supervision of pregnant Black womxn and their children?

We must talk about how this crisis is rooted in a deep history of racism. A passage from a recent *New York Times Magazine* cover story about the growing disparity in death rates for Black mothers and their babies haunts me: "For Black women in America, an inescapable atmosphere of societal and systemic racism can create a kind of toxic physiological stress, resulting in conditions—including hypertension and preeclampsia—that lead directly to higher rates of infant and maternal death."[8] Furthermore, "Black infants in America are now more than twice as likely to die as white infants—11.3 per 1,000 Black babies, compared with 4.9 per 1,000 white babies, according to the most recent government data—a racial disparity that

[8] Linda Villarosa, "Why America's Black Mothers and Babies Are in a Life-or-Death Crisis," *New York Times Magazine*, April 11, 2018.

is actually wider than in 1850, fifteen years before the end of slavery, when most Black women were considered chattel. In one year, that racial gap adds up to more than 4,000 lost Black babies."[9] There is a fine veil between surveillance and safety, and I wonder, who has the privilege to benefit from the safety that surveillance technology is supposed to bring about?

I think about walking down the street with my six-year-old child who is one year older than Kodi was when he witnessed the death of his mother, Korryn Gaines, at the hands of the police. Johari and I recently did an impromptu performance together at the art space Human Resources in Los Angeles for *The Evanesced: Embodied Disappearance* series. In a photograph captured by my great friend and performance collaborator, Tyler Matthew Oyer, I am lying on the ground somewhere between resting, playing dead, and about to rise, and Johari is standing over me. The image conjures a slain mother who has left her child in the land of the living, and it always makes me think of Korryn Gaines' last moments. A few days after the performance, as we walked down the streets, Johari pointed up at the tops of buildings and said, "Look Mom-Mom." "Yes?" I said. "Those are security cameras. They watch people all the time." I shuddered and said, "How do you know that? How do you know about security cameras?" Johari replied casually, "I just do."

Opposite:
Ming Smith, *Self Portrait (Total),* 1986.
Archival silver gelatin print, 20" × 16"

9 Villarosa, "Why America's Black Mothers and Babies."

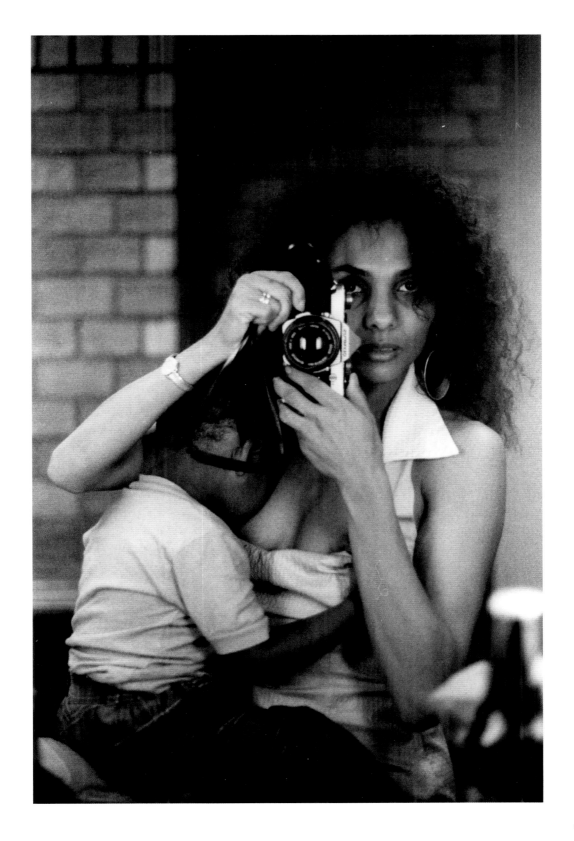

Mothering Swells[1]

LITIA PERTA

It is 8:53pm on Friday, the 30th of March, 2018, and I sit in the small room we hopefully call "the study" listening to the sound machine in the other room that has played seventeen hours of ocean waves on repeat pretty much since the night my son was born, almost exactly one year ago.

Today, I cried at the sink. Tonight, I breathed in the floor.

I cried knowing I would spend the afternoon alone with the baby and that somehow I would perform the nearly impossible task of bathing him and getting him to bed by myself while my person reads from their book of short stories and participates in a panel titled "Are you your body?" at a bookstore in Pasadena.

We no longer attend one another's events because now with a child it is miraculous to both of us that we have events at all.

Tonight, I breathed in the evening sky as I lay on the wooden floor in the bedroom by the baby's crib and snaked my arm through the wooden bars so that he could hold my hand as he made his way towards sleep. It was one year ago exactly that I sat huge and readying on the sofa in the living room drinking wine and watching *A Fish Called Wanda* hoping laughter might start the birthing. And I made a pool of water and was proud because I did not yet know that the absence of labor pains that heralded the beginning of our labor would mean a rugged trip through oneness to become a separating two.

I mention all this by way of a long-winded preamble that I will not skip, cannot skip, because aside from the disclamatory gesture it undoubtedly performs, it also locates the thinking I hope to do in the particular experience of a body and of this body's story, that is also the body and the story of an other, of a someone else. In thinking through feeling and in thinking through publics, I want to explore the originary human experience as being not one but always already at least two.

What I have to share is a series of ramblings and hunches, feelings and intuitions, fragments really, that have little to do with organized scholarship and everything to do with moving towards something that might be called knowing, but differently. Or maybe it's something else. I am drawn over and over again to what Fred Moten talks about as a kind of settler colonialism of knowledge: where knowledge too is treated and taught as a domain one moves towards and conquers, "masters" if you will.[2] Traces of this approach are everywhere in the educational systems of the "west." So if we all have been taught, to varying degrees, to settle, I'm interested in what it looks like, feels like, to un-settle. What are the modalities that might help us refuse the settler's approach to knowledge and give way to,

[1] This piece was first presented as an address titled "'Public' As The Space of Mutual Aid or How 'Not To Be A Single Being'" at the annual national convening of the American Comparative Literature Association session entitled "The Poetics of Public Feeling," held at the University of California, Los Angeles, March 31, 2018. "... not to be a single being ..." is quoted from the title of Fred Moten's *consent not to be a single being* trilogy, (Durham: Duke University Press, 2017).

[2] Fred Moten, "Blackness and Poetry," Mixed Blood Project, University of California, Berkeley, March 18, 2015, video, 1:11:07, March 19, 2015, https://www.youtube.com/watch?v=Su7iCumqLvo.

make space for, something else? I'm thinking here of fugitivity, blur, murkiness, moving away from clarity, from "getting it," from grasping—thinking about Glissant's notion of the right to opacity, of Audre Lorde's work on the necessity of poetry, of Fred Moten and Stefano Harney's work on the undercommons . . . [3]

1.

". . . Deviation is hard. Deviation is made hard . . ."[4] These two lines haunt.

They come from Sara Ahmed's "Complaint: Diversity Work, Feminisms, and Institutions," a talk she gave in 2018 at the University of California, Davis. Here, she describes the ways in which institutions of "higher learning," and the knowledge systems they teach were built to accommodate certain bodies/positionalities/approaches to selfhood and not others. So when bodies/positionalities/selfhoods that were not intended to make use of these systems attempt to use these systems, they find they do not fit. They find that they are "misfits."

"Deviation is hard. Deviation is made hard," she says. Again, this haunts me.

And if citation is a practice, Ahmed argues in the same talk, "In the Academy, you might be asked to follow the well-trodden paths of citation, to cite properly as to cite those deemed to have had, already, the most influence. The more a path is used the more a path is used. The more he is cited the more he is cited."[5]

I'm interested in the way citation might be framed as a potentially feminist practice: Who do we cite? Who do we bring proximate to one another in our works? And what systems are we reinforcing or resisting when we do so?

2.

In a way I cannot explain, I return again and again to Fred Moten's ". . . consent not to be a single being . . ." In a talk at the University of California, Berkeley in 2015 entitled "Blackness and Poetry," Moten engages in a series of dialogues with students about forms of knowing that mimic the movements of settler colonialism they may be trying to critique. In response to one student, he says "so you talk about 'settler' as . . . anyone who goes to some place that's not their own, and I would say that a 'settler' . . . is not the one who goes to some place that's not their own. The 'settler' is someone who goes to some place and tries to make it their own."[6]

I keep wondering about whether this framework can apply to what it means to be a self and to what kind of self it means we can be. If I emerge both from and into a fundamentally entangled sociality and am trained towards individualism, in what way is my own staking out of myself as separate from others (and so "individual") performing a settler colonialist gesture I might otherwise try to avoid?

If human being is an inter-implicated entanglement, if I harbor the unknowable other in my body, as my body, understanding that my body is not my body but a body given over to the being of an other, what does it mean to become "self-possessed"? In what way does self-possession perform the settler's gesture of being someone "who goes to some place" (where they are not from) "and tries to make it their own"?

[3] See Édouard Glissant, "For Opacity," in *The Poetics of Relation* (Ann Arbor: the University of Michigan Press, 1997), 189. See Audre Lord, "Poetry Is Not a Luxury," in *Sister Outsider* (Berkeley: Crossing Press, 1984), 36. See Stefano Harney & Fred Moten, *The Undercommons: Fugitive Planning and Black Study* (Minor Compositions, 2013).

[4] Sara Ahmed, "Complaint: Diversity Work, Feminism, and Institutions," Public University and the Social Good, University of California, Davis, February 20, 2018, video, 20:55, https://www.youtube.com/watch?v=4jf4sgw5NeQ.

[5] Ahmed, "Complaint."

[6] Moten, "Blackness and Poetry."

In an effort to consider what it might mean to use the term "public feeling," I want to share a short transcription of another talk Moten gave, this time with Saidiya Hartman, at Duke in 2016 entitled "The Black Outdoors." He says

> . . . there's that phrase about what it means to be sure of yourself? But I mean it in a slightly different way. Not sure of yourself in the sense of confident or . . . competent . . . but sure of yourself as in: sure that you are a self or sure that you have a self. So I would say that the less sure you are of yourself, the more possible it is to be in a community. And you know, luckily or unluckily for certain people in the population, they've had all kinds of . . . pseudo intellectual brutally viciously juridical reasons to be unsure of themselves. So . . . when it comes to that . . . it's the peculiar privileges of the underprivileged, you know, the specific wealth of the poor . . .[7]

So, to repeat, in his formulation: ". . . the less sure you are of yourself the more possible it is to be in a community . . ."

3.

I have been wondering for months what it means to say "public feeling." Does it mean a feeling I have in public? Or does it mean a feeling that I have together with a public? Or is it possibly a feeling that I can only have in public, a feeling that arises from being with and in and part of a public? I started wondering whether it was possible to have any feeling at all that is not public . . . is it perhaps feeling itself that is public, that we do in relation, that we do among? If my body, my being, is always already for another, is it not perhaps always already oriented toward the other that is in the public? Thinking of the entanglement that both sustains me and allows me to emerge, I keep wondering: is parenting a public feeling? What kind of public am I in when I parent?

4.

I have a sinking worrying feeling that motherhood is bound up with constructions of whiteness. There is a difference between motherhood and mothering. Mothering is something anybody can do, an action worked by people in all sorts of positions. It is a labor. Motherhood is a kind of being, a condition or form of self. And, I worry that, like many forms of selfhood, it cannot accommodate every person that cares for a child. At a certain point in the life of the child my culture encourages me to call "my own" (a form of reference so far from what I experience it overwhelms me to try and correct it) I felt myself so underwater, so submerged, I started seeking desperately for narratives that tracked this transition—not into being a mother, but back into a kind of originary multiplicity that my own education had managed to make foreign to me. There is a spate of new work written by women who are parenting and I am grateful for these and began to read them anxiously, hungrily. And I started to worry as I realized that the vast majority of these, the vast majority of women who have the privilege of mothering in public—who are published—are white women telling their stories. And so I started to seek anything that might undo what seemed to me a kind of enmeshment of mothering with whiteness.

[7] Fred Moten & Saidiya Hartman, "The Black Outdoors," Franklin Humanities Institute, Duke University, October 5, 2016, video, 2:04:02, https://www.youtube. com/ watch?v=t_tUZ6dybrc.

My findings have been slim. Fierce and slim.

I want to cite part of a passage by Alexis Pauline Gumbs who problematizes exactly this:

> What if mothering is about the how of it? In 1987, Hortense Spillers wrote "Mama's Baby, Papa's Maybe: A New American Grammar Book," reminding her peers that motherHOOD is a status granted by patriarchy to white middle-class women, those women whose legal rights to their children are never questioned, regardless of who does the labor (the how) of keeping them alive. MotherING is another matter, a possible action, the name for that nurturing work, that survival dance, worked by enslaved women who were forced to breastfeed the children of the status mothers while having no control over whether their birth or chosen children were sold away. Mothering is a form of labor worked by immigrant nannies like my grandmother who mothered wealthy white kids in order to send money to Jamaica for my mother and her brothers who could not afford the privilege of her presence. Mothering is worked by chosen and accidental mentors who agree to support some growing unpredictable thing called future. Mothering is worked by house mothers in ball culture who provide spaces of self-love and expression for/as queer youth of color in the street. What would it mean for us to take the word "mother" less as a gendered identity and more as a possible action, a technology of transformation that those people who do the most mothering labor are teaching us right now?[8]

5.

I am in a basement bookstore in Washington, D.C., bouncing my five-month-old child in a carrier strapped to my chest, trying to keep him quiet while my partner reads to an audience of strangers from her new book of short stories. My body sing-songs back and forth through bookshelves, shifting my weight from one foot to another, hanging towards the back of the room so that my son's tired sighs do not disturb the reading. This dance has seeped into my bones so that I catch myself swaying in its rhythms lately, even when he is not in my arms—a physical reminder that mothering continues long past when I put this child down.

I bounce by a small hardcover copy of Chimamanda Ngozi Adichie's *Dear Ijeawele, or A Feminist Manifesto in Fifteen Suggestions*. Suggestion six: "Teach her to question language. Language is the repository of our prejudices, our beliefs, our assumptions."[9] I look for language to describe this limit experience where the body of an other depends so entirely on mine for its survival that an originary multiplicity of being surges forth, rendering itself unavoidable, unforgettable.

Contagion is a common theme—a model that depends on a boundary that should be there but that hiccups, blurs—pathological.

I find I resist that *should*.

I have never felt more myself than I do now that I am two.

[8] Alexis Pauline Gumbs, "m/other ourselves: a Black queer feminist genealogy for radical mothering," in *Revolutionary Mothering: Love on the Front Lines* (Oakland, CA: PM Press, 2016), 22–23.

[9] Chimamanda Ngozi Adichie, *Dear Ijeawele, or A Feminist Manifesto in Fifteen Suggestions* (New York: Knopf, 2017), 26.

6.

On the 9th of October, we have been to the chiropractor, we have played, we have gone to the grocery store. Today, he has tried blueberries, bananas, and raspberries in a puree. Food is making his digestion different, slower, more effortful. It is late in the evening and I sit him on my lap and give him my right breast. I look at other things because this is how the milk flows best—when I don't think about it. Soon I realize he is not sucking in but pushing air out and I look down and his face is red. He is holding his breath, then pushing it out, pushing hard on his belly, fussing a little bit, as I see how uncomfortable it is.

He spends the next few minutes at it. It's tempting to laugh but his discomfort is so earnest and so unabashed, and his effort is so Herculean and so impressive, I am instead awed.

I finally hear the grunt of his butthole as it pushes out the mass that was inside him. When I go to the changing table, his body has produced a proper shit for the very first time. Up until now, it has been a bright mustard color liquid that smells, almost pleasantly, of sourdough bread. But unmistakably now this is caca— smooshed up into his nether regions in every wrinkle and crevice.

I am impressed. He worked so hard.

We change him with many wipes and a new diaper and sit back again to nurse. I curl him into me and hold my hand firm on his back, loving him hard, feeling this swell of pride at what he's just done.

And, arises unbidden, a mournfulness seemingly from the depths of me, as I realize I will not be able to hold his body—will not even be here at all—when his body is old. This kills. Tears come. The shit that moves me.

Opposite:
Kenyatta A.C. Hinkle, *The Evanesced #24*, 2016.
India ink and watercolor on recycled, acid-free
paper, 12" × 9"

Following page:
Kenyatta A.C. Hinkle, *The Evanesced #123*, 2016.
India ink and watercolor on recycled, acid-free
paper, 12" × 9"

144

Heavy Swimmers

ALEXIS PAULINE GUMBS

For Ebony Wilkerson
a black mother who drove herself
and her children into the Atlantic Ocean
saying she was taking them all to a better place.

i.

how can I protect them
says the pregnant mother
three children behind her
brown as ever

minivan plastic
right handed lever

we will be okay
as long as we're together

she drives out of town
and then drives to her sister
to dodge all the demons
that twist her and twist her

Ibo ungrounded
the people could fly
not in a Honda Odyssey
but she had to try
and as soon as the rubber
sank into the surf
all the ghosts grabbed the wheels
and said
yes yes
that works
come home

and the sea floor scattered
the large and smaller bones
of all those other mothers
who didn't swim

and their kin

ii.

is the walk on water gene
recessive
regressive
repressed by the stresses
of modern minivan life

a passed on secret
activated by a serum
in the heat of the blood
of abused wives

and what is the crazy part

to believe the weight of metal and plastic can float
to remember what it feels like
to be shackled in a boat

or to think there is a better place
 underneath
 or across

some way to get back
when we're lost

iii.

mom is crazy
they tell the police
she's trying to kill us

have you ever felt that?

the most scared i've ever been in my life
is in the back seat
of an SUV driven by my mother in rage
i have known
she could kill us all
with the same thick wild determination
she used to get us here

all this huge car metal
and no way to escape
hurricane cycles of abuse
repeated betrayals

single mother broke breadcrumbs
breed real demons
that are not us
and they don't stop screaming

it's just that most days
something else is louder
call it love
or inertia
or luck

have you ever seen a woman drive
like capitalism is chasing her
off the edge of herself
kids in the back
purse in the front seat

i have
and i am a pretty strong swimmer
but still

i was in a car
when i first heard your name
nowhere near the beach
and i had to pull over

iv.

how many women have wanted to take their jewelry off
dive back in
take their children with them
to where everything
is eventually warm enough
big enough
deep enough
to save us

if you listen
to everything
the ocean has to say
how can you stand it
how can you stay

heavy swimmer
bodies remember
wet dark places
that held us
when we were ready
to transform
gut brave enough
to breathe a different way

v.

Ebony you almost made it
but your body brought you back
and the tourists saved the children
and now you are just as black
and wearing orange
in gray rooms where they test your pee
for the alcohol level of cough medicine

is someone sending you books
by Toni Morrison
by Kate Chopin
Ebony you are not the only woman
crazy enough to remember
that some days we just cannot

we cannot live here

we cannot give our babies
to this world that eats our bones
like centuries of salt

and i am sending love
to the South Carolina centuries
that protected the part of you
that hears the ocean
and believes there has to be a better place

even if neither of us can see it
from here right now

and yes your babies
who survived

they will one day
understand

SOPHIE HAMACHER

I want to talk about your views on surveillance as a feminist, activist, mother, and writer working on issues of gender, race, and incarceration. But first, could you talk about your activism and its relationship to your experience as a mother?

KEEONNA HARRIS

Well, for me—my activism and what I consider motherhood or mothering are very much intertwined. It is about advocating for myself, it's about advocating for my family, and it's about advocating for my community. In my life, they are not separate things. They very much live together. As a mother it is very important for me to have built a strong foundation for my children so they can be present in the world and what's going on around them—what to expect of the world—but I also want to instill in them that they can stand up for themselves and advocate for themselves. I think it's also very important that they are connected to their community, being people of color, being of a certain socioeconomic status, so they are raised with an awareness of who they are. That is very important to me. So yes, my activism and mothering are one and the same.

SH I noticed that you answered the question with yourself in mind first. I don't think that happens very often. You said that you advocate for yourself and then you advocate for your children. Often it feels like mothers come last—or children always come first. I think it is really important that we as mothers retell the story or recenter the focus. We can't leave ourselves out of the picture.

KH I agree with that. I try to practice that in my personal life as well as when I'm teaching workshops or speaking with other women and other mothers—mothers who are biological mothers or non-biological mothers. Because I think that is important and I think society has instilled in us that when you become a mother you kind of forget about yourself and you are always supposed to put your children first. I think we need to go back to thinking: if I don't have myself together, if I'm not caring for myself, I am no good to anyone else, let alone children who are going to be looking to me to model behavior. My belief is that I have to take care of me first. I lived for years kind of forgetting about myself and it was to my detriment. I was getting physically sick or suffering bouts of depression because I wasn't taking care of myself.

SH Last time we spoke, we talked about the *New York Times* article "Motherhood in the Age of Fear" by Kim Brooks. How do you understand the entanglement between surveillance and motherhood in relation to that article?

KH The way I think about surveillance—I think it goes back a long way. I'm not sure if you are familiar with the term "the cult of True Womanhood"?

SH No, I'm not and it sounds like I should be?

KH It's a term used by historians to describe the value system among upper and middle class people in the nineteenth and early twentieth century in the United States and the United Kingdom. Basically, it emphasized this ideal of what femininity

KEEONNA HARRIS is a Black feminist activist, mother, and scholar whose research focuses on gender, race, motherhood, and incarceration. Specifically, her research advocates for women and children who are collaterally harmed by mass incarceration. In addition to her academic work, Keeonna is committed to community organizing and self-determination efforts, working with others who have also been directly affected by mass incarceration. Currently she is working to build a support and advocacy network for mothers and children who have incarcerated partners and parents.

is supposed to look like and be, the woman's role in the home, and the dynamic of working families. Women are supposed to possess certain values like piety and purity and domesticity and are to be submissive, right? The woman is basically the center of the family, these standards were basically set up for white people—white women in particular—although it was expected for all women to follow this model. Of course, Black women and immigrant women were not considered real women. So I feel like it all goes back to that. Even at that time there was surveillance; when you become a mother you are supposed to change and everything is supposed to be about your children, you are supposed to lead by example and that's when you start getting surveilled.

The article by Kim Brooks about the woman who had a warrant out for her arrest because she left her child in the car made me think about how things can be so innocent—I'm a mother and I've done that and I know plenty of mothers who have done that. It's that kind of surveillance—people are not worried about your children—they are surveilling your parenting skills and your behavior as a mother.

SH So now you are talking about a kind of societal surveillance, right? Not only a state surveillance—

KH But that is also part of the state. It's a trickle down effect. We don't just wake up with these thoughts and these fears. It is bigger than us. It is the state using random people to do their job, to be Big Brother, and it wants us to police one another. The instances described in the article—the journalist depicted someone who is more affluent—but of course there are more dire consequences for people of color.

SH And it's intersectional?

KH Correct. So for women of color, for me—I've felt highly surveilled from the moment I had my first child. I had my first son when I was fifteen. So I was already on people's radar—being Black, being low-income, now being a single mom, and being a teen mom. So I was constantly watched. Watched to see if I was going to be a good mother, was I going to go to my prenatal appointments, was I going to take my vitamins, was I going to finish school, was I going to be a statistic and just get cash assistance and have more children? It also made people surveil my mother. "What kind of mother would 'allow' her child to get pregnant?" So I have always been surveilled and it has only continued since I had more children— when I married my first husband who was incarcerated, that was an extra layer of surveillance. And I even feel surveilled now. I'm a PhD student, I'm doing all these great things, but there is still surveillance on my body. I have four boys and I'm pregnant with my fifth child and I'm still surveilled when I'm out with my kids. When my kids do certain things, when they say certain things at school, there is surveillance and there are certain consequences for me. If I were to leave my kids in the car versus a white woman—totally different consequences. And even when I was looking at the example of the affluent woman, there was another woman who was a D.A. or a prosecutor and she said something like, "You need to stand up for yourself, you need to question the police." That is privilege. That is something poor women, immigrant women, and women of color cannot do. So the article is speaking to certain privileges. And even in the other example of the affluent woman who actually was arrested, she wasn't given any kind of real punishment, although she did receive community service— which I thought was quite ridiculous. I felt like they were just trying to

make an example of her. The consequences for white women are rooted in patriarchy and white supremacy. White women have historically been complicit in surveillance of Black women and women of color, but now white women are faced with the same surveillance they perpetuated and continue to perpetuate on us. They helped create this system and only now are they realizing it actually hurts them too.

SH Now I'm jumping a bit. Others in this book have differentiated between motherhood and mothering and the concept of othermothering was discussed in an interview with Melina Abdullah. Do you see this distinction in your own life?

 KH I think in my life it is a definite distinction. Because I feel motherhood is rooted in a certain belief system. It is more of a title to me. Traditionally and historically the term *motherhood* is rooted in patriarchy and white supremacy. Mothering is the actual process and I think that the term *mothering* is like the practice. It also gives space to people who are not biological mothers because that is not the only way to be a mother. In this day and age, we don't have to stick to the nuclear family, the man and the woman and 1.5 children. There are so many ways in this world to mother. There are people who can't have children who adopt, there are people who have blended families, and there is also mothering called othermothering, which is rooted in Black epistemology. Othermothering may be through relation, it may not be through relation, but I'm still mothering. So that can be people who are raised by their grandmothers. Or people who are raised by other people who are not biologically connected to them, but they'll have the same major influence.

SH I agree with you. And my thinking has evolved since I started work on this publication, but I started from a place of interest in the trauma of childbirth. Becoming a mother was such a revolution in my body and mind and that's the only experience of motherhood that I know.

 KH I see this a lot in academic spaces and I do think there may be a different kind of story there when you are a biological parent, but I feel like there is room for everybody at the table and that's why I use the term *othermothering*.

SH Well, let's jump back again. When did you start thinking about the presence of surveillance in your own life?

 KH I started being aware of surveillance when I had my first son.

SH How did that awareness manifest?

 KH For me it came out by being very aware of looks that people gave me. As my belly grew, people began looking at me differently. These are people that I may have known for a long time—at the time I was in ninth grade so I was in high school. My teachers suddenly looked at me very differently, in a judgmental way. I was still the same person, my personality had not changed. I was still on the honor roll. So why did people stop smiling at me in the hallway all of a sudden? People were surveilling my body. That was my first indicator. I was being watched in a different way. I first noticed it with my teachers and definitely while I was going through prenatal care. I noticed the questions that the doctors were asking—when you get pregnant when you are over a certain age, no one asks you about the father of your child. The questions were totally intrusive, almost as if it's their right to know. There was a lot of that. Questions that had nothing to do with making sure I was well and my unborn child was well.

SH And has that changed over time? How do you feel now?

KH When I was married to my prior husband, who was incarcerated, and we continued to have children, I was surveilled in a whole different type of way. There was judgement placed on my body because people were like, "Oh, I see that you are married, where is your husband?" It was kind of like being shamed. They wanted an explanation of why this person was not at the doctor's appointment or at the birth.

SH For readers who aren't familiar, would you mind talking a little about conjugal visits? Do the policies vary from state to state? I ask this because so much around incarceration is hidden and has been made invisible to the general public.

KH Not all states and prisons allow conjugal visits, so I can only speak to the state of California that does allow conjugal visits. But even in the state of California there is only a specific incarcerated population that is eligible. If you have been charged with certain types of crimes you cannot have a conjugal visit. There is a lot of paperwork. They have these kind of bungalows that are set up like an apartment. Once all of the administrative work is taken care of, and there is so much paperwork and bureaucracy, then you go to the prison as if you were going to a regular visitation. They go through your bag and make sure everything is by the book and up to par and then someone will escort you to the bungalow.

SH Are there surveillance cameras there?

KH No there aren't. There are times when they come, like when it's count time they will come and check on him and make sure he is still there, but there are no cameras inside of the bungalow. It's a long process. There's a lot of surveillance. It is really intrusive. To me, it's all framed and rooted in making you feel shameful. And I am personally dedicated to trying to remove some of that stigma and shame because to me it's made to be a spectacle and it's really distasteful. The bottom line is that you are married to that incarcerated person, you are a family. And so being together as a family becomes this spectacle—the process of them going through your things. The whole thing is a spectacle. It makes the visit very uncomfortable upfront. It tries to diminish what you have as a family and your bond. And going back to when I was pregnant with my third child, when I was with my now ex-husband and going to the doctor—it adds another layer of surveillance because it assumes that the only way that I can get pregnant is by cheating on my husband and that I'm a certain kind of woman. Because you can't possibly get pregnant by someone who is incarcerated. So what my activism entails is trying to steer people away from that. It's very presumptuous and it's hurtful. I've heard it a thousand times, "Well, how did you?" And it's already presumed.

SH I did the same thing just now by asking you to describe how conjugal visits work, no?

KH I call my son my "resistance baby" because I resisted all the norms and all the bullshit people wanted to place on me about not continuing my family and my family not looking a certain kind of way.

SH Can you tell me about the advocacy network for mothers and children of incarcerated parents that you are working on? It sounds like you are creating networks of support outside of what is being offered institutionally.

KH Well, I'm working on creating that now. This will be a totally separate project. It is a very isolating experience and it's very easy to forget that you are not

the only person going through it. So my hope is to build a network, a person-to-person network and a digital platform where we can all interact and connect with one another and get support. I hope that this will allow me to do further workshops, do one-on-one work with women, and also to create a digital platform where we can connect once a month online as a group. I'd like there to be different models posted to help you get through the bureaucracy. It is important to realize that you are not alone, because I feel like that's what society and the state want you to feel. They want you to feel isolated and stay silent.

SH Can you tell me a bit about the workshops you teach?

 KH The workshops I teach and the workshop I am creating focus a lot on self-care. I'm going back to what we touched on earlier about taking care of yourself first so you can feel grounded and take care of the people and children under your care. I do a lot of affirmation-making. I do a lot of journaling and retelling our story because storytelling is really powerful. With storytelling you can reflect on things to get a better understanding about yourself. It is also a way to build a bridge with other people and build community. More often than not our stories are very alike.

SH Could you describe the book that you are working on?

 KH This project is basically a memoir spanning twenty years that is based on my life and my journey through mothering with an incarcerated parent. I want to carve out a space and show people what that looks like when you are trying to navigate the unfree and the free world—when you are living on the borderlands of the prison system. I'm not directly incarcerated, but I'm going to prison every weekend. My ultimate goal with this book is to show people that families can exist and transcend time and space and location. So the book will span twenty years, raising my children and what that experience looked and looks like—what my marriage looked like as my children grew. (My oldest son will be twenty-three next month.) It will also give some backstory about how I got there and what led up to the choice of me being very avid about keeping my family together.

SH I want to circle back to your comments earlier about your own experience of surveillance and the disproportionate policing and incarceration of people of color. How does that fact affect motherhood and mothering?

 KH Surveillance on Black women is very different. I've noticed that all my life and throughout the journey of being a mom. Even now I feel that surveillance. I have a different kind of worry and concern for my children that a lot of other women don't and will never experience with their children. And it's very scary—like to the pit of your stomach scary. It's a worry when my older two children are out—like my twenty-three-year-old and my nineteen-year-old—when they are out past a certain time it is *scary*. It is not the normal concern. Racial profiling means he can get pulled over just for driving his car and it could go a totally different way once he is interacting with a cop. My son could be the next body going viral on the news. That is a very scary feeling.

SH How does that affect your parenting in terms of protecting them?

 KH It is kind of sad. You have these little fantasies or ideals about what being a mom is and of course you teach your children right from wrong, you teach them what is "moral," but my sons have to live by a totally different rulebook. Not only do I have to teach them the regular stuff, but I also have to teach them to police their own actions. And that is a horrible feeling.

Before they leave the house I have to check how they are dressed because I need to see how they are presenting themselves to other people who are already assuming they are dangerous. They have to police themselves. Other kids don't have to do that. If your child, at eight years old, is unkempt, you are afraid someone is going to call Child Protective Services on you. Whereas, when white children look unkempt it is fine because they are expressing their creativity or they wanted to dress themselves. I have to police my own children and I have to teach them to police themselves.

SH So you are teaching them self-surveillance.

KH Yeah and it's horrible because I shouldn't have to. They should be able to explore life and be who they want to be in the world, but that is not the world that we live in.

SH I have one last question for you. If you were to create an image that represents the ideas surrounding motherhood and surveillance, what would it look like?

KH It would be all of these eyes staring at a woman. There are different levels: there is surveillance of the state, there is surveillance of women who surveil other women, there is surveillance of men surveilling women. There is a hierarchy of surveillance so to me the image would be full of eyes and it would go on different levels. Eyes, there would be surveillance cameras, there would be paperwork because I feel like we are surveilled by bureaucracy—so yeah, it would be a whirlwind of eyes, different ways of looking.

This conversation took place over the phone.

Kandis Williams, *Demeter Persephone
Downtown LA*, 2014. Mixed media on paper,
42.8" × 46.2"

Opposite:
Kandis Williams, *Child M/other 1*, 2013. Acrylic
paint and collage on canvas, 11.69" × 8.27"

156

Nel Nome del Padre

DUAE COLLECTIVE (SILVIA CAMPIDELLI, LUNA COPPOLA)

This text is drawn from the video piece Nel Nome del Padre.

Article 1 of the Universal Declaration of Human Rights states: All human beings are born free.

Italian law requires accordance with three conditions to determine that filiation is legitimate: that the mother of the child is the wife, that the father is the husband, and that the conception took place during the marriage.

In 2016 we decided to become mothers, a condition desired as an act of free choice, not entrusted to chance.

Our children were conceived in Barcelona, the city where we lived for many years, through the technique of assisted reproduction. Silvia underwent the treatment and during the thirty-seven weeks of gestation, our roles were equal, recognized by legislation and by Spanish society.

On February 1, 2017 Victoria and Noah were born, and from the first moment we were both recognized as co-parents with the same roles and same responsibilities. After a few days, they were registered at the offices of the civil registry of Barcelona as our legitimate children with a double surname. They gave us our family book and birth records.

However, our children had not acquired Spanish citizenship for lack of what is called "Ius sanguinis." Victoria and Noah are children of two mothers with Italian citizenship and by law they must acquire the citizenship of their mothers.

That requirement clashed with existing Italian legislation, which lacked a law that recognized us as a family and recognized our children as Italian citizens. In Italy, the "natural" family is formed from a socially recognized and lasting union of a man with a woman and their children.

Victoria and Noah, European citizens, were considered stateless persons without identity for about a year before being registered in Italy. Sons of two women in one country and no one's children in another.

On February 7, 2017 we started our battle. Our main interlocutor was the Italian Consulate of Barcelona. For a family to be considered "natural" the practice is very simple. You have to deliver the children's records to the registry office and communicate the birth to the municipality where the parents reside. After a couple of months pass, the question should be resolved.

IN 2016 WE DECIDED TO BECOME MOTHERS, A CONDITION DESIRED AS
AN ACT OF FREE CHOICE, NOT ENTRUSTED TO CHANGE

BEING PARENTS IS NOT A FACT OF BLOOD, A BIOLOGICAL FACT,
DOES NOT CONCERN THE LINEAGE NOR THE GENEALOGY, NOR THE SEX

Duae Collective, *Nel Nome del Padre*, 2018. Video (color, sound), 4:06 min.

In our case it took almost a year to get the same rights. Finally, after months of fighting, the municipality of Naples, despite the fact that in Italy there is not a law to regulate filiation of homosexual couples, revised the birth certificate with both of our names. We were finally recognized as two mothers. The birth certificate assured Victoria and Noah a full identity and rights in Italian territory.

We questioned ourselves as women and as mothers with respect to legislation that is based on patriarchal structures and language. Since Victoria and Noah were born, the question that is continually posed by people is: Who is the father? Don't you want to know who? Who do they look like? Is there some resemblance to the father?

The language reflects the lack of legislation. The terminology, for example, has not been updated and does not provide the neutral designation "parent," but instead requires the entry of the "name of the father."

The mother, the father, the son, are archetypes on which our society is based. The mother can be a symbolic function and not a biological body. Being parents is not a fact of blood, a mere biological fact, and does not concern the lineage, nor the genealogy, nor the sex.

Generating a child is no longer exclusive to a mother or a father. It requires a social contract beyond our requisite biology, extraneous to nature, a symbolic act, a decision, and an ethical assumption of responsibility.

Body Blitz

ANJULI FATIMA RAZA KOLB

for Sara Suleri

I asked once if you still wanted to be
alive and oh it came from under a crushed
cavern milked geode soared wall in emerald
a circle I didn't know how to close before and then I was like
of course gale-banged and off hinge
my daughter won't be able to look me full
in the face as I can't look
at my mother as laughing at your birthday dinner
when we could barely get you out the door
undertows violent into weeping so entirely
bodied by sadness and the no edge of it
to the limit to the wall

Host now and so excellent at blah blah blahing through the fire
me and the baby we live only in vine space nostalgic and untouchable to grow
this fruitheart slime space a seven second clip of a bedroom vocalist
doing Chaka Khan and you I think would have majorly loved
TikTok if I'd gotten you a proper phone
sent you the things that I looped endlessly for the purpose of flinging
any complete thought as far from us both
as possible like off the edge of that dock into the brutal Atlantic up there
"here's a step by step guide for becoming a fossil . . . step one: die"
the baby keeps me thrumming and inspired toward extreme laziness
you would have appreciated if I think about nothing
but that dying the heart that stopped exactly as the baby's started and that
we could if we wanted to time it to the almost minute

If I think I think nowhere
except in the tiled chamber of an old power station
on Adelaide but now it's an urban baths that emerged okay
if less enthused and more fascist after two pandemic years
brick barrel and a dead sea pool that wants an arch
wants an arch what does the baby want (donor wise) we asked tripping on mushrooms
like it was a real bolt of lightning I go SHE WANTS US ok ok
that baby is having a total blast at Body Blitz spa flying
all around at this at songs at chocolate what a babe
I can hardly read and I am definitely too scared to ask Tillat if that's
the sum total of your library we so carefully calibrate me and the baby
when it's allowed to feel until a tiny woman who isn't allowed to accept tips is hosing
us down after a walnut scrub from a pump box in the wall
this "glow" one of the stranger gifts I've received from another
one of the girls in a paper panty and under an orange heat lamp like we're roadside fast
food neglected I wish I could name her Sara but I can't and then we're uncalibrated

Your mind was so blown by Burger King chicken fries you threatened to write a book about it
the thoughts you suggested I maybe shouldn't have if I didn't want to suffer so much
down the drain in the middle of the tiled floor and I thank you for that advice
I want for her few and untroubled thoughts
she wants a good name
I want her to be able to look at me and love us easily
the way I can't look at my mother and I couldn't look at you
everything I envied has already buckled and no puzzle will solve
we're too old for that another thing you told me about real puzzles
I wished for you a head full of cotton not just at the end
my love could only suggest that density

If I think it's without her permission and it hazards this
way hard and equally dangerous in that
I hope it sounded like nothing on an endless loop
that it fell like a cotton ball down the marble stair
and then fell again like vine time and fell again
that you peeked playfully through the ironwork
that I looked directly back at you

Following page:
Cary Beth Cryor, *Rites of Passage no. 1*
(Self-Portrait During Childbirth), 1978.
Gelatin silver print, 10 ⅜" × 13 ½"

A Conversation with Priscilla Ocen

PRISCILLA OCEN is a Professor of Law at Loyola Law School, where she teaches criminal law, family law, and a seminar on race, gender, and the law. Her work explores the ways in which race, gender, and class interact to render women of color vulnerable to various forms of violence and criminalization. Her writing has appeared in academic journals such as the *California Law Review*, the *UCLA Law Review*, the *George Washington Law Review*, the *UC Davis Law Review*, and the *Du Bois Review* as well as popular media outlets such as the *Atlantic*, *Los Angeles Daily Journal*, *Ebony*, and *Al Jazeera*.

SOPHIE HAMACHER

As a lawyer, scholar, activist, can you talk about how you came to be interested in the rights of mothers of color?

PRISCILLA OCEN

I studied at UCLA School of Law in the Critical Race Studies program under amazing writers, scholars, and feminists Kimberlé Crenshaw, Cheryl Harris, and Devon Carbado, which certainly informs my politics and my thinking. I first came to be interested in the rights of women of color who sought to have children as a young attorney at the Lawyers Committee for Civil Rights of the San Francisco Bay Area. I was working with the California Coalition for Women Prisoners to develop a project to serve formerly incarcerated Black women coming home from prison. As part of the development of that project, I worked with volunteers at CCWP to visit women incarcerated at Valley State Prison for Women and California Central Women's Facility, both in Chowchilla, California.

During my meetings with women, inevitably questions of parenthood and reproduction came up. The women, who were disproportionately poor, Black, and Latinx, would ask me to inquire about the location of children who were placed in foster care after they were arrested or imprisoned. Women would speak to me about questionable hysterectomies that were happening in the prison. I spoke to women about strict visitation policies that often meant that they could not see their children for months, years, and in some cases, ever.

Women described, in harrowing detail, the experience of being denied medical care during labor. Many were shackled during labor and childbirth. Nearly all of the women who gave birth while in prison were immediately separated from their newborns. These conversations made it clear to me that motherhood, criminalization, and incarceration were deeply intertwined; that policing and prison were gendered institutions that regulated the reproductive autonomy of women as part of the punishment imposed upon them. Over time, I began to connect the contemporary experience of the women I spoke to with the long and troubling history of reproductive abuse in the United States. Indeed, the focus on motherhood and reproductive autonomy was part of the carceral state's management of women who were viewed as unfit for motherhood, deviant, or gender nonconforming through sterilization or incarceration in reformatories or mental institutions. As I made these connections, I came to see that if we as scholars and advocates want to contest the carceral state, we must contest the gendered regulation of reproduction and motherhood.

SH In the Pen America video in which you introduce yourself as one of the Writing for Justice Fellows of this year, you speak about "systems of surveillance that don't rely on people being in custody" and you refer specifically to how those systems of surveillance affect women and their communities. Can you explain which kinds of surveillance you are referring to and why specifically women are the ones affected by them?

PO When scholars, particularly in the legal academy, speak of surveillance and criminalization, we often focus our attention on the formal criminal legal system. In the context of the criminal legal system, we ask about policing and prisons, the scope of the Fourth Amendment, and the right to privacy. This focus, however, is too narrow. In my work and activism, I argue that there are many non-criminal systems that reproduce the logics and harms of policing and prisons. By this I mean that non-criminal institutions like welfare, schools, and hospitals disproportionately surveil, regulate, and criminalize poor women of color. In these systems, women of color, especially Black women, are forced to disclose personal information about themselves and their families. They are forced to allow state agents into their homes under the guise of "home visits." They are humiliated and demeaned. Their children are disproportionately removed from their custody. Even in visits with the doctor, Black women have been subject to warrantless, nonconsensual searches that can lead to arrest and, in some cases, imprisonment.

Increasingly, these non-criminal systems serve as pathways to criminalization and incarceration. For example, as legal scholar Kaaryn Gustafson documents in her book *Cheating Welfare*,[1] state welfare agencies have shared data with law enforcement as part of a sweep of people with outstanding warrants. In addition to the threat of criminal prosecution, these systems often require poor women of color to trade their dignity and privacy in order to obtain state aid. If they fail to comply, women risk the loss of vital support to provide for themselves and their families.

SH What role does surveillance play in the lives of the incarcerated mothers that you have worked with? I immediately jump to the conclusion that of course prisoners are surveilled, but are there more subtle forms of surveillance that specifically concern these mothers?

PO For incarcerated women, every aspect of their lives is monitored by the state, including their reproductive capacities. What is deeply troubling is the way that prisons obscure these forms of surveillance from the public. As a result, people incarcerated in women's prisons are subject to broad surveillance and reproductive abuses precisely because they are hidden from public view in prisons located hundreds of miles from the city centers where they come from.

SH You've written on these issues at length in the texts "Birthing Injustice: Pregnancy as a Status Offense" and "Beyond Shackling: Prisons, Pregnancy and the Struggle for Birth Justice."[2] How is it that pregnancy is considered a status offense in the legal system?

PO Across the country, states have arrested and prosecuted pregnant women for inducing abortions, using drugs, falling down a flight of stairs, and attempting suicide. In "Birthing Injustice," I argue that the prosecution of pregnant women for allegedly harming fetal life (by using drugs or other behaviors) constitutes cruel and unusual punishment in violation of the Eighth Amendment.

In particular, I argue that pregnancy is a status under Robinson v. California, a Supreme Court case that held that an individual's status cannot be criminalized under the Eighth Amendment. In Robinson, the Supreme Court found that drug addiction could not be criminally punished as it was an involuntary status. The Court also found that biological processes or illnesses could not be punished as they too constituted a status beyond the individual's control. In a

[1] Kaaryn Gustafson, *Cheating Welfare: Public Assistance and the Criminalization of Poverty* (New York: NYU Press, 2011).

[2] Priscilla Ocen, "Birthing Injustice: Pregnancy as a Status Offense," the *George Washington Law Review* 85, no. 4 (July 2017): 1163–1223. Also, Priscilla Ocen, "Beyond Shackling: Prisons, Pregnancy and the Struggle for Birth Justice," in *Birthing Justice: Black Women, Pregnancy, and Childbirth*, ed. Julia Chinyere Oparah and Alicia D. Bonaparte (Boulder, CO: Paradigm Publishers, 2015), 187.

series of other cases, identities such as race and disability have been described in terms akin to status. More recently, Robinson has since been extended by federal courts to include homelessness, thus prohibiting jurisdictions from punishing homeless people for sitting, lying, or sleeping in public.

Because pregnancy is a biological function, I argue that it should be viewed as a status. Understood as such, criminal prosecution of women for behavior during pregnancy is impermissible. In making the argument, I likened pregnancy to the broader regulation of women and noted that the criminalization of pregnancy raises precisely the same concerns that the Court was trying to address in Robinson: the use of the criminal law to regulate whole classes of marginalized people based on characteristics of the group, in this case pregnancy. In addition, I argued that the criminalization of pregnancy inflicts the same sort of harms that status-based offenses inflict in other areas: it carves out special rules for pregnant people and facilitates gender-based subordination and discrimination. As a result, I concluded, the criminalization of pregnant people should be deemed an impermissible status offense under the Eighth Amendment.

SH I started this project with questions about whether it might be useful to think about surveillance in relationship to the kind of watching that occurs within the family—questions that have been problematized and expanded through conversations with contributors. Can you talk about how you see "surveillance as care" from a legal perspective? Can surveillance be something that is desired when it is motivated by an interest in care and protection?

PO I don't know that I view surveillance as something that is beneficial to the individual or a community, particularly when that surveillance comes from a government entity. In the case of Black women, as mothers or sex workers or welfare recipients, history demonstrates that government surveillance under the guise of "helping," through monitoring of health information, income, or their child-rearing practices, has led to increasing criminalization and marginalization of the very people government claims to "help."

For example, as Khiara Bridges finds in her book *Reproducing Race*,[3] poor pregnant Black women who seek publicly funded prenatal care are often humiliated by social workers during visits and required to disclose deeply personal information about their home life, including their sexual practices. Moreover, Dorothy Roberts powerfully articulates the ways in which poor Black women's proximity to social welfare agencies actually increases the likelihood that they will be criminalized because of how much information they must disclose to government agencies as a condition of their receipt of benefits. Indeed, given the ways in which racism is structurally embedded in every government institution, attempts at "care through surveillance," often reproduce the forms of violence that they seek to contest in the lives of Black women.

Instead of "surveillance," I believe that what the government owes to poor Black women is radical structural change that will enable them to provide for themselves and their children in safety, security, and with dignity.

SH Your legal work and activism examines how the law and institutions structure and perpetuate inequality, work that you've said includes going into places where people are often invisible. Dynamics around visibility and hypervisibility have been discussed in a number of the texts and interviews collected here. Can you talk about how this plays out in a legal context?

[3] Khiara Bridges, *Reproducing Race: An Ethnography of Pregnancy as a Site of Racialization* (Berkeley: University of California Press, 2011).

PO In my work, I use an intersectional lens to explore how Black women and girls are simultaneously hypervisible and invisible. By hypervisible, I refer to the ways in which Black women's bodies are subject to constant surveillance by law enforcement, welfare institutions, and educational entities. Black women are disproportionately locked up in prisons and locked out of opportunity. Black women are more likely than their white counterparts to be killed by the police and Black girls are more likely than their peers to be kicked out of school.

At the same time that Black women experience these myriad forms of harm, they are often invisible in antiracist and feminist movements against state violence. For example, although Black women are disproportionately subject to incarceration and the reproductive violence that accompanies imprisonment, we often have to fight for Black women to be included in accounts of mass incarceration or reproductive subordination. This combined hypervisibility and movement invisibility leaves Black women continually vulnerable to state violence.

SH In light of the horrifying reports we are seeing regularly about immigrant families being separated at the U.S.–Mexico border, can you talk about how the judiciary denies mothers the right to stay with their children and how surveillance plays a role in these dynamics?

PO This is a big question. There are so many ways that the civil and criminal legal systems separate families and deny marginalized women the right to parent. The most obvious is the foster care system which, as Dorothy Roberts documents in *Shattered Bonds*,[4] disproportionately removes children of color from their homes. We also see the federal government utilizing civil and criminal immigration law as a mechanism to separate families along the southern border.

Beyond these prominent examples, the criminal legal system routinely separates mothers from their children. Here are just a few examples: law enforcement entities routinely arrest mothers for petty crimes, placing them in jail pretrial with onerous bail terms, thus separating them from their children. When women are convicted or plead guilty, they are often at risk of losing their parental rights if their children are placed in foster care. Indeed, nearly 80 percent of women in jail are mothers.

In many jurisdictions across the country, parental incarceration may factor into a judicial finding of parental unfitness and ultimately the termination of parental rights. Despite this, judges often fail to take into account a woman's role as the primary caregiver when considering sentencing options, which may include a community-based sanction that would allow a woman to maintain custody of her children.

Once incarcerated, women often have difficulty visiting with their children due to the remote location of prisons and restrictive visitation policies (which have been upheld by courts as constitutional). If a woman gives birth while inside, she may be separated from her newborn within just twenty-four hours.

In light of these dynamics, my work makes a simple claim: the fact that the criminal legal system routinely separates families is unconscionable. Loss of a child should not be part of the punishment for crime.

This conversation took place over email.

[4] Dorothy Roberts, *Shattered Bonds: The Color Of Child Welfare* (New York: Basic Books, 2002).

Together, Pat and Judge Friendly ride the elevator upstairs to a big room with benches. Lots and lots of people are waiting.

"It is hard to wait," says Judge Friendly.

"There are many families here, so we hope that everyone brings something to read or quiet puzzles to work on."

What 10 things don't belong in this picture?

Sable Elyse Smith, *Coloring Book 8*, 2018.
Screen printing ink and oil stick on paper, 60" × 56"

Opposite:
Sable Elyse Smith, *Coloring Book 41*, 2019.
Screen printing ink and oil stick on paper, 60" × 50"

Mama Virtual

JENY AMAYA

Mama Virtual is an episodic series of portraits of Central American immigrant mothers living in California. The film was inspired by childhood memories of my Salvadoran mother, who came to the United States as a refugee of the Salvadoran Civil War. It's reflective of her virtual relationship with my older brother, who she left in her home country at eight months old and met physically twelve years later. *Mama Virtual* materializes the virtual sphere that transnational mothers construct in order to reach their children and families living in their countries of origin.

The violence and poverty of postwar Central America compels mothers from this region to migrate to the United States seeking income that will allow them to provide as caregivers. To escape economic hardship and violence caused in no small part by U.S. foreign policy, mothers come to the United States to work while leaving their children in their home countries. Many of these mothers earn less than a living wage and are unable to fulfill their financial goals, prolonging these periods away from their children. Although many of these mothers cannot go physically back to their home countries, they are able to cross borders virtually.

Growing up, my family's home in the San Gabriel Valley, east of Los Angeles, served as a transitional house to many family members and acquaintances from El Salvador. Much of the time this meant that my sister and I had to share our room with recently arrived family. One of these relatives was my aunt Carla, who is the protagonist of the first version of the film *Mama Virtual* (2015).

My aunt Carla has not visited her home country since 2002. Besides her eldest daughter, most of her children live in El Salvador. Having worked with my aunt at an energy bar packaging factory the summer before graduating college, I spent time with her often and grew acquainted with her daily routines, which involved her virtual mothering. To visually explore this familial experience, I asked my aunt if I could make a portrait of her transnational motherhood through a film. Carla, a mother of three, is not with her children physically but makes every effort to tend to their economic and emotional needs. She sends big boxes to El Salvador full of carefully curated objects for specific people and prefers this to sending money.

As I made the film, I explored the practice of sending boxes to families in Latin American countries. While researching, I found a series of photographs of families who received boxes sent over by family members in the U.S. The boxes and the things in them amplified the presence and absence of the family member who sent them. The collection of photos resembles family portraits. Family members pose next to their delivered boxes in domestic spaces as if attending a professional photo studio. In this economic exchange, delivery men

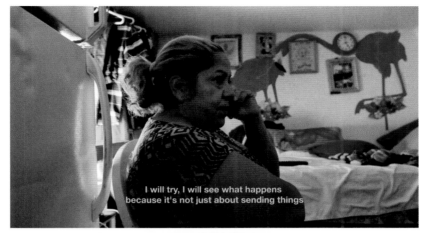

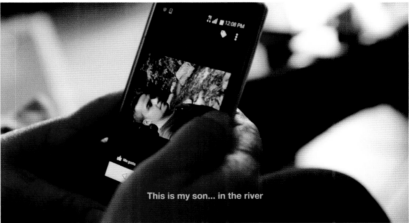

Jeny Amaya, *Mama Virtual*, 2015. Video (color, sound), 17:30 min.

become stand-ins for professional photographers. My dad said the reason these photographs are taken is to have proof the family received the box, a receipt that the transaction is complete. Showing love is done through commodities since physical contact is impossible. The economy of El Salvador relies on remittances, and the portraits are a reminder that capitalism tries to reduce working people to the status of commodities.

The following year I wanted to create a set of portraits of transnational motherhood. After having little luck with personal networks, I explored the Los Angeles landscape to find organizations that worked with Central American communities. A nonprofit organization in Los Angeles that helps organize and educate underserved residents allowed me to spend time at its job centers for the next few months in order to speak with the women there. They spoke of the difficulties immigrant women face in Los Angeles, especially women that are alone yet have to support their families in their homeland. A lot of the women that came to the job center described periods of luck and misfortune finding consistent work in chronically underpaid fields such as domestic labor. While there, I conducted interviews with twelve women that identified with the transnational motherhood experience. The stories of two of these workers, Alicia and Ame, became part of the final version of *Mama Virtual* (2016).

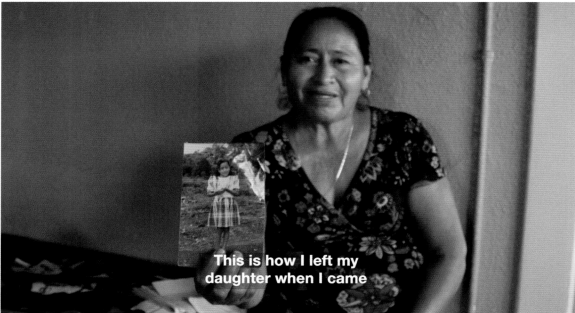

Jeny Amaya, *Mama Virtual*, 2016. Video (color, sound), 12:49 min.

Ame and Alicia, who live and work in Los Angeles and have children in Guatemala, make use of the virtual realm through their performance of "the mother's touch." This is accomplished through the touchscreen of a phone, digital images, phone cards, and other mediated technologies. Although both Guatemalan, Ame and Alicia have different experiences with transnational motherhood. Ame, a mother of three, doesn't have Internet on her phone, but connects with her children through remittances, phone calls, and photographs. As she looks through old photographs, she reflects on the day she left her children in Guatemala. She expresses that she came here out of necessity, defending a decision that is often vilified. Alicia, who has children in Guatemala and the United States, shows how her motherhood is balanced through cell phone photos, Facebook, and Messenger. Facebook is where her children in the U.S. and her children in Guatemala are in one place. It is a virtual space where she can share presence and place with her family.

That Central American migrants come to the United States in large numbers due to poverty and violence in their home countries is nothing new. These are long-term effects resulting from the ways the U.S. and Central American governments systematically oppress the working class. Getting a work or tourist visa as a working class person in Central America is nearly impossible, making unsanctioned border crossings the only alternative. When crossing the Mexico–U.S. border, migrants have to navigate intense surveillance, like ground sensors that recognize movement at the border.[1] If migrants are able to cross the border without getting detained, their social media and overall Internet activity is most likely monitored.[2] Social media posts that match certain keywords are collected and tools that interpret this data wrongfully identify many people as threats.[3] This data is then used in deportation cases. When detained, immigrants are placed in detention centers, many times operated by privatized prisons which force them to endure unlivable conditions for uncertain periods of time. This inhumane treatment controls undocumented immigrants through fear, making them vulnerable to exploitation.

For Central American immigrant mothers in the United States who can't return to their home countries, sometimes the only way they can provide care is through virtual presence and financial support. Lack of physical time and space is replaced by the virtual realm, creating a new environment for interconnectivity. Through these diasporic experiences, it is evident how the simultaneity of time and place arrange themselves in the everyday lives of these transnational mothers.

[1] Shirin Ghaffary, "The 'smarter' wall: How drones, sensors, and AI are patrolling the border," *Vox*, May 16, 2019, https://www.vox.com/recode/2019/5/16/18511583/smart-border-wall-drones-sensors-ai.

[2] Esther Yu Hsi Lee, "Homeland Security to monitor social media accounts of immigrants and citizens," ThinkProgress, September 26, 2017, https://archive.thinkprogress.org/dhs-social-media-7e002844c801/.

[3] Brennan Center for Justice, "Government Expands Social Media Surveillance with Little Evidence of Effectiveness," *Brennan Center for Justice* Press Release, May 22, 2019, https://www.brennancenter.org/our-work/analysis-opinion/government-expands-social-media-surveillance-little-evidence.

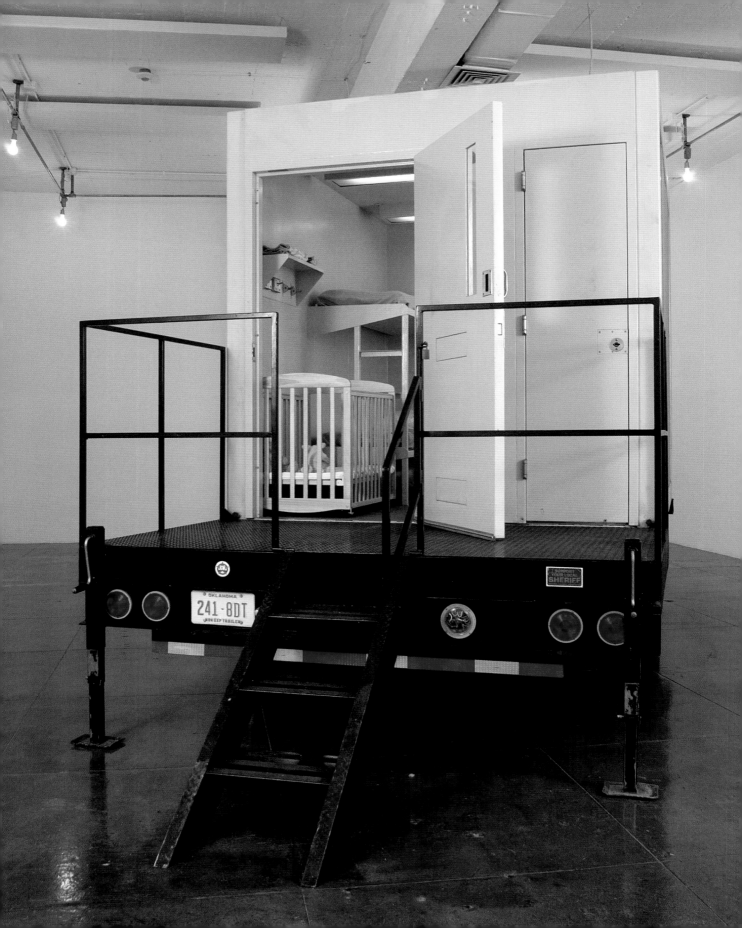

I rent a family-sized cell from a company that offers all types of products and services to the private prison industry in the United States. Taking T. Don Hutto's family cells as my model, I adapt it and live in it with my daughter and husband for 24 hours. When we come out, the door remains open and the cell is shown as a work of art.

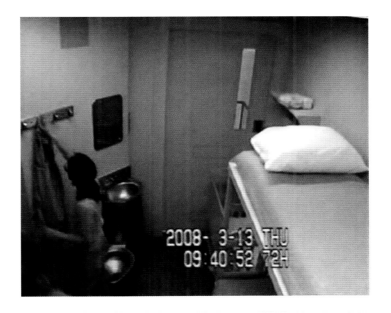

Regina José Galindo, *America's Family Prison*, 2008.
Mixed media, dimensions variable

Watching Her Watching Him

KATE WOLF

When the twenty-fourth edition of the annual *Salon De Mai* opened in Paris on May 4th, 1968, Lea Lublin participated with an unusual entry. For her work, *Mon fils (My Son)*, the Polish-Argentine artist took over a corner of the city's *Musée d'Art Moderne*, where the *Salon* took place. There she installed a crib for her seven-month-old son Nicolas and cared for him in front of visitors every day for just under a month. Surprising enough on its own, Lublin's piece was made even more conspicuous in an exhibition that featured no other live performance. Instead, she found herself surrounded by paintings by the likes of Marc Chagall and Pablo Picasso. In this staid atmosphere, she breastfed Nicolas, changed his diaper, played with him, and sang him songs near a painting on plexiglass she had made that captured his chubby head in profile, interspersed with bunnies.

Of course, anyone who has encountered the glare of strangers when their baby cries in a place as innocuous as the supermarket, or who has been urged to retreat to a bathroom to breastfeed as though the act were somehow illicit, will have an inkling of Lublin's audacity. As one of the few female artists in a major exhibition that took place before second-wave French feminism had been fully established as a frame, her wager to draw explicit attention to her gender and body (not as an object of sex either but—perhaps far more taboo in the art world—of care and maternity) still seems exceedingly bold.

In the series of black and white photographs that now represent *Mon fils*, however, Lublin appears unruffled. The pictures, seemingly all taken on the same day, show her beautifully coiffed, dressed in a dark wool suit, smiling radiantly with her child. She holds him tenderly to her cheek or hangs energetically over his crib with a toy in each hand; in another photo, she bends down to him as an older woman looks on approvingly from the side. No in-depth log of Lublin's time at the museum seems to exist, but in the pictures she comes across as a conventionally attentive, doting mother—one who delivers on classic expectations of what a mother is and does. Rather than a performance, she described *Mon fils* as a "displace[ment]" of her everyday life "to an artistic venue."[1]

Formerly a painter of large, expressionistic canvases, like many of her peers involved in Fluxus, happenings, and new media, by the mid-1960s Lublin had become critical of her commercial status. She was more interested in finding ways to reciprocally engage viewers and dissolve rigid distinctions between art and the rest of life. This objective pushed much of her work outside of art institutions, into the street and other autonomous environments. But in the case of *Mon fils*, she seized an opportunity to intervene in the sacrosanct cultural sphere of the museum with the thoroughly less exalted realm of the home, transposing private and public, offering intimate experience as opposed to an object, and invoking feminist debates around reproductive labor.

[1] Jérôme Sans, "The Screen of the Real: Interview with Lea Lublin," in *Lea Lublin: Retrospective*, ed. Matthias Muhling and Stephanie Weber (Gent: Snoeck, 2015), 201.

Accordingly, Lublin's piece is often mentioned in conjunction with the artist Mierle Laderman Ukeles, whose work honors what she termed "Maintenance," to refer to the devalued labor, including child-rearing, performed in support of "Development" (which, for Ukeles, includes progress, revolution, and the avant-garde). In her 1969 *Manifesto for Maintenance Art*, Ukeles outlines an ultimately unrealized exhibition entitled *CARE* that recalls *Mon fils*. She proposes moving into a museum with her child and husband, where she'll perform her regular domestic chores rechristened as art, with the aim of "flush[ing] them up to consciousness." No doubt, Lublin also shared the desire to flush up to consciousness the reality of being a single mother and an artist. In the context of the uprising of May '68 which was unfolding in the universities and streets of Paris just as the *Salon* commenced, her actions also take on the form of an occupation, as the art historian Catherine Spencer observes. But since there are no weekends or sick days in the mothering economy, Spencer writes, "Lublin was emphatically *not* on strike." Rather, "by performing the privatized act of childcare in a public realm, Lublin linked her own quotidian experience with that of the wider society, in a way that uncovered its communal political potential."[2]

One newspaper at the time proclaimed simply that Lublin was exhibiting Nicolas. Clearly, though, she intended *Mon fils* as more of a triangulation between herself, her son, and viewers—one in which she would watch her child and be watched simultaneously. Moving into the museum was not just a way for Lublin to display herself with her family, but to puncture the primacy of the mother–child relationship by giving it that unlikely third element: an audience. Or perhaps this audience is not so much unlikely, but underrecognized, a specter that accompanies mothers practically from the point of conception in forms ranging from the corrupt application of state control and incarceration to the ever-present burden of social expectation. If from the photos of *Mon fils* it might seem that Lublin didn't actively subvert the standards by which mothers are judged—namely the imperative of joyful submission to, and effortless managing of one's child—Spencer notes that her deliberate staging of an image of mother and son (the painting of Nicolas that hangs over his crib, for example) indicates she was attuned to the ways in which motherhood was "produced, policed, and consumed" by the public and that she was invested in "the possibilities for its deconstruction."[3]

It also seems worth noting the ways in which childcare resists spectacle. Compare Lublin's modest performance to the multimedia extravaganzas of Allan Kaprow-style happenings of the early 1960s, which also purportedly introduced real life into galleries and other art settings. Or even to the theater of reality television. A few years after *Mon fils*, a show called *An American Family* premiered in the U.S. to surprisingly high ratings. Often described as the first example of reality TV, its immense popularity announced a budding interest in everyday life and nuanced portraits of complicated family dynamics (romantic affairs, divorce, and an openly gay son were all featured). The show was billed as cinema verité and was composed from over three hundred hours of footage. Yet its creator, Craig Gilbert, edited this documentation down to twelve tightly constructed one-hour episodes, producing entertainment rather than monotony. In contrast, Lublin's presentation of motherhood unfolded in real time, with no intervention or streamlining apart from the exhibition's hours. While it showed that the work of mothering deserved attention, it also likely demonstrated that motherhood is rife with instances of boredom and discord (Ukeles on motherhood: "The mind boggles and chafes at the boredom"), and that parts of the experience were not possible for viewers to assimilate.[4]

Later, Lublin would sum up her ambition with *Mon fils* as wanting "to produce a work which confronted the real with its representation."[5] This aim extends to both the manner in which her piece challenged formal expectations of what an artwork

[2] Catherine Spencer, "Acts of Displacement: Lea Lublin's *Mon fils*, May '68, and Feminist Psychosocial Revolt," *Oxford Art Journal* 40, no. 1 (March 2017): 65–83.

[3] Spencer, "Acts of Displacement," 65–83.

[4] Patricia C. Phillips and Larissa Harris, *Mierle Laderman Ukeles: Maintenance Art* (Munich: DelMonico Books, 2016), 210.

[5] Sans, *Lea Lublin*, 201.

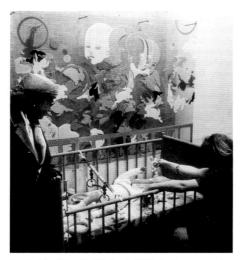

Lea Lublin, *Mon fils (My Son)*, 1968. Performance at the *Salon de Mai*. Gelatin silver print, 9 ⁷⁄₁₆" × 7 ¹⁄₁₆"

could be, as well as how it refuted one-dimensional depictions of maternity. By showing herself taking care of her Nicolas in public and foregrounding her experience, Lublin traded a fixed image of motherhood in favor of a more complex and ambiguous, moment-to-moment reality. "A baby's metabolism is three times faster than ours," Ukeles writes in a statement on mothering. "That means the mother must calibrate herself to a completely different time and space . . . isn't that sculpture?"[6] It may no longer be revelatory for women to admit that having and taking care of a child can cause intense feelings of ambivalence, but Lublin cannily passed some of this conflict on to her audience, confronting them with their own sense of frustration or indifference in light of the length and more mundane aspects of her performance.

At the same time, Lublin's work leaves itself open to the interpretation that mothering and caretaking can be creative acts, a sentiment that may now seem obvious, but was likely more contentious at the dawn of the second-wave feminist movement in France that Lublin was immersed in. With abortion not yet legal, Lublin's open embrace of her child and his apparent supplanting of any other artistic production in her life could have easily been read as a tacit acceptance of oppression. Though the landscape of childcare in France began to improve after the agitations of May '68, feminists still questioned if their desire to have children was authentic or just an urge dictated by others. Certain strains of the movement promoted the philosophy that women should cease procreation altogether until the downfall of capitalism. For one of these groups, Psych et po, Claire Duchen writes, "the only positive form of childbirth . . . is as metaphor . . . intellectual production, which for them replaces the production of a child."[7] With *Mon fils*, on the other hand, Lublin seemed to actively question the creative hierarchy upheld by patriarchy. Why should we think of the daily work of life—often the realm of women—as less valuable than the "serious" artistic and intellectual output society lionizes, and why, indeed, should we insist on keeping them separate? These questions again echo Ukeles, who wrote in 1970:

> In women's hard-winning and new-finding of power and freedom,
> I do not want merely to adopt the blinkered classical definition of
> artistic freedom: "up up and away" i.e. off the backs of their unseen
> maintenance systems. Rather I want to use my freedom to move not
> only "up" and "away," but also "sideways," "backwards," "through,"
> and "around and around"; to weave and loop and to loosen existing
> structures: to see them . . . I operate both from acute ambivalence
> and ecstasy of being tied to other people and bound to the earth.[8]

That *Mon fils* embodies all these things—the ambivalence and the ecstasy of being tied to others, the initial shocking reality of a child who impinges on every aspect of your life, the dearth of options mothers have in caring for their children—

[6] Phillips, *Mierle Laderman Ukeles*, 214.

[7] Claire Duchen, *Feminism in France: From May '68 to Mitterrand* (London: Routledge & Kegan Paul, 1986), 63.

[8] Phillips, *Mierle Laderman Ukeles*, 212.

Lea Lublin, *Mon fils (My Son)*, 1968. Performance at the *Salon de Mai*. Gelatin silver print, 7 ¹⁄₁₆" × 9 ⁷⁄₁₆"

without seeking to resolve them, only to show them in depth, is something I felt viscerally when I first encountered it. (In the excellent exhibition *Radical Women: Latin American Art, 1960–1985*, with my own crying baby in tow.) Apart from the unexpected context, I was surprised that the images of Lublin and Nicolas would strike me as radical, possibly because I was inured to the various conventions they broke. But reframing and revealing new aspects of what we think we know was integral to Lublin's practice as an artist. Lublin even titled a 1965 work *Voir clair/Ver claro*, or *To See Clearly*. For *Voir clair/Ver claro*, she invited viewers to spray water on and then activate a windshield wiper affixed to panes of glass behind which were mass-produced images such as the *Mona Lisa*, symbolically wiping them clean of their cultural residue so they could be encountered afresh. Similarly, she deconstructed many Renaissance paintings for another series, teasing out their underlying relationships to gender and desire. "It's because I begin with history as a material that my wish to explore the field of the visible brings me to discover what is there to see but that no one has seen," Lublin asserted in an interview toward the end of her life. She goes on to compare her approach to Jacques Lacan's reading of Edgar Allen Poe's tale, "The Purloined Letter," "which tells the story of a police investigation around a letter which is present in the room but which no one sees."[9] Lublin understood that despite its universality—its very underpinning of life itself—motherhood could be like this too, with its myriad labors and complexities hidden (or just ignored) in plain sight. Pushing these elements to the fore is part of her legacy, and why five decades later, *Mon fils* still seems like such a brave work. Lublin was convinced her experience as a mother was worthy of the public's attention, so she brought Nicolas to the museum with her and made them look.

9 Sans, *Lea Lublin*, 202.

A Conversation with Caitlin Keliiaa and Stephanie Lumsden

CAITLIN KELIIAA is an Assistant Professor of History at UC Santa Cruz. Her book project *Unsettling Domesticity* examines how Native women domestic workers negotiated and challenged an early 20th-century Indian labor program. Dr. Keliiaa is Yerington Paiute and Washoe.

STEPHANIE LUMSDEN is a member of the Hoopa Valley Tribe. She is currently a PhD candidate in the Gender Studies department at UCLA and a recipient of the Ford dissertation fellowship. Her dissertation examines the relationship between ongoing Indigenous dispossession and the development of the carceral regime in California.

180

SOPHIE HAMACHER

Caitlin, you have examined labor history and the dispossession that continues the U.S. project of settler colonialism, genocide, and surveillance of Native bodies. Specifically, you have worked on how Native women domestic workers negotiated and challenged the Bay Area Outing Program during the early part of the twentieth century. Can you talk about this project and the discoveries you made while researching? What were these "outing programs" and for what purpose were they developed? How are they tied to surveillance of home and the body?

CAITLIN KELIIAA

"Outing" was a nationwide project in the late nineteenth and early twentieth centuries that extended from federally run U.S. Indian boarding schools. On school breaks and sometimes during the school year, Native students were contracted to labor for white businesses and families; boys were often sent to work on farms and ranches while girls were employed in domestic service. Outing was peddled as "work experience" yet functioned as labor extraction. In the West this was especially apparent as local industries relied on Indian children as cheap wholesale labor.

The San Francisco Bay Area iteration of outing known as the Bay Area Outing Program was exclusively for Native girls and women. In practice, it funneled Native women from Western-based Indian boarding schools to work as live-in housemaids in homes across the Bay Area. For over two decades this program coercively recruited over a thousand Native women and established an exploitative labor market.

Because women labored in private homes, they were subjected to the surveillance and control of their employers and "outing matrons." They suffered conditions consistent with modern live-in domestics—loneliness, abuse, exploitation—in addition to sexual surveillance and bodily regulation. At the peak of the Bay Area Outing Program, outing matrons required all Native women and girls to submit a health clearance prior to placement. Superficially, these clearances were meant to protect homeowners from contracting illness from Native women—which frames Indian women as pathologically unhealthy and diseased. However, these health clearances were interested in the details of a young woman's sexual activity, if she had contracted sexually transmitted infections, or if she was pregnant. This bodily regulation put outing girls in the crosshairs of local authorities and social service agencies who incarcerated Native women in detention centers, facilities for the "feebleminded" and targeted them for sterilization. Further, while outing matrons were agents of the state, so too were outing employers. In fact, the very project of outing is an example of the government shirking its federal responsibilities and placing them in the hands of white homeowners. The fact remains that Native girls and young women were sent to labor in the private homes of their employers. Employers were required to surveil and control their child servant. This labor project was rife with gendered and racialized colonial dynamics intent on domesticating young Native women. In this way, the outing program and outing homes were productions of colonial rule, maternalist regulation, and an extension of the settler colonial project.

A 1927 *Oakland Tribune* article reporting that "forty Indian girls from the Carson Indian school at Stewart, Nevada, will put their knowledge of domestic science to good use in Oakland during the vacation period."

SH Caitlin, I read that your research for the project *Unsettling Domesticity* involved uncovering a lot of Native women's voices from federal archives—could you talk about the systemic racism inherent in the archival system itself? How can we think about surveillance in relation to the archive when we are speaking about reproductive health and women in particular? Stephanie, this question is also for you.

CK This is such a good question and one that historians do not discuss enough. My research is based on a federal archive—documents that outing matrons largely wrote and collected on each outing participant as well as their interactions with Indian agencies, boarding schools, maternity wards, detention centers, etc. Woven within these records are many assumptions about the perceived promiscuity of Native women, at times their supposed ineptitude and overall disobedience. Outing matrons' predispositions imbue the data, and nuanced analysis is critical. Their role was designed to bring Native women under the civilizing influence of white supremacist heteropatriarchy and the archive reflects that mandate. Further, while the archive is revealing, it does not capture the full weight of the outing program—there are absences. For instance, letters between outing girls and their families are not present in the archive unless confiscated by the matron. We will never know the stories they shared with family. Nonetheless, my archive exists because of federal surveillance and management of Native women's lives and bodies. It is revealing of the violence outing matrons, federal officials, and local authorities inflicted on Native women through the outing program. Including federal intervention into Native women's intimate lives and their reproductive health.

STEPHANIE LUMSDEN

I think Caitlin's work is such a great example of the kind of historical projects that require a deep skepticism of the state. It's important to know that the state sometimes dons a facade of care that is animated by white women in

order to maintain the colonial chokehold on Native peoples' capacities for social and biological reproduction. Scholars use state archives to inform our research, but we should also read against them, refuse them, and talk back to them in order to avoid reproducing state narratives in our anticolonial scholarship. Regrettably, many scholars of Native American history use state archives without interrogating them and Native peoples suffer the consequences of their intellectual laziness.

SH As your research shows, the reproductive capacities of Native women have historically been undermined and surveilled by government-run institutions in an effort to assert control over their reproduction. Stephanie, can you talk about the false benevolence of this kind of surveillance in relation to dispossession and criminalization?

SL State practices of surveilling Native peoples' reproduction have shifted over time to facilitate the ongoing project of settler colonialism and to circumvent Native resistance to colonial violence and occupation. Historically, An Act For the Government and Protection of Indians, passed into law in 1850 in California, is an example of how the state targets Native peoples' reproductive capacities with genocidal violence while taking a position of benevolence. Section three of An Act For the Government and Protection of Indians had perhaps the most significant impact on Indian tribes because it formally authorized the kidnapping and de facto enslavement of Indian children as well as adults. California Indian children were taken and exploited by white settlers who wanted domestic servants for their homes and laborers for their stolen land. The theft and exploitation of Indian children was a systematic way for the state of California to interrupt the continuity of Indian families and identity while also creating a racialized and subjugated class of Indians whose labor was appropriated to make white settler life possible.

What is most striking about this law is that, in spite of the terrible violence it enshrined during this period of history, the law is couched in the language of paternalism and care. Through this law the state espoused concern for the well-being of Native peoples and claimed to be offering protections to them even as state and federal governments were bankrolling vigilante militias to engage in a campaign of Indian extermination. California Indian children as well as adults were compelled to labor for white settlers under this law if they were deemed "vagrant" and in need of the civilizing influence of work. The emphasis in the law on the care and protection of Indian children looms large in the memory of California Indian peoples and resonates in the contemporary moment.

The language of benevolence is one way that the state masks its surveillance and policing of Native peoples' cultural and biological reproduction. For example, Child Protective Services (CPS) and state-run foster care programs exist under the guise of concern for neglected Native children even while they obscure the colonial machinations of power that actively destroy Native families. Not only do these sorts of child welfare programs enact a form of Indian child removal, they are also sites of physical and sexual abuse. Foster care programs are in no position to guarantee the safety and well-being of Native youth as evidenced by the highly publicized tragedy of Tina Fontaine, a fifteen-year-old Sagkeeng First Nations girl who was abducted and murdered while in foster care in 2014. Tina Fontaine's murder brings into stark light what several studies have shown, which is that being placed in foster care as a Native girl is a precursor to becoming a Missing and Murdered Indigenous Woman (MMIW). Rather than providing safety and care for Native youth, CPS and foster care programs are

mechanisms through which the settler state extends the reach of its surveillance on the reproductive capacities of Native peoples and perpetuates longstanding state practices of Indian child removal.

Indian Health Service is another "helping" institution that provides essential services for Native peoples' health and wellness, including their reproduction. However, as the scholarship of several Native feminists have demonstrated, the reproductive capacities of Native women have historically been undermined and surveilled by the federal government via Indian Health Service. So how do we explain these acts of surveillance? I would argue that Native peoples' reproductive capacity and the role of mothering in particular is a constant source of settler state anxiety. As Mohawk scholar Audra Simpson has compellingly argued, Native women and girls pose a threat to the settler state because they represent alternative polities that challenge settler state sovereignty and legitimacy. Native women and girls are targeted for state surveillance and intervention because they remind the state that its future is not promised and Native resistance has not abated. Hupa tribal member and scholar Cutcha Risling Baldy similarly asserts that "attempts to subvert the roles and place of Native women were built into settler colonial policies because Native women, who at one time exercised autonomy in Native societies, represented a threat to the settler colonial state and settler colonial societal organization." The analysis put forth by both Baldy and Simpson is useful for explaining the repressive violence enacted by the police against Native women and mothers.

SH Stephanie, reflecting in a previous text on the concerns of your work, you put it beautifully, and I feel your statement has much to do with the aim of this volume overall: "This is . . . an effort at making these connections visible so that we can better theorize the reach of the state into the intimate spaces of our lives, and begin to imagine a future without it." I want to ask both of you which surveillant tactics you want to bring to light and what the future could look like without them?

CK Over time these surveillance tactics look different. In the above mentioned example from the early twentieth century, surveillance was a fact of the outing home, but also in outing matrons' insistence on "health" clearances and their detailed control of Native women's lives. One matron was so intent on surveillance that she would track Native women after they moved on from the outing program—often commenting on her husband, her children, and whether she seemed well-adjusted. While seemingly benign, these tactics regularly led to drastic material consequences for Native women including Indian child removal. The Office of Indian Affairs enacted these forms of surveillance at various scales down to Indian agents and "field matrons" in each tribal community. Into the mid-twentieth century, surveillance of Native women's lives and bodies took upon a similar shape and quality. Much of the same practices that outing matrons enacted on Native women were later executed by social workers. Their actions in the social welfare system resulted in the mass separation and adoption of Native children from their mothers and families. Simultaneously and especially in the 1960s and '70s, this surveillance of Native women's intimate lives and bodies led to forced sterilization on a massive scale. As many scholars have revealed, the federally operated Indian Health Service (IHS) sterilized thousands of Native women, often without their knowledge or consent. In fact, IHS facilities singled out full-blood Indian women for sterilization procedures; women often agreed to procedures when they were threatened with the removal of their children or loss of cash aid. One scholar estimated that

during the 1970s IHS sterilized at least 25 percent of Native American women between the ages of fifteen and forty-four. Much like Indian child removal, sterilization was the state's effort to foreclose a future where Native resistance could contest the settler state. Atrociously, surveillance that led to Indian child removal and sterilization was often disguised as benevolent—Indian children would be better off separated from their families and Indian women would be unburdened and free to labor. This state power was expressed as a form of custodianship, wardship, and perhaps even "care." Care that fiercely controlled and contained Native women. These are the enduring consequences of settler colonialism. The surveillance and control of Native lives and bodies continues but in new and sometimes related forms. Whether early twentieth-century Indian agents or modern-day social workers, these are agents of the state who continue to infringe upon the lives of Native women.

SL The false benevolence of "helping" institutions is demonstrated by the threat of a police encounter that is attached to their promises of resources, services, and care. In the aftermath of the police murder of George Floyd, the subsequent protests against police violence in the summer of 2020, and growing public demands for abolition spearheaded by the Movement for Black Lives, it is urgent that we shed light on the ways in which Native mothers are targeted by police and killed. Abolitionist scholar and activist Andrea Ritchie argues that Native women's reproduction is a site of policing and punishment. Loreal Tsingine, Sarah Lee Circle Bear, and Jacqueline Salyers were all Native mothers killed by police who were pathologized and depicted as imminent threats to the officers who killed them. Right now in Spokane, Washington, Colville tribal member and mother Maddesyn George is being held in the county jail for defending her own life from a white man who raped her. She faces up to seventeen years in prison. Policing is a pervasive form of settler state surveillance, it actively watches and records and has the capacity to turn deadly in an instant. As I have argued elsewhere, policing and "prisons are just another in a long line of disciplinary spaces that have been used to inhibit the reproductive capacity and sovereignty of Indian peoples." If we are serious about decolonization, we will all have to become abolitionists.

I often reflect on my motivation for doing research on these topics and I come back to the simple truth that we are not meant to live a life that is patrolled by police, we are not supposed to be partitioned off from one another or from our land, we are not supposed to relate to each other through logics of property ownership and rights of exclusion. All living beings are meant, I believe, to make life full for each other and that's what the future will look like. Decolonization means land back, and land back means coming home to each other and leaving the state behind.

This conversation took place over email.

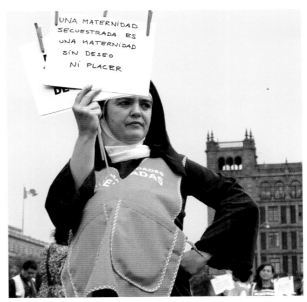

Mónica Mayer, *Maternidades secuestradas— Abducted Maternities*, 2012. Installation

The signs in each photograph can be translated as follows (clockwise): Abducted maternity means: that we poor women continue to die from complications during pregnancy; Abducted maternity means: that I am left to die in a secret clinic because the government and the church forbid me from making decisions about my own body; Abducted maternity is motherhood without desire or pleasure.

Following page:
Stephanie Syjuco, *Total Transparency Filter (Portrait of N)*, 2017. Archival pigment print, 40" × 30"

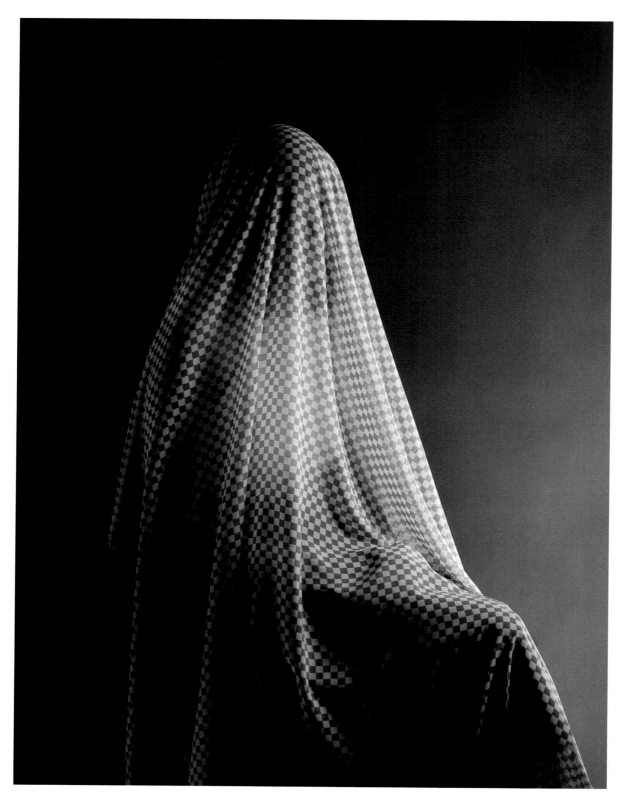

Afterword

LILY GURTON-WACHTER

What is the relationship between how we watch and how we are watched? How might the attention that mothers pay to their children forge a kind of counter-attention to the many ways in which mothers' bodies and behaviors are observed, made public, exposed, surveilled, and policed? The interviews, essays, stories, poems, and images collected in this book offer a complex and nuanced kaleidoscope through which to consider these questions, offering neither an easy solution nor an argument but something more important: a new way of looking at the strange site where how we look coincides with how we feel ourselves being looked at. Reading through this volume made me wonder how to understand the intensity and vigilance with which parents watch their children. Is it internalized from the sense that they are themselves always being watched and evaluated as parents—as Jennifer Hayashida writes, "I am seized by a feeling of being watched, but it is me watching the two of us watching our daughters"? Or is maternal or parental care a different style of watching, one about tenderness and love or what Sarah Blackwood so perfectly calls "the wasteful, grief-stricken, and chaotic process of attachment"? The chaos of that process of attachment is one, of course, in which the gentlest of care is often tinged with a wild fear and need to control the uncontrollable, and surveillance is a practice of control.

When my son was a baby, I was coincidentally already in the process of writing an academic book about the history of watchfulness, about the demands that both poetry and war make on the faculty of attention. Focused on the turn of the nineteenth century, the period right after Jeremy Bentham's proposal for a panopticon prison, my work considered a time before the emergence of modern psychology when attention was nevertheless very much in crisis, pulled in many directions. It didn't escape my notice as I struggled to find the time to write about watchfulness that mothering also demanded that I keep watch, in both ordinary and extraordinary ways, and that that watch could very easily and imperceptibly slip into a compulsive and immobilizing paranoia and surveillance. I remember sitting for hours, immobilized, because staring at the sleeping baby on my lap seemed less scary than letting go and having to wonder about him sleeping by himself. I remember feeling desperate to drop him off at daycare only to scroll through photos of him all day. I watched my own watchfulness growing strange and desperate—I had never before had someone that I cared about so much that I was willing to give up everything just to keep watch. I'd like to think that it was all coming from a place of tenderness and care, but I also know that my tenderness and care wasn't and still isn't ever completely separable from my fear and anger and a desire to never let go.

This book unapologetically investigates what Irene Lusztig calls "the least visible, least acceptable margins of feminist work": the experience of mothering. Its focus

on surveillance pulls in two directions that may initially seem contradictory. First, the painful way that mothers are under constant scrutiny, surveilled and policed, made hypervisible. From Lusztig's observation that the pregnant body is often treated like public property, touched and monitored, to the important reminders from Kenyatta A.C. Hinkle, Melina Abdullah, Caitlin Keliiaa, and Stephanie Lumsden that Black and Indigenous mothers in the United States are particularly oversurveilled, controlled, and policed in ways that middle-class white mothers are not. As the mortality rates suggest, this is not a surveillance of care but rather a harmful one of control and judgment; Priscilla Ocen explains in her interview that "attempts at 'care through surveillance' often reproduce the violence that they seek to contest in the lives of Black women."

The other direction this book pulls is that which, following Alexis Pauline Gumb's work on "revolutionary mothering," we might call revolutionary watching, something like a maternal countersurveillance that seems to transform the very technologies used to control and police mothers into tools of love, curiosity, and empowerment. Despite the negative connotations of the term *surveillance*, which evokes for some of the thinkers here a concerning lack of consent, the book ventures to ask, in Kenyatta A.C. Hinkle's words, "how can we use surveillance without internalizing its function as a tool of systemic control?" Keeonna Harris's powerful image of a "whirlwind of eyes" staring at a mother raises the question of how, given the enormous pressure put on mothers, the constant surveillance, they might surveil differently. How might they reimagine and reinhabit the experience of watching? Throughout her interviews, Sophie Hamacher asks about the difference between the terms "motherhood" and "mothering": the former, following Hortense Spillers and Gumbs, is a category reserved typically for white, middle-class mothers. But "mothering" is an activity, something, as Litia Perta puts it, "anybody can do, an action worked by people in all sorts of positions. It is a labor." A verb not limited by race, class, or even gender, mothering is a labor of care forged *despite* the hypersurveillance of mothers. "What would it mean," asks Gumbs, "for us to take the word 'mother' less as a gendered identity and more as a possible action, a technology of transformation that those people who do the most mothering labor are teaching us right now?"[1]

In her visual essay "Drawing on the History of Gestation," Hamacher draws on top of historical anatomical images of pregnant women's bodies, images that evoke the medicalization of childbirth at the end of the eighteenth century and the convergence of the medical gaze with hierarchies of power, control, and surveillance. The title offers a suggestive pun: "drawing on" here can refer both to the artist's literal drawings on top of earlier images, but it also evokes the sense of borrowing from, or as one dictionary puts it, using "information or your knowledge of something to help you do something," as in: "she has a wealth of experience to draw on." The title thus suggests an attunement to the history of how mothers have been seen, but also an active attempt to forge, on top of that troubled past, a new way of seeing. The images suggest a movement toward taking control of our own bodies, even when—or especially when—they house another body, despite a long history in which women's bodies become at that very moment increasingly policed and controlled. I like that double sense of "drawing on" because it reminds me that we cannot just do things differently without remembering and thinking about our histories, without an awareness of what Hinkle calls the "Historical Present." Without being aware of the ways in which we are surveilled, watched, and monitored, we might not be able to forge a different way to watch. This book offers reminders and specters of the histories of mothering that are often forgotten or not considered important enough to be written: the history, from the 1937 Zenith Radio Nurse to the many

[1] Alexis Pauline Gumbs, *Revolutionary Mothering: Love on the Front Lines* (Oakland, CA: PM Press, 2016), 22–23. See also Hortense Spillers, "Mama's Baby, Papa's Maybe: An American Grammar Book," *Diacritics* 17, no. 2 (1987): 64–81.

monitors today that promise to prevent SIDS, of how parental fears have been commercialized, capitalized on, and encouraged; the histories of how Black mothers and children in the United States have been criminalized, out of and against which the tradition of othermothering has emerged; the history, documented in Jeny Amaya's *Mama Virtual*, of a transnational mothering made possible through screens; and the way that the history of mothering is tied up with so many other histories, the histories of photography, race, medicine, mental illness, the breast pump, class, hope, vaccines, guilt, labor, postpartum depression, immigration, food, feminism, sexuality, prisons, slavery, colonialism, rage, the cell phone, misogyny, Child Protective Services, the Internet, paranoia, climate change, obstetrics, disability, and so much more. These histories need to be told—and drawn on—if we want to find new ways to look.

Contributors

Gemma Anderson is an artist, academic, and mother. She has developed a number of innovative art/science projects including *Representing Biology as Process* (2017–2021) at the University of Exeter; *Hidden Geometries* with the mathematics department at Imperial College London; *Isomorphology* and the *Cornwall Morphology and Drawing Centre* at CAST with the Natural History Museum, London; and *Portraits: Patients and Psychiatrists* in collaboration with psychiatrists and patients at Bethlem Royal Hospital. Most recently, her work is part of the exhibition *The Botanical Revolution in Contemporary Art* at the Kröller-Müller Museum, NL; *Critical Zones; Observatories for Earthly Politics* at the Centre for Art and Media (ZKM), Karlsruhe, Germany and *The Botanical Mind: Art, Mysticism and the Cosmic Tree* at Camden Arts Centre, London. Recent books include *Drawing Processes of Life* (Intellect Press, 2022) and *Drawing as a Way of Knowing in Art and Science* (Intellect Press, 2017).

Jeny Amaya is a Los Angeles-based filmmaker. Her recent body of work explores autobiographical narratives, notions of family, and how the past materializes itself in the present Central American diaspora in California. Amaya's work has been featured in Artists Television Access, San Francisco; Northwest Film Forum, Seattle; UnionDocs Center for Documentary Art, New York; Echo Park Film Center, Los Angeles; Santa Cruz Museum of Art, Santa Cruz; Porter Sesnon Underground Gallery, Santa Cruz; and Santa Cruz Film Festival, Santa Cruz. She has a bachelor's degree from the University of California, Santa Cruz in Film and Digital Media Studies and Latin America and Latino Studies.

Sarah Blackwood is the author of *The Portrait's Subject: Inventing Inner Life in the Nineteenth-Century United States* (UNC Press) and the introduction to a new Penguin Classics edition of Edith Wharton's *The Age of Innocence*. Her criticism has appeared in the *New Yorker*, the *New Republic*, *Slate*, and *Los Angeles Review of Books*. She is Associate Professor of English at Pace University in NYC.

Lisa Cartwright is known for her writing about visual culture and the body in feminist science and technology studies and works at the intersections of art and medical history and critical theory. She is the author of books including *Screening the Body: Tracing Medicine's Visual Culture* and *Practices of Looking: An Introduction to Visual Culture* (co-author Marita Sturken). Recent essays consider the landscape photography of photographers including Catherine Opie, the history of film tech-

nology, and the visual culture of viruses. Cartwright is currently Professor of Visual Arts with additional appointments in the Department of Communication and the graduate Science Studies Program and an affiliation with the program in Critical Gender Studies. She directs the Catalyst Lab, an initiative that supports collaborations across art, science and technology with emphases in feminist and critical theory and in experimental documentary practice. The lab is home to the online journal *Catalyst: Feminism, Theory, Technoscience*.

Cary Beth Cryor (1947–1997) received a BS in art education from Morgan State University in 1969 and in 1971 earned an MFA in photography from Pratt Institute, where she studied with Gordon Parks. After graduating, she worked in the motion picture industry as a film editor for three years, including assistant editing the film *Claudine*, starring Diahann Carroll and James Earl Jones. Cryor was a freelance photographer, Associate Professor of Fine Arts at Coppin State College in Baltimore, and archivist for the *Baltimore Afro-American* newspaper. About the series *Rites of Passage*, a photo from which is included in this volume, Cryor said: "These photographs were taken by me during labor, between contractions and during the actual delivery process. There are many feats in us and many challenges still to conquer. As unusual as this may appear, it was not difficult. It is my hope that this will serve as an inspiration to other women who may want to do the unthinkable, the unfathomable, the utterly ridiculous." See Jeanne Moutoussamy-Ashe's 1985 book *Viewfinders: Black Women Photographers*.

Duae Collective is a collective and, at the same time, a family based in Barcelona, Spain. It was founded in 2015 by Luna Coppola and Silvia Campidelli. The Collective develops projects and artistic research with a multidisciplinary and transversal approach, through the use of video, photography, new technology, drawing, cartography, sound, installations, and combining an exchange of knowledge, collaborative dynamics, creativity and environmental issues that explore the intersections between art, technology, ecology, and science.

Sabba Elahi is a multidisciplinary visual artist, educator, and cultural worker who grew up in a traditional Pakistani household in the Midwest. Through her artwork and teaching she confronts the politics of otherization, representation, and cultural resistance. As a cultural worker she seeks to complicate the narratives of the South Asian

diaspora, Muslim Americans, and center the voices of communities who have been marginalized.

Laura Fong Prosper lives and works in Berlin. Her video installations and audiovisual essays explore the boundaries between the analog and the digital, as well as the meanings and placements of the contemporary and the historical. These projects address questions of cultural belonging, displacement, memory, and motherhood. While working with archival material, old photographs and analog video synthesizers, and more recently with VR sets, she conducts her own research as a recycler of audiovisual equipment and media. She holds a degree in film editing from the International Film and Television School of San Antonio de los Baños in Cuba (EICTV) and an MFA in New Media Art from the Bauhaus University in Weimar, Germany.

Regina José Galindo is a visual artist and poet, who uses her body as the main means of work through performance and, more recently, in collective actions. Galindo lives and works in Guatemala, her native country, using its own context as a starting point to explore and confront the ethical implications of social violence and injustice stemming from racial and gender discrimination, as well as the human rights abuses arising from the unequal relations of power endemic to contemporary society. Working in the context of a newly democratized society, Galindo has developed a socially and politically motivated practice in which she strives to acknowledge the thirty-six years of civil war her country endured, but also looks forward to a more peaceful and productive future. She has received several awards, including the Golden Lion for a Promising Young Artist at the Venice Biennale (2005), the Prince Claus Award of the Netherlands (2011), and recently the Robert Rauschenberg Award from the Foundation for Contemporary Arts.

Michele Goodwin is a global thought leader and advisor. She is the host of the popular podcast, *On the Issues with Michele Goodwin*, at *Ms.* magazine. Her writings address pressing matters of law, society, and global health. An award-winning author, her publications include five books and more than one hundred law review articles, book chapters, and commentaries. Her opinion editorials and commentaries can be found in the *New York Times*, *LA Times*, *Salon.com*, *Politico*, *Forbes*, *the Christian Science Monitor*, and other platforms. She is a frequent contributor to *Ms.* magazine.

Alexis Pauline Gumbs is a Queer Black Feminist writer and scholar and an aspiration cousin to all life. Alexis is a coeditor of *Revolutionary Mothering: Love on the Frontlines* and the author of several books, most recently *Dub: Finding Ceremony* and *Undrowned: Black Feminist Lessons from Marine Mammals*. Alexis is the cofounder of Mobile Homecoming Trust, an experiential archive amplifying generations of Black LGBTQ Brilliance.

Lily Gurton-Wachter is an English Professor at Smith College. Her teaching and research focus on British Romanticism, with a particular emphasis on poetics, the history of feeling, and the shifting relation between literature and politics, history, and ethics. Gurton-Wachter's book *Watchwords: Romanticism and the Poetics of Attention* was published in 2016 by Stanford University Press.

Sophie Hamacher is an artist, filmmaker, and curator whose work concerns media, technology, and the archive. She attended the Whitney Independent Study Program for Critical Studies and currently teaches at Maine College of Art & Design in Portland, Maine.

Jessica Hankey is an artist and publisher based in Cambridge, MA. She has held editorial positions at the Museum of Modern Art, NY, the Los Angeles County Museum of Art, and the Museum of Jurassic Technology, Los Angeles.

Jennifer Hayashida is a poet, translator, and visual artist. She is currently a PhD candidate in Artistic Research at Valand Academy, the University of Gothenburg, Sweden. Her research project, *Feeling Translation*, focuses on translation, poetics, race, and affect. *A Machine Wrote This Song*, her debut collection of poetry, was published in 2018. From 2010 to 2017, she served as Director of the Asian American Studies Program at Hunter College, CUNY.

Kenyatta A.C. Hinkle is an interdisciplinary visual artist, writer, and performer. Her practice encompasses collaborations and participatory projects with alternative gallery spaces within various communities and projects that are intimate and based upon her private experiences in relationship to historical events and contexts. A term that has become a mantra for her practice is the "Historical Present," as she examines the residue of history and how it affects our contemporary world perspective. Her artwork and experimental writing has been exhibited and performed at the Studio Museum in Harlem, Project

Row Houses, the Hammer Museum, the Museum of Art at the University of New Hampshire, the Museum of the African Diaspora (MoAD) in San Francisco, Made in LA 2012, and BALTIC Centre for Contemporary Art, Newcastle upon Tyne, UK.

Magdalena Kallenberger is a visual artist, researcher, and writer working across film, photography, and installation. She holds an MFA in Media Art and a BFA both from the University of Arts Berlin. She served as Professor of Practice at the American University in Cairo (2016–2017) and Lecturer for time-based media (2010–2016) at the German University in Cairo. Since 2018 Kallenberger is a PhD candidate at the Bauhaus University Weimar and a fellow at the Friedrich Ebert Foundation. Her works produced solo and collectively have been exhibited and presented at Bamako Encounters Photography Biennial Mali, Haus der Kulturen der Welt Berlin, Camera Austria Graz, and Cairotronica. She is one of the founders of MATERNAL FANTASIES, a feminist art collective based in Berlin.

Anjuli Fatima Raza Kolb is a scholar of colonial and postcolonial literature and theory with particular research interests in the history of science and intellectual history, poetry and poetics, gender and sexuality studies, political theory and independence movements, the gothic and horror, and comparative literary studies. Her work has been supported by the Hellman foundation, the Edward W. Said fellowship at Columbia University's Heyman Center for the Humanities, and City College of New York's Beyond Identity program where she served as visiting expert scholar in women's and gender studies in 2017. Her book *Epidemic Empire: Colonialism, Contagion, and Terror, 1817–2020* was published in 2021.

Tala Madani makes paintings and animations which bring together wide-ranging modes of critique, prompting reflection on gender, political authority, and questions of who and what gets represented in art. In Madani's work, slapstick humor is inseparable from violence, and creation is synonymous with destruction, reflecting a complex and gut-level vision of contemporary power imbalances of all kinds. Madani's recent solo exhibitions include a midcareer retrospective at the Museum of Contemporary Art, Los Angeles; Start Museum, Shanghai (2020); Mori Art Museum, Tokyo (2019); Secession, Vienna (2019); Portikus, Frankfurt (2019); and La Panacée, Montpellier, France (2017).

Mónica Mayer has developed an integral focus in her work that, in addition to performance, drawing, and interventions, considers writing, teaching, and community participation as part of her artistic production. She is considered a pioneer in feminist art, performance, and digital graphics in Mexico. In 1983 she founded Polvo de Gallina Negra (Black Hen's Dust), the first feminist art group in Mexico, with Maris Bustamante, and in 1989, with Víctor Lerma, she initiated the project *Pinto mi Raya* (I Draw the Line) which has created a major archive on contemporary Mexican art. Mayer has published several books, including *Rosa chillante: mujeres y performance en México* (*Bright Pink: Women and Performance in Mexico*) and *Intimidades… o no. Arte, vida y feminismo* (*Intimacies… or Not. Art, Life and Feminism*).

Iman Mersal is an Egyptian poet and Associate Professor of Arabic literature at the University of Alberta, Canada. Her books include *In the Footsteps of Enayat al-Zayyat* (2019), *How to Mend: Motherhood and its Ghosts* (2018), *Until I Give Up the Idea of Home* (2013), *These Are Not Oranges, My Love* (2008), and *Alternative Geography* (2006). In English translation, her poems have appeared in the *New York Review of Books*, *Parnassus*, *Paris Review*, the *Nation*, and *American Poetry Review*, among others. *The Threshold*, a selection of Mersal's poetry, was published in 2022 by Farrar, Straus and Giroux, translated by Robyn Creswell.

Hương Ngô is an interdisciplinary artist. Born in Hong Kong, Ngô grew up as a refugee in the American South and is currently based in Chicago, where she is an Assistant Professor at the School of the Art Institute of Chicago. Her archive-based practice began while a fellow at the Whitney ISP in 2012. She was awarded the Fulbright U.S. Scholar Grant in Vietnam (2016) to realize a project that examines the colonial history of surveillance in Vietnam and the anticolonial strategies of resistance vis-à-vis the activities of female organizers and liaisons. Her work has been exhibited at the MoMA, NY (in collaboration with Hồng-Ân Trương); the Museum of Contemporary Art Chicago; the New Museum; and the Renaissance Society, Chicago. She was awarded the 3Arts Chicago Next Level Award (2020) and has been included in the Prague Biennial (2005) and the New Orleans triennial *Prospect.5* (2021).

Litia Perta is a writer and teacher who lives with her family off the grid in the San Juan Islands in western Washington. Current work includes two book-length projects: an examination of American higher education, and a study of beauty as critique in the work of Huguette Caland. Her work has appeared

in *Sublevel* magazine, *ArtForum*, the *Brooklyn Rail*, and *Hyperallergic*, among others; and she is co-conspirator of the book *Writing Bodies* (2018).

Claudia Rankine is an American poet, essayist, playwright, and the editor of several anthologies. She is the author of five volumes of poetry, two plays, and various essays.

Viva Ruiz is a community educated artist and advocate and a descendant of factory-working Ecuadorian migrants, raised in Jamaica, Queens. They are a maker working in performance, film, writing, music, and dance with a collaborative practice grown out of their experience in NYC nightlife. Their original telenovelas have been shown at festivals and art spaces such as Mix NYC, Outfest LA, Deitch Projects, MoMA PS1, and Futura in Prague. Ruiz founded the *Thank God for Abortion* initiative in 2015, an ongoing awareness-raising project with multiple manifestations. In 2019 Ruiz's solo exhibition *Pro Abortion Shakira: A TGFA Introspective* was shown at Participant Inc. Ruiz became the first artist awarded a residency from the pro-abortion cultural organization Shout Your Abortion.

Ming Smith moved to New York in the early 1970s. There she worked with a wide network of fellow artists, musicians, and dancers. She was the first, and for many years the only, woman member of the Kamoinge Workshop, a collective of African American photographers based in New York. The group formed with the aim of challenging negative representations of Black communities and to develop photography as an artistic practice. In 1975 she became the first African American woman photographer to have work acquired by the Museum of Modern Art, New York. Throughout her career she has traveled extensively, capturing life in America, Africa, Europe, and East Asia.

Sable Elyse Smith is an interdisciplinary artist, writer, and educator based in New York. Using video, sculpture, photography, and text, she points to the carceral, the personal, the political, and the quotidian to speak about a violence that is largely unseen, and potentially imperceptible.

Sheida Soleimani is an Iranian-American artist, educator, and activist. The daughter of political refugees who escaped Iran in the early 1980s, Soleimani makes work that excavates the histories of violence linking Iran, the United States, and the Greater Middle East. In working across form and medium, she often appropriates source images from popular/digital media and resituates them

within defamiliarizing tableaux. The composition depends on the question at hand. For example, how can one do justice to survivor testimony and to the survivors themselves (*To Oblivion*)? What are the connections between oil, corruption, and human rights abuses among OPEC nations (*Medium of Exchange*)? How do nations work out reparations deals that often turn the ethics of historical injustice into playing fields for their own economic interests (*Reparations Packages*)? Based in Providence, Rhode Island, Soleimani is an Assistant Professor of Studio Art at Brandeis University and a federally licensed wildlife rehabilitator.

Stephanie Syjuco works in photography, sculpture, and installation, moving from handmade and craft-inspired mediums to digital editing and archive excavations. Recently, she has focused on how photography and image-based processes are implicated in the construction of racialized, exclusionary narratives of history and citizenship. Born in the Philippines, she is the recipient of a Guggenheim Fellowship and has exhibited widely, including at the Museum of Modern Art, the Whitney Museum, and San Francisco Museum of Modern Art, among others. She is an Associate Professor at the University of California, Berkeley, and resides in Oakland, California.

Hồng-Ân Trương is an artist who uses photography, video, and sound to explore immigrant, refugee, and decolonial narratives and subjectivities. Her work has been shown in solo and group exhibitions at the ICP (NY), the Nasher Museum of Art (Durham, NC), the Kitchen (NY), Nhà Sàn (Hanoi), the Irish Museum of Modern Art (Dublin), the Rubber Factory (NY), and the Phillips Collection (Washington D.C). Her work was included in the New Orleans triennial *Prospect.4* and her collaborative work with Hương Ngô was exhibited in *Being: New Photography 2018* at MoMA. She was a Guggenheim Fellow in 2019–2020, the Capp St. Artist in Residence at the Wattis Institute for Contemporary Art in 2020, and a MacDowell Residency Fellow in 2022. Hồng-Ân lives in Durham, North Carolina where she is an activist and a teacher. She is Professor of Art at the University of North Carolina at Chapel Hill.

Carrie Mae Weems is widely renowned as one of the most influential contemporary American artists living today. Over the course of nearly four decades, Weems has developed a complex body of work employing text, fabric, audio, digital images, installation, and video, but she is most celebrated as a photographer. Activism is central

to Weems' practice, which investigates race, family relationships, cultural identity, sexism, class, political systems, and the consequences of power. Over the last thirty years of her prolific career, Weems has been consistently ahead of her time and an ongoing presence in contemporary culture.

Kandis Williams' versatile practice spans collage, performance, assemblage, publishing, and curating. Her work explores and deconstructs critical theory, addressing issues of race, nationalism, authority, and eroticism. Recent exhibitions include Made in LA 2020 at the Hammer Museum, for which Williams received the Mohn Award, and solo shows at the Night Gallery, Los Angeles; KW Institute for Contemporary Art, Berlin; and Ficken 3000, Berlin, Germany. In Fall 2020, the Institute for Contemporary Art at Virginia Commonwealth University opened *Kandis Williams: A Field*, a multistage solo exhibition curated by Amber Esseiva.

Mai'a Williams is a writer and artist, living in Minnesota. It was their living and working with Egyptian, Palestinian, Congolese, and Central American indigenous mothers in resistance communities that inspired their life-giving work and art-making practices. They are the coeditor of the anthology *Revolutionary Mothering: Love on the Front Lines* and the author of the memoirs *This is How We Survive: Revolutionary Mothering, War, and Exile in the 21st Century* and *The Future of Love*.

Carmen Winant's work utilizes installation and collage strategies to examine feminist modes of survival and revolt. Winant's recent projects have been shown at the Museum of Modern Art, Sculpture Center, the Columbus Museum of Art, the Wexner Center of the Arts, and through CONTACT Photography festival, which mounted twenty-six of her billboards across Canada. Winant's recent artist books, *My Birth* and *Notes on Fundamental Joy*, were published by SPBH Editions, ITI press, and Printed Matter, Inc. Winant is a 2019 Guggenheim Fellow in photography.

Kate Wolf is a writer based in Los Angeles. She is an editor at large for the *Los Angeles Review of Books* as well as a host and producer of its podcast, the LARB Radio Hour. Her short stories, interviews, essays, and reviews have appeared in publications such as the *Nation*, *Bidoun*, *Bookforum*, *Frieze*, *Art in America*, *East of Borneo*, and *Night Papers*, an artist's newspaper she edited from 2011 to 2016.

Hannah Zeavin is an Assistant Professor at Indiana University and a visiting fellow at the Columbia University Center for the Study of Social Difference. Zeavin is the author of *The Distance Cure: A History of Teletherapy* (MIT Press, 2021) and at work on her second book, *Mother's Little Helpers: Technology in the American Family* (MIT Press, 2024). In 2021 Zeavin cofounded The Psychosocial Foundation and is the Founding Editor of *Parapraxis*, a new popular magazine for psychoanalysis on the left. Her essays and criticism have appeared or are forthcoming from *Dissent*, the *Guardian*, *Harper's Magazine*, *n+1*, the *New York Review of Books*, the *New Yorker*, and elsewhere.

Edited by Sophie Hamacher with Jessica Hankey

Managing editor:
Jessica Hankey

Art director:
Ozlenen Ozbicerler

Copyeditors:
Robert Dewhurst, Cielo Lutino, Imani Roach

Additional copyediting:
Marni Berger, Erin Johnson, Ramone Lampos, Jeremy Libby, Sarah Wang

Proofreading:
Jenna Crowder

Cover design:
Samuel Alexander Forest

Cover photo:
Sophie Hamacher

Book design:
Samuel Alexander Forest and Amy Kunberger with Briaanna Chiu and Sarah Friedman

Design assistant:
Yu Jung Jung

MIT Press:
Acquisitions: Katie Helke

Production: Kate Elwell

Publicity: Nicholas DiSabatino

Typefaces:
Aktiv Grotesk by Dalton Maag and Elena by Nicole Dotin

Printed and bound:
Versa Press, Inc.

Library of Congress Control Number: 2022941340

ISBN: 978-0-262-04781-4

For Marms and for Luca and Nuri Lou

Thank you Negar Azimi, Lisa Cartwright, Roger Conover, Jenna Crowder, Kassie Daughety, Robert Dewhurst, Constanze Flamme, Molly Garfinkel, Anja Groten, Lily Gurton-Wachter, Kelsey Halliday Johnson, Johannes Hamacher, Leone Hankey, Georgia Hill, Steven Hobson, Carol Jacobs, Sarah Montross, Erin Hyde Nolan, K-Sue Park, Shayna Roosevelt, Jessica Tomlinson, Anuradha Vikram, Louise Witthöft, Kate Wolf

Supported in part by a grant from the Maine Arts Commission, an independent state agency supported by the National Endowment for the Arts; the Ellis Beauregard Foundation, the Kindling Fund; the Collective Futures Fund; and the American Rescue Plan grant.